DUBLIN'S VANISHING CRAFTSMEN

Kevin Corrigan Kearns

The Appletree Press

For My Mother

First published and printed by The Appletree Press Ltd,
7 James Street South, Belfast BT2 8DL.
Copyright © Kevin Corrigan Kearns, 1986.

First published in Britain 1987

British Library Cataloguing in Publication Data
Kearns, Kevin Corrigan
 Dublin's vanishing craftsmen : in search
of the old masters.
 1. Artisans—Ireland—Dublin (Dublin)
 I. Title
 680'.92'2 TT60.D8

 ISBN 0-86281-176-7

 9 8 7 6 5 4 3 2 1

Contents

Preface

This book was born of discovery and curiosity. Over the past fifteen years of trekking the back streets, mews and lanes of Dublin in the course of various research projects, I sometimes unwittingly stumbled across the intriguing and incongruous sight of traditional craftsmen working in their antiquated shops. It was a spectacle to behold, a rare glimpse into a preternatural world. Saddlers, shoemakers, coopers, farriers and others nestled in the shadowy nooks and crannies of the cityscape, going about their craft in a manner unchanged for centuries. Like primordial periwinkles they cling tenaciously to their cloistered niches while all around them swirls the modern world. Their little shops, dark, dusty, encrusted with age, have a surrealistic, Dickensian aura about them. They are a splendid anachronism — overhead an Aer Lingus jet screams skyward breaking the quietude of the shoemaker's shop on Castle Street where once carriages clattered by. It is as if time here has been suspended.

It is remarkable, indeed miraculous, that craftsmen who can trace their heritage back centuries should have survived into the 1980s. They are enigmatic figures, relics of a bygone epoch. Their existence is little known to Dubliners. Who would suspect that in the heart of the city remain two farriers with their old forges? Or that at Smithfield is to be found the last cooperage in all Ireland? However, the days of such craftsmen are numbered. Sons do not follow their fathers into moribund crafts. By their own admission, they constitute the 'last generation' – a vanishing species. They are in their twilight years and their crafts are on the brink of extinction. There is a palpable resignation and stoicism about their fate.

Timothy O'Neill, in his book *Life and Tradition in Rural Ireland*, laments that the 'great variety and mass of craftsmen are gone and many have vanished unrecorded.' In truth, the *vast majority* have passed unrecorded. 'What a pity,' he muses, 'that more of these had not the education, interest or ability of Seamus Murphy', whose classic book *Stone Mad* is a personal, definitive account of stone cutters. It is, however, a quixotic notion to expect the old craftsmen to tell their own tale. I have found them distinctly disinclined to do so. Most lack not only the interest and ability, but also the time. They have a strong aversion to retirement, preferring to work at the bench until literally their dying day. They are not apt to write their own story late in life. Indeed, even Murphy confessed that 'I would not have attempted it at all but that I know nobody else is likely to do it.' He is the rare exception.

Certainly, innumerable books have been written about crafts and trades. Historical treatises on craft guilds, labour unions and trade organisations are, however, normally written in a detached, analytical fashion with scant, if any, reference to individuals. Conversely, the typical genre of works devoted exclusively to crafts seem invariably to focus on tools, techniques and creations; the creators appear strangely incidental. The prevalent attitude is that crafts are worth recording but that

craftsmen should be allowed to fade quietly into gentle oblivion. Consequently, we know a great deal about crafts but precious little about craftsmen. This is regrettable, because they are the descendants of great masters and the inheritors and keepers of ancient skills and traditions. They are the last link in a long and illustrious chain extending back to the guilds of the fifteenth century. Conspicuously absent from books are their *personal feelings* and *human emotions*. What do we know of their struggles, sacrifices, fears, rewards, eccentricities and joys? As the last vestiges of old-world creativity and craftsmanship, they embody values, ideals and characteristics long held dear by Irish society – independence, a passion for life, dedication to creative workmanship and pride in their heritage. Imperilled progenies from a distant past, they deserve to be recorded and praised.

Sean O'Sulleabhain, Kevin Danaher and E. Estyn Evans have made monumental contributions to the study of Irish craft history and folklore but they have concentrated on the rural realm; urban artisans have been woefully neglected. O'Sulleabhain, in *A Handbook of Irish Folklore*, concedes that 'city and town-born individuals possess traditional information' worthy of documentation. He particularly stresses that 'items of craftlore should be carefully recorded.' Yet this has never been done in Dublin, the centre of Irish craftsmanship. Doubtless some scholars would attribute this to the reverence in the Irish psyche and culture for country life and values and the inherent bias against cities. Whatever the rationale, the omission is evident. Most of the surviving craftsmen are now in their sixties, seventies or eighties. They indisputably constitute a rich repository of history, tradition and craftlore. But they remain unacclaimed and unrecorded. A few have been accorded superficial journalistic treatment or an interview or filming session by *Radio Telefis Éireann* (RTE) but these, too, have dwelt on implements and manual techniques. Laudably, the Irish Folklore Commission dispatched several students to write down the recollections of some craftsmen but their pages are few and fragmentary. So the old men continue to pass blithely from the scene without eulogy or epitaph. As Vincent Tyrell, a seventy-five-year-old cooper, so poignantly put it when describing the coopers' last solemn gathering in 1983 to dissolve their Society after nearly five hundred years of glorious existence, 'Nobody knew we were going.'

We cannot rely upon the ancients of the city to bequeath us their mysteries, so we must go in search of them and extract what should be passed down to future generations. Therefore, during the summers of 1983 and 1984 I ferreted out and talked exhaustively with surviving craftsmen. Placing my tape recorder unobtrusively on their workbench, anvil or shop floor I sought to probe their minds and tap their hearts. The results exceeded all expectations. Most have lived in obscurity and anonymity; each had his own lively story of struggle and persistence to relate. Oral histories flowed freely and spontaneously. For many it was clearly therapeutic. At times there was a sense of urgency to 'get it all out.' Their reminiscences and musings were always interesting, frequently moving, sometimes humorous and quite often sad. They spoke with a candour and eloquence which defies embellishment. For this reason, whenever appropriate, I have allowed them to speak with their own

inimitable voice. The purity of their thoughts and descriptions is more striking than any academic rhetoric or polished journalistic script. There is an honesty and simplicity in the telling that no author could contrive.

What emerges from these pages is a book more about craftsmen than crafts. By tracing the decline of various crafts through the lives and words of the vanishing craftsmen themselves we savour a very personal sort of history and sociology. In essence, it is undiluted *urban craftlore*, expressions, accounts and stories unearthed from the intensely human chronicle of a few dozen venerable craftsmen – the last of their breed. It is also about the passing of an age, a time when men worked by the strength and skill of their hands, the sweat of their brow, had a passion for their beloved craft and possessed fierce pride in their heritage. Surely we must be enriched by sharing their life and work, just as we are impoverished by their passing.

Acknowledgements

This book is the product of three years' labour including several research trips to Ireland. The task of identifying, finding and documenting surviving craftsmen hidden throughout Dublin's maze-like cityscape was a challenging and difficult one. It could not have been accomplished without the assistance of generous individuals who provided me with direction and information. I wish to thank the following for their kind support: Anne O'Dowd, National Museum of Ireland; the staff of the Irish Folklore Department, University College, Dublin; Professor Mary E. Daly, Department of Modern Irish History, University College, Dublin; Peter Walsh, Curator of the Guinness Museum; the staff of the Pearse Street Library, Gilbert Collection; Professor Sean Rothery, Department of Architecture and Town Planning, College of Technology, Bolton Street; Mary Clark, Archivist, Dublin Corporation; Patrick Nagle, Irish Transport and General Workers' Union; and Laurence Looby, Bord na gCapall. Greatest graditude is due to the craftsmen themselves who put down their tools to share with me their innermost thoughts on life and work, struggle and survival. Their collective recollections, insights and personal sentiments constitute the heart of this book and imbue it with life and originality.

Special thanks are extended to Leslie Lauren Smith and Kathy Welch Bradley who worked faithfully beside me throughout the long process of search and interview. Their tireless assistance, unfailing support and devoted friendship contributed to the formation of this book in ways that only they will understand. To them I am deeply indebted. Finally, I should like to acknowledge the financial support of the University of Northern Colorado Research and Publications Committee. Their investment in this project made the extensive field work possible and served as an important source of encouragement.

Look! Look, what life is in these quaint old shops
Denis Florence MacCarthy, 1854

As he lives, he dies – unwept, unhonoured, and unsung
Joseph Reilly *The Journeyman Tailor* 1920

We will go on till we become just a memory for another generation, and perhaps they will think of us occasionally – maybe honour us with a little study
Seamus Murphy *Stone Mad* 1966

Introduction

If we are to discover what the craftsmen make and why they love their work, we must go into their workshops, watch them at their work and make notes of their conversations as we wish had been done with many of the famous artists and craftsmen of the past.[1]

We shall find them in the big main streets, up the little side alleys. . . we may happen upon them at any time, though we may experience rather more difficulty in finding them than in days gone by. But when we do find them we shall see them working with much the same devotion as that displayed by their forefathers; for they are their father's sons, and tradition dies hard with the craftsmen.[2]

Dublin is a city of exhilarating unpredictability and eccentricity, full of mysteries and improbable sights. A glistening skyscraper hovers intimidatingly over humble eighteenth-century Georgian houses. Tinkers in tattered garb meander among the fashionable crowds along Grafton Street. Moore Street traders hustle their handcarts between Mercedes and minibuses in the city centre. Scruffy youths are benignly juxtaposed with decorous dowagers on benches in St Stephen's Green. Incongruities abound, but no sight is more curious or anachronistic than that to be discovered in the dark enclaves of the cityscape, where one can peer through the clouded window of an antediluvian workshop and observe an old craftsman hunched over his bench working at a craft passed down from the days of the guilds. Having defied the Industrial Revolution, escaped the perils of Darwinian economics and been spared draconian urban redevelopment, the craftsmen have astonishingly survived into the last quarter of the twentieth century. Amidst the mechanisation and automation of a city with over a million people, they stand as cultural dinosaurs – living historical relics. Unbeknownst to government and citizenry, they constitute a rich repository of history, tradition and urban lore.

In *The Guilds of Dublin*, Webb tells us that during the seven and a half centuries which elapsed between the expulsion by the Normans of the last Scandanavian ruler of Dublin and the establishment of the native government there were 'few features in the history of Dublin of such intense human interest. . . as the daily round of work of the craftsmen.'[3] The city was the cynosure of Irish craftsmanship, teeming with weavers, cutlers, bookbinders, plasterers, gold gilders, silversmiths, farriers, coach builders, wheelwrights, tanners, bell-founders, coopers, tailors, blacksmiths, cabinet-makers, goldsmiths, tallow chandlers, woodcarvers, saddlers, stonecarvers, shoemakers and many more. They worked in a climate of mutual dependence. So firmly entrenched was the guild system that it 'lingered on in Dublin much later than in other countries.'[4]

Even when it finally collapsed in 1840, the city retained a large body of craftsmen. Since the Industrial Revolution largely bypassed Ireland, factories were less prevalent than in most European countries. This preserved the need for local craftsmen. Around the turn of the century craftsmen throughout much of Europe quickly began to fade away; but 'traditions died harder in Edwardian Dublin, with its sluggish economy, than in most other centres in the British Isles.'[5] Also, since Dublin was spared the ravages of two world wars, there was little architectural upheaval amd redevelopment in the capital. This meant that the old workshops were not obliterated.

In the post-war period the Irish Government embarked upon a scheme of massive modernisation and industrialisation. During the 1950s and 1960s the pace of urban redevelopment in Dublin was frenetic. Old neighbourhoods were divested of populations, their homes and shops eradicated to create space for new buildings. Concurrently, the growth of domestic factories combined with Ireland's entry into the European Economic Community (EEC) made manufactured items more accessible and cheaper than ever before. As a consequence, the demand for hand-crafted articles declined. Economic hardship forced many craftsmen to close their workshop doors. Those who survived saw their sons seek alternative occupations with a more secure future.

It should be regarded as providential that, owing to Ireland's economic backwardness and other factors, so many traditional craftsmen made it into this century, for by their very presence they bequeath us a living heritage. Yet they have received no serious attention or documentation. It is true that throughout history craftsmen have laboured in 'anonymity and without recognition'[6] but this seems particularly so in Ireland. In his study of artisan activity, D'Arcy found that historians tend to write in such a detached and dispassionate manner, relying on impersonalised records, that 'the world of the Irish working classes appears more like the product of determined evolution than the outcome of human activity.'[7] He rebuked another scholar for his 'failure to record the name of a single member' of a workers' movement about which he was writing. In short, social histories of the Irish working classes have not been very humanised; we know little of persons and personalities.

Some forty years ago, O'Sulleabhain, recognising the urgency of chronicling the last of the country's craftsmen, implored academics and students to 'write down traditional information of all kinds, describe a typical shoemaker's shop, give accounts of local tailors. . . was the craft hereditary? What types of men generally became tailors? Write down information about the smith, the forge. . .'.[8] Similarly, two decades later Seamus Murphy, fearing that the life of the 'stonies' would go undocumented, wrote that 'most of the men are old now, and the apprentices are few, so the chances of it being recorded grow less every day.'[9] The craftsmen in this book expressed similar sentiments. All felt that, as the last generation, they were fated to carry to their graves information which should be written down and read by generations yet unborn, but they had little faith that this would be accomplished. They cited fellow craftsmen about whom they said, 'Ah, now you should have talked with him. He would really have told you about the old times and characters. . .

but he's gone now.' It is now they who are the 'old characters' – the last source.

As we enter the last quarter of the century a few of the craftsmen are still with us. They go largely unnoticed. The little attention they do receive is often in the form of being viewed as curiosities or museum pieces. In the censorious words of one who feels they deserve better treatment, it is a shame when they are reduced to being merely 'a curio for idle-gazers.'[10] Nor should they be swathed in sentimentality and romanticism, for theirs has hardly been a romantic existence. More often it has been an enduring struggle against great obstacles. We should venerate them for the proper reasons:

> Such men make an interesting study in themselves as they typify a bygone age and the spirit of the craftsmen of the past. They belong to an age that knew what it was to have to work hard and well for their living, for they are the descendants of those who fought and survived the coming of industrialism. They have characteristics which many of the younger generation would do well to study.[11]

Search and Research

You must take things as you find them when you journey in search of craftsmen.[12]

It is with a sense of adventure that one sets about exploring for old craftsmen. The task is to identify, locate and contact them. There is no directory for such individuals because they normally exist outside the established business system. Initial inquiries made to government agencies reaped sparse results. I eventually learned that craftsmen often value their anonymity and obscurity, being wary of bureaucratic-governmental bodies (a topic to be subsequently discussed). Correspondence with the Irish Transport and General Workers' Union regarding the existence of any handcraft shoemakers and other craftsmen elicited the reply that they could be of 'very little help. . . such people are a fast dying breed and are not being replaced.' Even the director of Winstanley's, Ireland's largest shoe manufacturer, established in 1852, believed there to be but one shoemaker left in the city and could not recall his name or location. On the other hand, the Folklore Section of the National Museum and the Irish Folklore Commission did provide a few good 'leads'. Several coopers were also tracked down with the assistance of officials at Guinness' Brewery.

Most craftsmen were, however, found by methodically plotting out the city by map and exploring streets, lanes, mews and alleys. Because their workshops are usually small and visually undistinguishable, they easily go undetected. For this reason, local shopkeepers and residents were asked about their existence. Inevitably, there were some 'dead ends'. Tips were received that there was a tanner or blacksmith down a particular alley; upon investigation it turned out that he had died or departed five or ten years earlier. However, once a craftsman was found he invariably knew of peers, so few are they in number. As Gerald Devereux, one of the last handcraft 'bespoke' tailors, put it, 'the *real* old craftsmen know

of one another.' Whenever possible, cross-referencing was done to verify a craftsman's status. For example, to authenticate the remaining four master signwriters, I talked with the Director of Painting and Decorating at AnCO as well as with a manager at J. F. Keating's, one of Dublin's oldest painting firms. This type of investigation reinforced my confidence in the final selection process.

Initially I identified more than twenty crafts to study. However, as my research evolved I found that many were defunct or perverted from their original form. Many, such as weavers, cutlers and wheelwrights had simply disappeared. Others, like silversmiths, bookbinders and goldsmiths still exist but they are not traditional craftsmen with direct historical links to past masters; the heritage is just not there. I decided to concentrate only on those craftsmen who had served their apprenticeship under the old system, inherited the craft from fathers or other relatives or learned it from other bonafide masters, and were using authentic tools and techniques from the past. This limited my scope of inquiry to seven crafts: coopers, signwriters, shoemakers, farriers, saddle-harness makers, stonecarvers and tailors.

To place the craftsmen in their proper historical perspective, archival research was conducted. I collected valuable information on crafts, guilds and craftsmanship but there was scant data on personal lives and conditions. However, the main body of this book rests on the personal narratives and oral histories collected from the craftsmen themselves. This method of constructing Irish history and folklore has gained greater acceptance in recent years due, in part, to the expanded and more skilful use of the tape recorder. Three particularly fine works are Henry Glassie's *Irish Folk History* and *Passing the Time in Ballymenone* and Lawrence Millman's *Our Like Will Not Be There Again*. As Glassie vouches, eliciting personal history demands patience and persistence since the 'great and primary responsibility is recording exactly, completely, permanently' an individual's words, expressions and intonations.[13]

Taping sessions stretched over the summers of 1983 and 1984. Craftsmen were met on their own 'turf' (i.e. their workshops, forges and yards), the environment in which they were most comfortable. On a number of occasions they invited me into their homes, so afternoon sessions would spill over into the evening. Recording periods would normally extend from two to five hours. Most men were re-visited and taped again during the second summer. Having had a full year to dwell upon my original questions it was interesting, and rewarding, to find what new memories and insights came to mind. Not infrequently, the second tapings proved more fruitful than the first. A few individuals were visited three times and the Dunnes, keepers of the last cooperage, were the subject of five taping sessions. At the outset some craftsmen exhibited a healthy wariness and scepticism about my probings. However, their early misgivings dissipated once confidence and trust were established. For this reason, follow-up meetings were very valuable. It was heartening to find that eventually every man proved eager to 'go on the record'. Quite commonly an unexpected query would awaken images and ideas long dormant, delighting even the craftsman. Relating oral history seemed a therapeutic exercise for some, like the unburdening of a legacy long car-

ried within. Some sensed their place in history more keenly than others, but all felt it important that their information be chronicled. As one cooper so simply expressed it, 'Unless it's written down we'll all forget about it.'

Characteristics of Craftsmen as a Vanishing Breed

The craftsman is at once the counterpart and antithesis of the industrial worker.[14]

The craftsmen in this book share collective characteristics which set them apart dramatically from the typical modern worker in an office or factory. It is the totality of these distinctive traits which makes them a composite vanishing breed. They possess five salient characteristics:

1. Pride and satisfaction are more important than money
2. Work gratification is its own reward
3. Independence, isolation and obscurity
4. Strong attachment to workshop and tools
5. Aversion to retirement and consequent longevity

Pride Over Profit

My father always said that if you take off your coat and work at a bench you'll never have any money, you'll never be rich. . . but you're always happy.

Christy Glynn, woodcarver, 1983

Sociological studies show that man in contemporary society tends to take little pride and finds small satisfaction in his daily work. Studs Terkel in his highly acclaimed book *Working* interviewed individuals in more than a hundred different occupations. The vast majority felt bored, frustrated and empty going about their tasks. Most found little, if any, genuine satisfaction in their labour and even questioned the old work ethic. For many it was like a 'Monday through Friday sort of dying.'[15] He discovered that the typical worker had a 'hunger for meaning, a sense of pride' in his work. However, he did come across a 'happy few who find a savor in their daily job' (of these, two were craftsmen – a stone mason and a bookbinder). Their common attribute was a 'meaning to their work well over and beyond the reward of a paycheck.' Similarly, Gailbraith, in *The Affluent Society*, contends that for the masses whose jobs are dreary and monotonous the 'reward rests not in the task but in the pay.'[16] This is diametrically opposed to the motivation of craftsmen, for whom pride and satisfaction are far more important than financial profit. The issue of pride versus pay is hardly a recent one, as evidenced by the following passage from an 1888 article in *The Irish Builder:*

> The craftsman is bound to act upon some loftier prompting than that of making a profit. . . we are all too eager to make fortunes; no one is content to make a living. But the craftsman could take contentedly the modest pay that would supply his wants. His craft comes before his pay or he is no craftsman worth the name.'[17]

Dublin craftsmen today are no less noble in motive than their predecessors of a century ago. They normally require only enough money to provide life's necessities, not luxuries. All have experienced economic hardship over the years and for some it has been a constant struggle. They tend to reside in modest dwellings and do without nice cars, home appliances and holidays. Some have never been able to afford a car and have taken only a few holidays over the past fifty years. These deprivations do not seem to be resented but accepted as a natural part of the craftsman's life. Such sacrifices are more than compensated for by the immense pride and satisfaction they feel in their work. Every craftsman, without exception, cited this as significantly more important than monetary gain. There was no wish, even subtly conveyed, to exchange positions with those in more lucrative positions. Pride was paramount. 'If you don't have that pride in your work where's it going to get you?' says eighty-one-year-old Harry Barnwell, the doyen of Dublin shoemakers. 'There's more to a job than money, you know. . . you must have love.' Surely no sociologist could more lucidly or eloquently express the meaning of pride to craftsmen than the old cooper who once worked beside Robert Dunne. When finished fashioning a perfect wooden cask he stood back admiringly, extended his hands before his eyes and exclaimed unabashedly, 'Now who am I going to leave these to when I go?'

Part of the craftman's contentment also stems from the fact that he is born into the craft. He does not question his calling; it just seems preordained that he will take up the family craft. From early childhood most had no thought but to follow in their father's footsteps. Such was the case with Willie Robinson, now in his eighties and one of the city's four remaining master signwriters, who was doing second-coating on letters for his father at the age of seven. 'A young fella in my day always followed his father. . . so what he was doing, I copied.' Some individuals were assimilated into the craft during infancy. Since craftsmen are born into their occupation they are spared he deliberation over career choices and the multiple shifting of jobs that other workers endure. They possess a clear sense of identity and purpose in life. For them any other sort of work would be incomprehensible.

Work Gratification

The craftsman's work is the mainspring of the only life he knows.[18]

To the average worker, labour is little more than a business transaction. He sells his time and skill, seeking the job that will pay the most for the 'bits of his life that he surrenders'. He puts in his eight hours a day, anticipates five o'clock, and at the day's end work is put out of his mind. Work is sharply separated from home, social life and leisure time. In an office or factory population his contribution is only one minuscule fragment of the larger production process. He accepts the reality that he is dispensable and can be replaced without loss of over-all functioning of the company. Gratification normally comes through pay, power or position rather than any personal fulfilment gained from actually performing specific jobs. Very few people are able to 'lose themselves in their tasks' as does the craftsman. As Stowe explains, the modern worker does not

feel gratification because 'unlike the craftsman who makes something from the raw materials stage through the finished article, the worker of today is more often than not performing one process in a conveyor-belt system of manufacture. He is deprived of any sense of creation.'[19]

It is from this creativity that the craftsman derives his gratification. There is intrinsic pleasure in the work itself. He is not forced to relinquish fragments of his life to his work because the craft *is his life*. The entire process of craftsmanship, from inception to completion, imparts a feeling of achievement. The craftsman makes things individually by hand, designs his own creations, makes them one at a time, and produces a small quantity of high quality. No two are ever exactly alike. Every stage of the operation is under his control; he can modify at will. A sort of gratification is even derived from encountering resistance and challenges and emerging victorious over recalcitrant materials. Signwriters, tailors and stonecarvers are constantly confronted with new problems which they find highly stimulating. Every object that the craftsman produces carries his personal mark of identity, reflecting his ideas, skills and techniques. Uniqueness is gratifying.

In sharp contrast to other workers he does not mentally shift gear at the end of the day and flee the workplace in quest of relaxation and leisure. To him there is no natural division between work and play. Play is something you do to be happily occupied, 'but if work occupies you happily, it is also play.'[20] For craftsmen, their work is their greatest pleasure. They are most content and fulfilled when at their bench or in the yard. Says stonecarver Dermot Broe, 'The yard is the only place I'm happy in, never bored. . . if I had a bar here now I'd be in heaven.' Nor do they feel compelled to escape work through holidays. Even when they do go on holiday they are often unconsciously drawn back into their craft. When visiting a different part of the country the stonecarver instinctively wanders about a cemetery examining carvings and inscriptions, the signwriter ambles along streets, chin arched, assessing fascia lettering, and the farriers cannot resist asking locals if there is a remaining forge around. It is just their nature.

Dublin craftsmen exhibit an uncommon contentment and serenity. This is a characteristic of artists and other creative individuals who have a love and passion for their work. The concept of the craftsman as artist is a valid one. If an artist is 'one who is imbued with an acute sense of what constitutes beauty and can impart that beauty into the work,' Arnold asks, 'can a craftsman *not* be an artist?'[21] The perfectly handmade wooden barrel, pair of boots, saddle or sculpted statue is undeniably a work of art, a unique and beautiful creation. Craftsmanship as an artistic endeavour results from the 'whole man, heart, head and hand in proper balance.'[22] It is this holistic experience based on creative freedom, imagination and the purity and intensity of work which so conspicuously distinguishes craftsmen from ordinary workers.

Independence, Isolation and Obscurity

The craftsman is master of the activity and of himself in the process.[23]

The modern worker is part of a massive labour pool. He clocks in and

out, draws a computerised pay cheque and blends in with dozens or hundreds of others around him. There is little sense of independence or individuality. In contrast, the craftsman is not part of any crowd. He stands apart from the work force, the economic 'system', mass production and computerisation. He is the quintessential 'loner', a self-reliant figure at his work bench. Independence comes in part from self-employment, being one's own master. There is more to it than that, however. He sees himself as being a self-made man, beholden to no-one, fully responsible for his own work, shop and economic welfare. There is no-one to rescue him if he is in trouble or replace him if he becomes ill. Thorstein Veblen discusses this distinctive trait in *The Instinct of Workmanship:*

> He draws on the resources of his own person alone. . . he owes nothing to inherited wealth or prerogative. With his slight outfit of tools he is ready and competent of his own motion to do the work that lies before him. Even the training which has given him his finished skill has come through no special favour or advantage, having given an equivalent for it all in the work done during his apprenticeship and so having to all appearance acquired it by his own force and diligence.[24]

No-one determines the price he charges or the speed at which he works, and no-one is qualified to judge or criticise his products. He is serenely removed from the world of production schedules, time clocks, wage disputes and threats of redundancy; but with independence can come isolation, resulting from the decline of the craft and loss of friends. Until the 1950s most craftsmen had others in the shop with them. Today they are mostly alone.

It is a loneliness they have adapted to over the years, but they speak nostalgically about the old times when each day in the shop there was great chat and camaraderie. In the sixties, John Cruite, one of Dublin's last two saddlers and harness makers, lost his partner after twenty years: 'When he died off it was very sad. I'll never forget it. . . it was like a part of you gone.' Contact with customers is now the major source of socialising. A few have become especially reclusive, almost hermitical. Barnwell found that when the other shoemakers with whom he had worked for nearly half a century finally passed away he was all alone 'with this big clock, the only friend I had in my little world. . . it used to talk to me.'

Craftsmen often value their obscurity, preferring to maintain a low profile. This is because they typically feel intimidated by 'authorities'. Most have little formal education and limited exposure to officialdom and government bodies. Confrontation with government officials, union bosses, tax men or inspectors is a daunting prospect. Knowing that their *démodé* shops do not meet modern safety regulations and that their book-keeping might not conform to standard practice, they do not wish to draw any attention to themselves. They are seldom natural businessmen, and have a dislike for accounting and record-keeping. To clutter their minds with such mundane matters is a distraction from the purity of the creative process. Nonetheless, they customarily keep detailed hand-written notations of all transactions in musty, sometimes crumbling ledgers heaped on the back shelf. If an inspector arrives he is welcome to excavate

for information. A few craftsmen have been harrassed over the years for minor infractions by petty officials flaunting their authority; it is always an unsettling experience.

Attachment to Workshop and Tools

The craftsman's workshop is a complete picture of himself and his work.[25]

The office or factory worker hardly feels much affinity for his workplace. It is usually modern, efficiently compartmentalised, sterile and impersonal. By comparison, the craftsman's incommodious, dusky, often dilapidated workshop is a relic of a past age when Dublin streets were lined with modest family-owned establishments. Everything was on a personal scale. Merchants and craftsmen knew customers by name and were familiar with their families. Through the front window the craftsman worked before all the world; he might occupy a back room or have quarters above the shop. In any case, he was always ready to render immediate attention, make adjustments or answer questions. There was a mutual trust between customer and craftsman and if anything was wrong it was promptly righted.

The workshops of Dublin's surviving craftsmen are like fossilised chambers eons removed from the twentieth century which rages just beyond the door. Upon entering, everything immediately seems of another time. The sight of the solitary figure stooped contemplatively over his workbench is like a solemn benediction; there is a spirituality about the scene. A visual harmony exists between man, shop, tools and materials. It is impossible to imagine him in any other setting. The ambience is so authentic, so charmingly 'dated', that it appears to be a meticulously contrived stage set at the Abbey Theatre. Everything is cluttered and awry. Drawers, cupboards and shelves are jam-packed with scraps, tools and oddments. Countless jars, dented tins and crumpled boxes hold nails, screws and unidentifiable knicknacks. On walls dangle various curios and slanty calendars. Underfoot is the detritus of ages – snippets of metal, leather, wood, cardboard and cloth strewn higgledy-piggledy, heaped up in corners. To the uninitiated it is a grand gallimaufry of exotica. The entire face of the workbench is gouged and striated by contact with the human hand. Counter edges have been smoothly worn by palm and elbow in the course of good conversation. A path between door and counter is worn into the wooden floor. Shops and workyards tend to take on the hues and textures of the materials – the woody brown-beige tint of the cooperage, the dark leathery look of the shoemaker's or saddler's, the gritty chalkiness of the stonecarver's yard. The only splash of bright colour is usually the pictorial calendar, a reminder that there is another world beyond these walls.

This is the craftsman's private domain, his sanctuary. All around him might be gaudy stores and bustling commerical activity, but here he works like a cloistered monk in blissful solitude. The juxtaposition of some workshops and their surroundings is odd, even ludicrous; Greer's saddlery is in the shadow of the looming Metropole Cinema, Malone's shoemaking shop is hidden in a tiny courtyard beside the Olympia Theatre, and James Harding, a farrier, must shoe skittish horses in his

forge on Pleasants Lane only fifteen feet away from the flashing, pounding disco just across the way. On this spot two centuries collide. These old premises are increasingly endangered by urban redevelopment and demolition. Usually, when a shop falls victim to progress it spells the end for the craftsmen. Though the Dublin Corporation might compensate them financially for their lost property they seldom, owing to advanced age and conservative nature, have the heart to attempt relocating in new territory. Consequently, a good number of craftsmen have been eliminated during the past two decades due simply to the loss of their shop. Those shops which have been spared are beleaguered by theft and vandalism, a modern scourge which saddens and frightens their owners. Almost all have had tools and articles stolen. In the old days they routinely left doors open, even when away on errands. A note was left on the window or counter informing customers that they would shortly return. Today doors, windows and roof must be barricaded against a hostile world.

Craftsmen have great affection for their tools which, when in use, seem a natural extension of their hand. These usually have sentimental value, being inherited from father or grandfather. Over time, the handles can take on the very shape of the man's hand. Many are now museum pieces and cannot be replaced. The craftsman's covetous attachment to his tools is manifested in different ways. James Tyrell recalls that it was never customary for coopers to exchange or loan tools even to close friends. 'To equip yourself with tools was very expensive and so they were handed down. Men. . . left them to their sons. . . a man's tools were sacred.' Every evening before departing, Tommy Malone carefully hides his shoemaking implements beneath mounds of leather scraps and debris deliberately left on the floor for this purpose; it is a practice born of experience. The love of a craftsman for his tools is perhaps best exemplified by Paddy Licken, an eighty-two-year-old shoemaker who in 1984 was finally forced to give up working at the craft full-time due to disability. In just the last few months working in the shop beside his son, Sean, old age has begun to cause insecurity and disorientation. For comfort he has taken to bringing his little shoe hammer home with him every evening. As Sean explains, 'It was more personal to him than any other tool he had. It was something he understood. When he had the hammer he was alright.' When the time comes, Sean intends to place the hammer beside his father in his coffin – as a final tribute.

Retirement and Longevity

For many people retirement looms in the mind like a grand emancipation from toil and drudgery. It is the ultimate reward, offering life's pleasures denied in the working years. Not so the craftsman. To him it is anathema. The will to work, remain creative, keep his mind occupied and his hands entertained is a powerful force in his life. Since the age of fourteen or thereabouts he has found gratification and contentment in his daily tasks. The notion of retiring, just suddenly giving it all up, is unthinkable. Retirement would not be a reward but a punishment, an insufferable hell for some. Rather, his wish is to work until the end of his days. As Willie Robinson avows, 'I'll work until my hands become decrepit.'

The correlation between work fulfilment and longevity is unmistake-able. This is generally true of creative individuals who, through their passion for work, remain lively to advanced ages. Dublin craftsmen, who are mostly between sixty and eighty years old, are remarkably young in mind and spirit. As their eyes lose sharpness and their hands steadiness, they tend to slow down and produce fewer articles, but the quality remains constant. Only as a result of serious disability do they normally give up the craft. Experience has shown that when they are removed from their shop it is as if their very life-blood has been drained from them. Unaccustomed to taking standard holidays, and having missed few days through illness over the years, the sudden inactivity and loss of creativity and purpose is absolutely numbing. They become lost souls, depressed and dispirited. To be involuntarily deprived of craft, as happened to so many coopers, is especially debilitating. Tyrell tells of a fellow cooper who, when Guinness' closed the cooperage and transferred him to their plastics factory, literally lost his will to live. 'All he knew was making casks. . . he was used to creating. Now he was subject to this terrrible discipline. It was mentally disturbing to him. It killed his spirit. He didn't last any time. It killed him.'

To spare them mental and physical 'imprisonment' at home, craftsmen usually bring their fathers into the shop daily with them even after they are no longer capable of fully practising their craft. There is always some task that can still be performed. Being in the workshop with familiar tools and materials provides emotional and psychological security. Contact with customers contributes to alertness and retention of memory. When in the shop their minds are most lucid and their spirits highest. The little workshop remains the core of their daily life until the very end. Sean Licken says of his father, 'If I was to insist that he doesn't come down to the shop anymore he'd probably die within six weeks.'

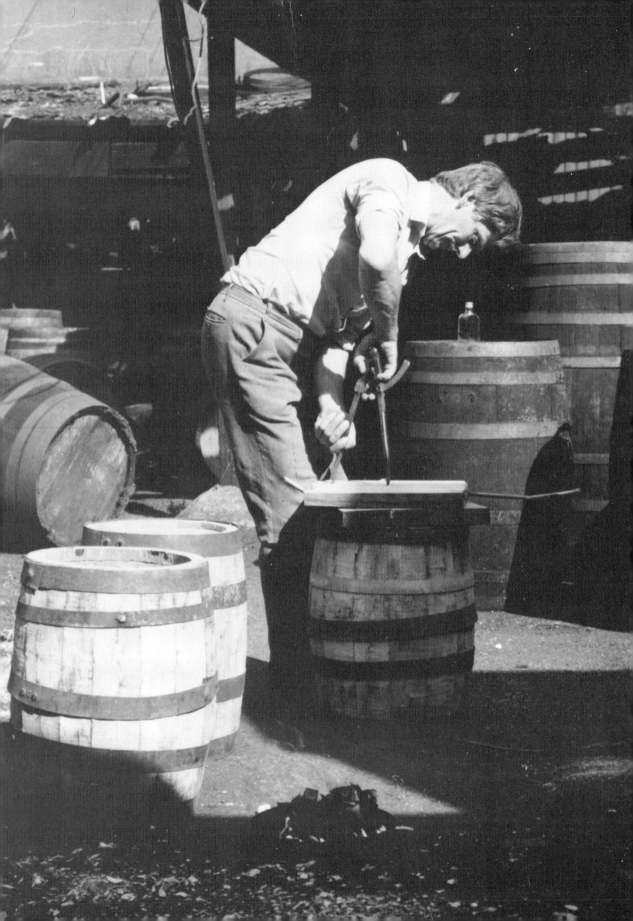

1
Coopers

I'm the last of the tribe.

<div align="right">Robert Dunne, 1983</div>

It was really sad in that it was a way of life just gone, pulled out from under their feet, never to be resurrected again. From 1501 to 1983, a great span of years and a lot of history. So it was sad to see it go. . . and the way it went.

<div align="right">Augustine Gibney, 1984</div>

An intoxicating scent of burning oak chips wafts across the rippled cobblestones of the old Smithfield Market. The distinctive aroma, so evocative of bygone days, seems to jolt the human senses. Smoke rises indolently from behind large red-painted wooden gates with 'Dunne's Cask Merchants' proudly, if forlornly, emblazoned on the front. Warped slats allow for a glimpse within. A cooperage! The last in all Ireland – an archaeological site of sorts. Here time has been intriguingly petrified. Wood, sawdust and earth blend to shroud the scene in a musty beige hue, like an old photograph faded with age. Casks have stood so long on the same spot that they appear to have taken root in the ground. Wooden staves are stacked in orderly fashion as if they still have a mission. Voices and hammering of days past are muted and forgotten. Weeds have brazenly assaulted the yard and a morgue-like hush has long settled over the cooperage. The only movement is that of cats frolicking about the barrels and the wind gently nudging the foliage sprouting from the old stone walls.

Robert Dunne, cooper

Just beyond the main yard a half-open door leads to a tiny, dusky office. The clutter allows for circuitous entry. Behind rickety crates and cardboard boxes is a smallish fireplace long dormant and crammed with crumpled papers. In the corner rests a 4 ft-long tool box half filled with implements over a century old. The dated calendar just above is a reminder of a time when days and weeks were counted and there were schedules to be met. At the desk sits Eddie Dunne, aged seventy, a master cooper and owner of the cooperage. A large, stocky, grey-haired man, dressed in a brown pin-striped suit, he looks every bit the working businessman awaiting clients with new orders. But such days are no more. Yet, like a religious ritual, he is compelled to return daily to the old workplace, sit at the desk, have a cup of tea, read the newspaper, then peer out the window into the deserted yard and reflect in repose. His attachment to the setting is palpable. 'I've been coming in here so long that I couldn't sell it. It occupies my mind. . . I love the place. In another ten years Smithfield will be gone, this place'll be gone. This is the last cooperage in Ireland.'

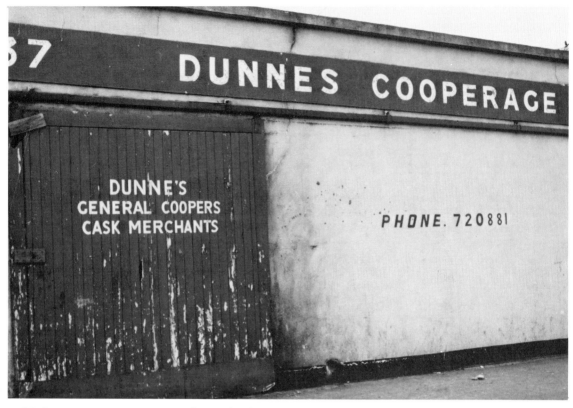

He has a rare perspective on the craft of coopering in Dublin and deep pride in his heritage. 'I've heard it said that we Dunnes are the second oldest name in the Coopers' Society. I'm sure that it goes back to the 1500s.' His father, grandfather and great grandfather were well-known coopers in the city. Of the eleven children in his family, seven were sons, six of whom went to the craft. For over fifty years he worked at all facets of coopering, from the old Mountjoy Brewery, to Guinness', to Power's Distillery. He served as apprentice, journeyman, foreman and finally master to his own yard. When he started his own general cooperage a quarter of a century ago in Smithfield the craft was still healthy. The place was a frenzy of activity alive with thirty coopers, the musical clanging of hammers on hoops, timber arriving and casks being loaded for delivery. Never did he imagine that the craft would die in his time. 'No, I never saw such a day, but that's how life is. It'll soon be gone for all time. It'll just survive in history books. . . I'm the very end of the line.'

The quiet is broken by the thudding sound of mallet striking wood in the rear yard. Bent over a cask, beside the modest oak chip fire which is charring the bottom, is the lone figure of Robert Dunne, Eddie's younger brother by fourteen years. Bulging forearms belie a slight frame. His ruddy, weathered visage matches the texture of the wood he shapes. Here is the last real working cooper in Dublin. For several hours each day he ekes out a living making a few casks and barrel tubs for decorative purposes. His stock of staves dwindles away. 'I'm not making any money at it. . . but I want to hold on.'

Front yard of Dunne's cooperage in Smithfield

Irish Coopering in Historical Perspective

The Dunnes are part of a long tradition, for theirs is a craft of great antiquity. Coopering was mentioned in the Bible, known in ancient Egypt, and brought to the British Isles by Roman invaders.[1] By the eleventh century the wooden barrel, or cask, was the standard container in all European countries. In the fourteenth century coopers' guilds were formed. The Regular Dublin Operative Coopers' Society was created in 1501. Of all Ireland's revered crafts it was always one of the most honourable, producing many notable members. One was a Wexford man by the name of Kennedy whose grandson became President of the United States. And the family of former Taoiseach, Sean Lemass, owned a cooperage in Dublin.

Irish coopering was in its heyday during the latter part of the eighteenth and most of the nineteenth century when coopers were kept busy turning out a wide assortment of wooden vessels. Those craftsmen known as 'white coopers' produced pails, butter churns, washtubs, noggins, piggins, cream butts, turf and coal buckets and sundry other items for farm and household. 'Dry coopers' made casks for non-liquid products such as cheese, butter, grains, flour, fruit, cereals, meat, tobacco, fish, fats and pottery. 'Wet coopers', the most skilled, created liquid-tight casks to hold wine, beer and whiskey. Coopering was such an indispensable feature of both countryside and city that its future seemed forever secure. It was particularly conspicuous in seaport towns, where most goods travelling by sea were packed in casks. An idea of the volume of casks in Dublin in the early 1800s may be gained from McGregor's *New Picture of Dublin* (1821) in which he accounts for the number of barrels used in the annual sale of various commodities: 'wheat, above 50,000 barrels, barley near 30,000 barrels, oats above 150,000 barrels'.[2] About whiskey and brewing he wrote: 'There are nine distilleries in Dublin producing annually about two million gallons of spirits. . . the malt used in the spring and winter months, when alone the distilleries are at work, averages 18,000 barrels a month. The number of breweries amounts to thirty-five, the quantity of corn malted for brewing is estimated at 10,000 barrels monthly and the annual produce at 300,000 barrels.'

It has been estimated that around 1840 there were as many as 10,000 coopers in Ireland, though this figure may be somewhat inflated.[3] However, coopering began its decline shortly thereafter and this accelerated during the latter half of the century, following the natural fluctuations in Ireland's provision exports. The export of live cattle brought about a serious decline in packing, and around the 1870s the introduction of refrigeration aboard ships, whereby meat no longer needed to be salted in casks, took a further toll. White coopers and dry coopers were the first to be affected by the Industrial Revolution and the invention of alternative containers. Gradually, more fish, butter, cheese, oils, fruits and fats were being packed in steel drums. Wooden buckets and barrels became increasingly 'old-fashioned' as coopers began to fade from sight. By 1901 the number of coopers had fallen to about 3,000, and in 1911 to 2,200. In 1936 only 993 remained.

Around this time alarm was expressed over the craft's capacity for survival. In 1944 Coleman noted with concern that 'cooperage shops

owned by master coopers are practically non-existent'.[4] Another warned that the entire craft was 'fast vanishing' and would constitute a significant cultural loss.[5] However, while their brethren fell victim to the modern age, Dublin's wet coopers continued to prosper. Indeed, 'while many old tradesmen were laying down their tools, and quietly submitting to the superiority of twentieth-century technology, the wet cooper, in all his antiquity, was still there at the block practising an art and craft that was defying this industrial revolution'.[6] The Dublin Coopers' Society actually reached its peak of membership in the 1920s, when there were over 800 members on its books. Coopers at the city's flourishing breweries and distilleries were confident that no machine could ever manufacture, repair or maintain casks as efficiently as man.

The wooden cask remained a ubiquitous feature of the Dublin cityscape well into the first half of the twentieth century. Since motorisation came late to Ireland, the cask continued to be used as the ideal means of packaging when almost everything was still manhandled between horse and cart and boat. It could be easily manoeuvered and rolled about. The old familiar thunderous sound of barrels being tumbled across cobblestones is a nostalgic memory to many Dubliners. Casks were transported daily along the River Liffey on Guinness' barges and every pub had its stack. The docks were honeycombed with thousands of every variety. Even in shops, barrels long continued to be used to hold and display all sorts of items such as soap, grain, apples, biscuits, paraffin, pickles, fish and even pigs' heads. It provided an exotic visual cornucopia. Children always seemed especially entranced as they tried to peer over the tops to satisfy their curiosity. Eddie Dunne recalls that 'in shops you might see crockery and other items on display in large barrels and in most of the old bars you'd find at the back of the counter there might be about six or seven large barrels, all varnished, with the names of John Jameson or John Powers and they all had a tap on them and the price would be on the barrel. There were some at the Gaiety Theatre. They were dressed up for display purposes and a real whiskey drinker would like to go and get his drink right from the barrel. . . but that's all finished now.'

The containerisation revolution really invaded Ireland in the post-World War II period as metal, plastic and paper packages swiftly replaced the old types. Folklorist Kevin Danaher witnessed with disappointment and some disdain this new 'age of the individual wrapper' and the 'notion of having everything neatly made up in a tin or packet or bottle'.[7] Compared with the simple charm of a wooden barrel, the newfangled containers had an antiseptic sterility about them that left little to aesthetics or imagination. By the 1950s it was evident that even the last strongholds of coopering, the breweries and distilleries, might be imperilled by modern technology but no-one could have prophesied the complete collapse of the craft over such a short span of time – or the bewilderment and anguish which it would bring to the coopers themselves.

The coopers who lived through the final decades of the craft are lively repositories of information about social and economic change. Their vivid recollections of the last half century of coopering in Dublin provide a revealing and fervent historical documentation. In their minds are etched every detail of circumstance and event which conspired to bring

their craft to its deathbed after nearly five hundred years. Augustine ('Gus') Gibney can trace coopering in his family back nearly three hundred years. He plied his trade at old general cooperages, at Guinness', and at Irish Distillers, where he was on duty the day the Dublin coopers put their tools down for the last time. As the last President of the Dublin Coopers' Society he had not only to witness but record formally the end of the ancient fraternity dating back to the Guild period. It was he who had the solemn task of officially signing the Minutes of the Dissolution Meeting of the Coopers' Society in March 1983. Similarly, Vincent and James Tyrell (cousins ten years apart) can claim a long lineage at coopering. Vincent, born in 1910, worked locally at Guinness' for thirty-seven years until forced retirement in the sixties. Both Tyrells, from boyhood through manhood, devoted their lives to the craft only to be made obsolete in their prime. They might well identify with the song 'Dublin in the Rare Old Times' which tells of the craftsman's plight in a changing world:

> My name it is Sean Dempsey as Dublin as can be,
> Born hard and late in Pimlico in a house that ceased to be,
> My trade I was a cooper, lost out to redundancy
> Like my house that fell to progress, my trade to memory.

The Dunnes, the Tyrells and Gibney retain wonderfully lucid memories of their life at coopering. They are saddened by the passing of their craft and vexed that it went unheralded by the public, media and scholars. James expressed their common concern that 'unless it's written down we'll all forget about it.'

A Cooper's Apprenticeship

One of the most intricate of all woodcrafts, coopering demands great skill and precision. It is only learned through years of rigorous apprenticeship. The cooper does not rely on written measurements or patterns to make a cask of specified girth and capacity; everything is gauged by the eye and perfection is required since each cask must be airtight, strong enough to withold the force of fermenting liquids, and sufficiently durable to withstand years of rough handling. Because of the precision and perfection demanded, it may be said that coopering is more 'wrapt in mysteries' than most other crafts. Indeed, as Kilby affirms, 'Robinson Crusoe was able to make practically anything, but he never made a barrel.'[8] To learn to do so originally took seven years of apprenticeship. In more recent times this was reduced to five. It has always been a closed craft; if your father or grandfather was a cooper then you were eligible.

Undertaking apprenticeship in such a hardy craft was a daunting prospect for a youth fourteen or fifteen years of age. The process normally began with rudimentary tasks such as sweeping up wood shavings, keeping the fires burning and sharpening tools while learning their names and uses. An apprentice was responsible for doing practically anything his master required, including going out for tobacco, carrying messages and running other errands but he would only have to serve his own master unless another cooper got permission to use his services. The attitude of the master was 'that's my boy', and he valued his apprentice as a personal

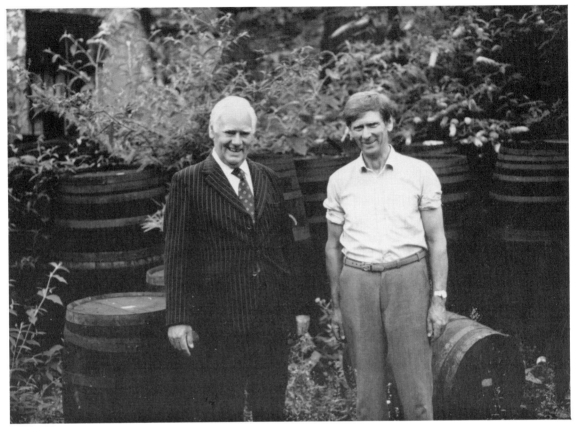

Eddie (left) and Robert (right) Dunne at their Cooperage in Smithfield Market. Theirs is the last family cooperage in all Ireland

asset. Hence, it was prudent to break him in gently, as Gibney experienced. 'I served my apprenticeship at Lemass' cooperage in Benburg Street at fourteen years of age. The first weeks you were more or less learning to use your hammer and driver. The hammers we used were all around four and a half pounds in weight. Now the driver is the tool that you use in your left hand that you're driving the hoops with. It was really a tool that you had to get used to, otherwise you could very easily lose the top of your fingers. There was a kind of "breaking in" period for the use of tools. My master would repair a cask and hand it over to me to tighten up. It was done on a gradual basis and maybe by the second year I was able to repair a cask myself. I was more or less a peasant to him. He would tell me to do something and I just had to do it, I would never question him. As a matter of fact, if you did question him you'd probably end up with a thick ear. That was the tradition throughout the years, that you didn't question your master. As a matter of fact, if for some reason the foreman cooper came along and he was speaking to your master, you didn't just stay there and listen, you went off and out of ear's reach to give him privacy. You didn't really get into his confidence until maybe the second or third year and then he'd see the progress you were making and begin to treat you as an apprentice rather than as a peasant.'

Over time a mutual respect normally developed, but the apprentice's role was always subservient. The master had the power and was not to

be challenged. For an apprentice to violate any codes of conduct would be to jeopardise his job. He worked directly for and was paid by his master, not the cooperage at which they were employed. There was a minimum wage scale but masters could give apprentices something extra as an incentive or reward. This was a pragmatic arrangement, since most coopers were on the piecework system and the more the apprentice contributed, the more the cooper earned. Robert Dunne served his time in the early 1940s. 'My first year I got eighteen shillings which is the equivalent of ninety pence a week. I got only a proportion of what a fully qualified cooper got, which was about five pounds. So, your first year you got less than a fifth of the actual wage, then the second year you got two-fifths, and the last year you got four-fifths. We started at eight in the morning and worked until six and sometimes you had to work maybe three hours overtime and half days on Saturday.'

Since the apprenticeship system was a personal relationship between man and boy it was subject to human failings. Physical maltreatment, such as a master taking his hand to a youth, was a rarity and never condoned by others. More common was a subtle form of economic exploitation in which the apprentice might be used as slave labour. Gibney saw such exploitation. 'Now the effort of dressing and hollowing out staves, you really sweat doing that, and this apprentice that I saw was at that for about two and a half years which was really wrong because he was only there to do the "muling" end of it and he wasn't actually being taught the finer art of coopering, because he turned out at the end of his apprenticeship knowing very little about coopering so, to me, he was only being used as a mule.' There was nothing really to prevent a master from compelling his ward to do the heavy work while he assumed the lighter load other than loss of peer respect and perhaps reputation.

Injustices sometimes stemmed from the reluctance, or outright refusal, of a master to pay the apprentice his wage. As Eddie puts it, 'Some masters were very tight and the apprentice more or less had to keep his mouth shut.' Those coopers given to drink and gambling might make it a practice to put the lad off, claiming that they were short of money at the time. It was not an uncommon sight at the week's end to see a young apprentice waiting for hours outside a pub for his master to come out so that he could ask for his pay, only to be handed a token sum and lame excuse. This very thing happened to Eddie when he was working at the Mountjoy Brewery for a master who regularly short-changed him. They were on the piecework system with Eddie continually being given the heaviest tasks while receiving only a fraction of the earnings. His master, fond of the local pub, made it a habit of not even returning to work many afternoons, leaving full responsibility to his apprentice. One such week it ended up that Eddie did all of the work and was offered a paltry 'four shillings. . . I told him to keep it, that I'd look for a new master. Well, it wasn't done (going to the foreman with a request to change masters) but I was going to try it. If I *had* done it he (the foreman) probably would have told me to go and grow up, but I threatened and it worked. He (the master) pleaded with me not to do that and handed me a pound note. . . I nearly went through the floor.' Most masters, however, treated their wards with firmness but dignity and the abuses were few.

Until a few decades ago, when an apprentice finished his time he needed only to have his master and one other cooper attest to his competence and he advanced to journeyman. Eddie divulges, 'In the past it was sufficient for the master of the apprentice to say that he could work and, of course, they (representatives of the Coopers' Society) knew that the master was a good worker (and would take his word for it), and then they would get somebody else out of that particular cooperage to vouch that this information was correct. But if they found that they had vouched improperly, that they had been insincere and the boy's work might be rejected somewhere else, the voucher and the master would be fined.' In this century the 'honour system' was apparently abused, because there were so many complaints that the Coopers' Society had to begin requiring that all apprentices pass a test before they could be certified to practise the craft. This meant going before members of the Society and making or repairing a cask. If not to their satisfaction, the apprentice failed and was required to do an extra year's time. Eddie attributes this problem of 'apprentices turned out who should never have been turned out' largely to a general deterioration of pride, quality control and the traditional foreman-worker relationship over the past three or four decades (a topic subsequently discussed). Also, there was the human element that some fathers, as masters, might be inclined to pass their sons, despite knowing that they lacked the basic skills or were not fully qualified. For this reason, some conscientious fathers would place their sons with fellow coopers to avoid the predicament.

Successful apprenticeship ended with a traditional initiation ceremony known as a 'comber'. As Gibney describes it, the apprentice was 'put into a big barrel and they pounded the barrel and when he was practically deaf they turned the barrel down on its side and rolled him around the shop and then he was taken out and hosed down. It could last for an hour and a half.' Vincent embellishes, 'Then maybe we'd have a sing-song and, of course, all get jarred.' The merriment, relished by all in the cooperage, was always at the apprentice's expense. It was his responsibility to provide bottles of whiskey or pay for beer at the local pub. This tradition was carried out at Irish Distillers all the way into the 1970s.

Upon graduation to journeyman, the fresh cooper might be hired by his parent cooperage or have to go out into the world and find a job on his own. In such cases, the reputation of his master might serve him well as a reference. Eddie's experience during the Depression years illustrates what a momentous event this was for an aspiring young journeyman. 'My first job was in Power's Distillery and, looking back on it, it must have been a tradition. . . I must have been the last because I haven't seen it since. . . but going to my first job my grandfather gave me certain tools, my father gave me certain tools and they gave me a box for to put my tools in and on the instructions of my father I was told to go out and engage a cabby. The cab arrived at the house and it was, of course, a horse-drawn cab at that time, and my box was put up on top of it and I was put sitting in it and I "drove off in State". It seems that it might have been a sort of tradition for coopers to start off with such style. You know, coopers were sort of a class above other workers and they probably had this pride in themselves. I haven't seen that happen now since, so I

must have been the last that arrived "in State" to a job. . . often I think what they must have thought, seeing this young whippersnapper arriving in a cab.'

From Splank Yards to Distilleries

A journeyman cooper could be employed at a brewery, distillery, general cooperage (commonly known as a 'splank yard') or a jam factory. Each type of cooperage had its advantages and disadvantages. In terms of prestige there was a status hierarchy, with distillery coopers at the top, brewery coopers next, and then jam factory workers. However, coopers who worked at a good splank yard often acquired the skills to perform all these tasks and were regarded as the most versatile. Eddie worked at every type of cooperage in his day and had the opportunity to assess the differences. 'The coopers in the distilleries were looked upon as being the top class coopers, a cut above the others because with a cask of stout if it leaked you lost a couple of pints and it didn't make so much difference, it wasn't very valuable and you could sort of beat over the staves where it was leaking. But you couldn't do that with a distiller's cask, you couldn't lose that much because whiskey was so expensive. So you had to do a finer job and you got more money for repairing a cask in a distillery because it took that little more time and you had to be that much more careful. Now the jam factory cooper, I wouldn't want to cast any aspersions on them but a lot of them wouldn't be able to do distiller's or brewer's work.'

Guinness' Brewery was the dominant employer in Dublin. In the 1920s about 400 coopers (half the city's total) worked there and in the 1940s there were still around 300. A job at Guinness' carried status and security and was the ambition of most coopers. 'Now the brewery cooper at Guinness',' affirms Eddie, 'he had the name for getting the big money because Guinness' was going "hell for leather" all the time and if you were on piecework you could earn big money. So if you worked at Guinness' you were financially very well looked after and you had a pension and medical facilities, a lot of security in those days which you wouldn't get in other cooperages.' No such system of pensions or medical benefits existed at small breweries or splank yards. Gibney concurs that it was the dream of most coopers to get into Guinness' but points out that 'in Guinness' there wasn't as fine a work being done as outside. To me, it was a bit cruder. You hadn't to be that particular about it as you would with the barrel of spirits. Guinness coopers may have considered themselves the elite but there was a greater knowledge of coopering outside of Guinness'. . . in Jameson's and Power's and in splank yards in particular where you had every form of cooperage.'

Splank yards were really the heart of the craft, with all sort of characters making every imaginable type of cask, bucket and wooden container. Many of the innovations within the craft sprang from the freedom found in splank yards. Dunne's and Lemass' general cooperages were the best known but other smaller ones existed around the city. They might employ four or five men or, as at Dunne's in its prime, as many as thirty. Splank yards had a special, exotic ambience. The pace of activity and variety of

work made them places of great interest. They were similar to the old smith's forge in that passers-by often couldn't resist coming in for the sake of curiosity or a chat. With their open gates they were more visible and accessible to the public than were cooperages at breweries or distilleries; they were part of the neighbourhood. Fires were always lit, hammers pounding away, cats roaming about the yard and perhaps a side of ham or other meat hanging above the flames to absorb the oak flavour. People just seemed to be naturally drawn to the scene and 'liked to be around the barrels'.

Though splank yards could not match the pay or benefits of breweries or distilleries, many coopers preferred them for several reasons. They offered experience in every facet of the craft which, in the long term, provided men with a wider range of skills and more mobility than coopers specialising in just one job. Also, many coopers disliked the regimentation and boredom of doing the same thing every day in a brewery or distillery and welcomed the diversity at general cooperages. There was also a sense of independence and individualism working in a small yard amid a more personal 'family-type' atmosphere. Gibney savoured the assorted jobs assigned him during his early years in the splank yard. 'Lemass' was a general cooperage. Today you could be in repairing casks, tomorrow you could be in a warehouse examining casks, the next day you could be down at the docks at the Dublin port where a consignment of barrels would be coming in with sherry or port and the cooper would have to be there in case there was a casualty, and you could be making a churn the next day, and a barrel for a brewery the next. It was a wide variety of work and anybody who served their time in Lemass' was considered a good cooper.' Thus, splank yards produced all-round coopers who were always on call for any type of work. They could be dispatched on short-term loan to breweries, distilleries, jam factories, warehouses, shipping companies or wine merchants. Only splank yards provided such wide exposure to the craft.

The larger jam manufacturers such as William & Woods and Scott's might employ three or four coopers on the premises while smaller firms normally borrowed them from splank yards on a sporadic basis as they were needed during the season. Over the years jam factories provided a modest but reliable source of work for coopers. It was a nice departure from other types of coopering. Eddie would annually send men from his yard on special assignment to jam factories, sometimes joining them himself. 'The jam factories would usually use 40-gallon barrels mostly for the storing of jam; a few would be used for shipping. They'd purchase oranges, apples, strawberries, raspberries and put them in barrels and add one of those additives, SO_2 or something, and leave the barrel there with the fruit in it. The cooper would seal the end tightly and it would be left out there in the field or shed until such time as they wanted to make jam. It would more or less rot the fruit, it would become mushy and they would then want the cooper to take the end out of the barrel when they wanted to make the jam. At that time they would take in maybe 300 or 400 of these barrels and empty them. When you opened up one of the fruit barrels it was a lovely smell but I didn't like it myself because I dreaded, hated, my hands being sticky and the handle of the

Rear yard at Dunne's cooperage

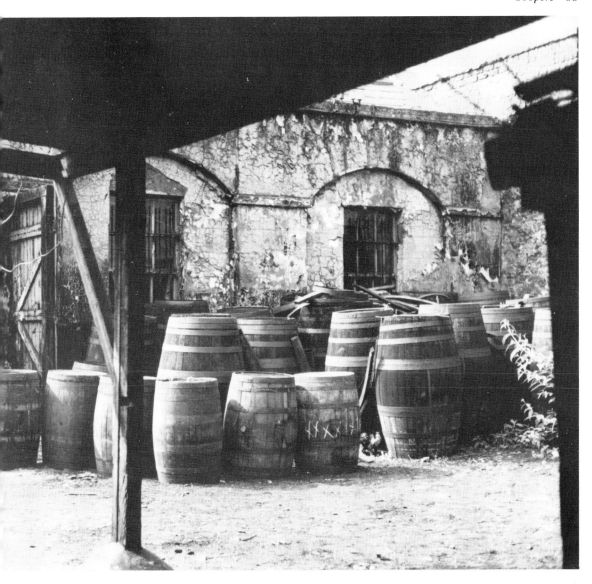

hammer would become sticky and you couldn't keep your hands and tools clean. And another thing I didn't like about it was there would always be swarms of wasps around you for the juice of the fruit.'

Guinness', because of volume and scope of market, had a division of labour that did not exist in other cooperages. The majority of coopers were engaged in making or repairing barrels; most men could do both but some specialised. Unlike the distilleries and jam factories which relied on 40-gallon casks, Guinness' produced different sizes. There was the *firkin* (8 gallons), the *kilderkin* (16 gallons), the *barrell* (32 gallons), the *hogshead* (52 gallons) and the *butt* (104 gallons), a monster container unmanageable for most publicans. Some men preferred working on a particular size of cask at which they were most efficient. Then there were speciality craftsmen such as the 'town coopers'. Guinness' had only a

few such men (one of whom was Gibney's father) whose duty it was to spend about four days out of each week visiting the various public houses around the town (hence their title), going down into the cellars to check barrels for leaks and doing on-the-spot repairs. They were general coopers but had a knack for detecting and quickly repairing leaky casks. Another specialist was the 'pick man', the first cooper to meet the casks when they were taken off the lorries for refilling. He was expert at knowing exactly how to strike the cask with a pick to knock out the wooden plug, known as a 'bung', so that it could be inspected and cleaned. Then there was the 'smeller', of whom Vincent remembers about thirty at Guinness'. 'They were the people who smelled the casks to see that they were fit to put beer in for human consumption. That was their only job. They would get an hour on and a half hour off. You see, a cask would come in and it would have been left maybe in some publican's yard for a long time and you'd go through the process of cleaning it and then after that you'd smell it again to see that it was fit. The smeller was the expert who would pick out the sweet one, the "dodgy" one.'

Regardless of the type of cooperage in which a man worked there could be opportunities for diversion. There was a reciprocal arrangement among many cooperages in which they would shift some of their men around to cope with fluctuating production schedules and seasonal demands. For example, distillery work was heaviest from about November to March, whereas the busy time for Guinness' and the jam factories was during the summer months. Therefore, Power's and Jameson's would send coopers to Guinness' during the summer and Guinness would reciprocate in the autumn and winter. These, of course, were coopers possessing the skill to do both types of job. From May to September the splank yards would supply coopers to the jam factories for peak production.

Working Conditions

Working conditions at cooperages around the city varied widely. They were best in Guinness' and generally worst in the splank yards. Weather was the major enemy – heat, cold and rain. Often there was scant protection from the elements. At 'cushy' Guinness', coopers mostly worked in a covered environment but in the splank yards and some small breweries and distilleries men worked in open or semi-open conditions which could only be described as primitive or, as Gibney more bluntly opines, 'atrocious, desperate'. Eddie survived the old Mountjoy Brewery where 'conditions were bad. . . we worked in individual berths inside a shed and they were open, no partitions separating men, men spaced out about ten feet apart, no stool or anything like that. You only had a block, a portion of a tree, and each man had his own tool box. Lighting was the ordinary old bulb. In the warm summer months the cooper's shed became hot, perspiration would flow but the men did not remove their shirts. . . the men wouldn't think to take their shirts off.' This was a matter of decorum and dignity associated at that time with the gentlemanly craft and if a man at some cooperage did take the liberty of removing his shirt the

foreman was likely to ask him to put it back on lest he blemish the image of the trade.

Eddie found conditions at Power's Distillery equally harsh, especially the cold and dampness. 'There was no such thing as heating. We maybe just had a fire lit with oak shavings. Now the scald bank, where we tested the casks for leakage – it was the last word altogether. Hot water was put into the casks and there was a man there and he gave them a roll around and shoved them up a bit and if they leaked the cooper was there to stop it. It was called the scalding bank because of the scalding hot water. This was done outside where the casks were elevated for leakage detection and the wind would come up beneath them. Now there was a sort of roof over it but it was open on the sides and it was on a level with the dome of the Four Courts and when there would be a north-easterly wind it was the worst I have ever experienced. The driver we'd hold for driving the hoops, we'd have to go down every so often and stick it in the fire. We couldn't hold it because our fingers would stick to it, it was so cold. . . because of the frost we'd stick it in the fire so it would get a certain heat into it and then go back to driving the hoops until it got so cold again. That was the coldest spot I can ever recall. And when casks would be brought into the shop for repair on wet days after being out in the weather they were absolutely wringing. You couldn't work them because the hoops wouldn't stick back on them once they were wet and you would have this big fire going round the shavings and you would bring in your casks and put them all around it for to dry them out and occasionally give them a turn to dry on all sides. It was frustrating because you'd be anxious to earn money but they'd be half wet and half dry. You'd be impatient to get working on it and frustrated because it meant time lost.'

Cooperages were essentially devoid of safety devices, and each man was responsible for his own health and well-being. 'Safety standards were non-existent,' relates Gibney, 'coopers in those days were all working on the piecework system and they cut their own corners, kind of. Safety was the last thing they would consider. All they were interested in was getting a barrel finished as quickly as possible and in those days if you cut your finger with a knife or anything what we used was a rush. The rush would act as a sealer around the head of the cask. They were reeds that grew in canals and were harvested and cut and bought up by cooperages and used as sealers in between the staves. We would split these sealers and a cooper always had to keep his nails long because he used to have to split this rush with his nails. So we used to split the rush, wrap it around our finger and that would stop the blood. It was very unhygienic but serious accidents were uncommon and that's difficult to explain because of the nature of the work. It was so heavy, so demanding, the pace of work so fast that there should have been a lot more accidents.' Doubtless the scarcity of serious accidents was due to the coopers' great skill, respect for the tools and recognition that, if injured, income would cease. Actually, the most common ailment stemming from the craft was impaired hearing resulting from the often-deafening noise in some cooperages. Many coopers ended up with hearing disabilities in their later years.

Drinking Habits of Coopers

Coopers the world around have always had the reputation of being heavy drinkers but the stereotype may be especially pronounced in Dublin, where the 'jolly coopers' were as much fact as fiction. Indeed, stories within the craft about the fondness for, and capacity to consume, copious quantities of beer and whiskey are legendary. The principal explanation for, and justification of, liberal imbibing is that their craft is so physically strenuous that it saps a man of both energy and bodily liquids. Vincent rationalises, 'Coopers were very hard drinkers, they had a capacity for it. You must remember that the work was difficult and it demanded a tremendous amount of physical strength and as a result they had to resort to something. We had to drink to keep going. Physically we were perspiring all the time and you had to put it back in with liquid. . . ah, those fellas could put away gallons in a day.' Water, it seems, was an unknown elixir.

A fringe benefit of working in a brewery or distillery was the allocation of free drinks during the working day. If you worked in Guinness' you got two pints a day, one in the morning and the other in the afternoon. It was known as the 'script' because your name was put on a small piece of paper like a tram ticket and you would tender this for your pint. Similarly, at distilleries the coopers were allowed two glasses of whiskey per day, termed the 'grog' (like seamen receiving their rum), one around lunch time and the other toward 'knocking off' time. However, there were opportunities for augmenting one's daily intake. If an apprentice, who was entitled to the same privileges as the others, did not drink, his master had the right to consume his portion. Other teetotalers could assign their share to friends. This raised marvellous possibilities. As Robert testifies, 'Someone might be getting three or four pints in the morning and three or four pints in the afternoon. They'd be pretty well along. They became seasoned drinkers. They became so used to it that it took no effect on them. My own father now, he was very well known for his drinking habits. He would get my allowance (as his apprentice) and he'd get everyone else's allowance and he often told me that when the day was done he'd had maybe twelve pints and he wouldn't be satisfied then. He'd have to have a drink on the way home. But he worked until he was in his seventies and lived into his eighties. It didn't affect him. Coopering is very much manual work, hard work, and you worked in sweat. . . coopers would drink to replace their vitality.'

While repairing whiskey or wine casks, coopers might happen upon unexpected pleasures. 'If you were working in a distillery,' says Robert, 'most of the barrels soak in whiskey so in certain times of the year such as warm summer days if the barrel had been airtight some of the seepage would come back out into the barrel so that if you got a barrel in to repair you could find in it as much as a pint of good whiskey. So, the trouble was that if you were in any way fond of the drink you would drink it and your work would be [laughing]. . . I remember one time now, one particular cooper, he got in these wine barrels to repair and as it happened the wine had seeped into the bottom of the barrels and he began to drink the wine. At the end of the day he came out and he was

falling about and he went over to wash himself in the tub and fell straight in. He was a terrible character for doing all the wrong things. . . he left our place to become a chauffeur.' Excessive drinking had its more serious consequences, causing erratic working schedules and absenteeism at some cooperages. As Gibney tells it, 'They were very hard drinkers. Coopers who were on piecework at Guinness' and these splank yards used to go in and work very hard Monday, Tuesday and maybe Wednesday and they would go on the beer then for Thursday and Friday because they would have considered themselves to have earned enough money in those three days. They used to spend Thursday and Friday all day in public houses drinking.'

Merits and Evils of the Piecework System

Though most were temperate drinkers, there is little doubt that the combination of drink and the piecework system created misery for some coopers and their families. In fact, the piecework system was always one of the most controversial features of the craft, praised by some and cursed by others. The merits and evils were debated by coopers up until their last days in the early 1980s, when it caused some lingering dissention at Irish Distillers. Even the Dunne brothers are in some disagreement. Robert contends that 'on piecework you got so much for each barrel you made or repaired and you would get more money, even double, what you would get from a standard wage because you were going that much harder. But piecework was a bad idea, really, because it would allow people to put out bad work. They tried to get so much work out and the trouble was that they weren't producing the highest quality.' In rebuttal, Eddie explains that this problem only appeared in recent decades, that in his father's time it did not exist because men were more conscientious and the foremen stricter; they would never allow shoddy work to pass inspection. 'Once you were on piecework you were always working and the one thing that you had was *pride* in your work and you wanted to safeguard your job rather than have casks go out leaking because you'd be afraid that the foreman or boss might ask you, "Does this cask belong to you? . . . It's a disgrace" and he'd put you on time work and the wages were a lot less.'

Some men were better suited by temperament, skill and speed to piecework than others and it was usually in the best interests of the cooperage to give them a choice. Those capable of combining speed with quality, such as Eddie, profited handsomely. 'Now I was the highest paid cooper in Power's, this was back in 1937, and I was working on piecework and I'd hardly speak to anyone during the day. Now I wouldn't be discourteous or anything like that but I wouldn't stop and stand around and talk, it would cost money. I could go in at ten in the morning and I'd have my tea break and lunch break and be finished by about three and I didn't have to work on Saturday, but I did go in to see that my work was passed. I was earning at that time on piecework sixteen pounds a week while the cooper who was working on timework would be in at eight and finish at five and he was only getting four pounds eighteen. That was the basic pay rate.'

Piecework encouraged initiative and independence and the men who worked on the system for years abhorred the notion of regimentation and punching a time clock. However, as Gibney reiterates, this very sense of freedom was conducive to drinking and sporadic working hours. 'They didn't even have to come in to the job because when you were on piecework you were your own employer kind of, you came and went when you pleased. At Guinness' some men were on piecework and others on a time rate. They called it "on time". You were clocked in and this was really controversial among Guinness' themselves. There was one fellow (in management) who wanted to put everybody on a time rate, clock in and clock out, but it didn't meet with the approval of many.' On Thursdays and Fridays the Guinness' cooperage population would be visibly depleted as pieceworkers began to spend their earnings. On the other hand, a cooper on time rate was expected to arrive promptly and it was an old custom that if a man was tardy his colleagues would start rattling their tools in good-natured disapproval. Though Eddie defends the piecework system, he concedes that time rate work benefited coopers as they grew older and slowed down. 'Old men when they'd get to the stage that they weren't capable of making or repairing casks (as efficiently as when they were younger), well, you couldn't throw them out in the road. Well, that man might volunteer to go on time work because his family would be reared and his children educated and now he says, "I'll take a nice easy job tightening hoops in the warehouse or something." He just wouldn't be able to keep up with the younger men.'

Old Tools and Mauled Hands

To practise his craft, a cooper needed only his tools, an apron and wood. Oak was really the only timber satisfactory in terms of workability, durability and imperviousness. Years ago what was known as Memal oak was imported from the Baltic regions of Russia and Poland but in recent times oak was largely obtained from North America. Coopers had great respect and affection for the tools with which they worked this wood. Since it was traditional that tools were handed down from father to son, they had strong sentimental value. Almost all are peculiar to the craft and have not changed significantly over the centuries. Many were named after birds (for some reason no-one seems to remember) such as the 'hawk', 'swift', and 'titlark'; others are the adze, jigger, buzz, chive and heading knife. They had to be imported from England or Scotland, though some coopers were able to make some of their own.

It was never the responsibility of the cooperage to provide tools; coopers had to come equipped with their own full set. They were treasured possessions, the basis of livelihood. James discloses that it was not customary to exchange or loan them. 'To equip yourself with tools was very expensive and so they were handed down. Men went on pension and they left their tools after them and gave them to their sons or someone else. . . a man's tools were sacred.' Says Gibney in agreement, 'A cooper would covet his tools and he wouldn't loan them to anybody. I always kept them in very good working order. I used to spend maybe two and a half hours every week grinding them. Throughout the years of cooper-

ing you might have to replace the handle of your hammer a half dozen times and your hand would have actually worked a bed into it through constant use. . . it shaped into your hand. You were using the hammer in practically everything you were doing and I suppose that out of the eight hours of the day you could be using it for five hours and it was easy to see how you could fashion the shape of your hand into the handle.'

Mauled hands were a mark of the craft – and a source of great pride. Robert remembers seeing an old cooper unabashedly admiring a fine cask that he had just completed. Then, looking at his outstretched gnarly hands, he exclaimed, 'Now who am I going to leave these to when I go?' The constant hard contact with robust tools and raw wood left hands cracked and leathery, and joints enlarged. It required regular treatment to keep them pliable and presentable. At the end of each day, Eddie would have to 'repair' his mutilated hands. As he tells it, 'Your hands would be in a terrible state. They would be split open from dryness and from rubbing the timber down along the jointers. My hands would be sore and hurting at the end of every day, particularly in the winter. I used grease and mutton fat on my hands and covered them with gloves and I'd go to bed at night with gloves on so that I'd not destroy the good linen. So, in the morning your hands were grand again and then by lunch hour they'd get dry again and be wide open. It would be raw looking and the dirt would get in the cracks with the result that when you were going out at night you had more bumps and lumps on your hands and you had to try and make them into a presentable way so that people wouldn't be looking at you.

'I remember going into a restaurant one night and my hands, having done the best I could with them, were still in bits and pieces and I sat down at this table and had a meal and there was a man sitting opposite me and he said to me, "If you don't mind my asking, I'm just looking at your hands." So I thought that he was referring to them being in a filthy condition, so I said, "Yes, it's very embarrassing. . . I find at times that I can't seem to get them right at all." And he says, "What do you work at?" And I told him as a cooper. So, he says, "Now I'm a barrister and I wish that I had those hands of yours. . . you should be proud of them".'

A cooper's apron was usually made of leather such as moleskin or chamois. It was worn around the waist because he was constantly digging his knees and lower body into the rough casks. This protected his body and preserved his clothing. A good chamnois apron was an expensive investment. Gibney once saved up for a long time to buy a fine one at Clery's on O'Connell Street which lasted him for nearly twenty years. Some coopers resorted to converting an old sack into an apron but over time this afforded little protection. There was an old superstition in the craft that if a man was caught out in the cooperage yard without his apron it was an ominous sign that something nefarious was happening at home with his wife. His friends would chide him about the 'milkman' or 'coalman' visiting in his absence.

Image, Status and Nicknames

Dublin's coopers were always a colourful lot, known not only for their sometimes prodigious drinking habits but also for their special status, dress, musical talents and imaginative nicknames. Pride and status were always associated with the craft. Eddie remembers as a young boy being impressed when he overheard a neighbour say, 'Oh, that's Mr Byrne, he's a cooper. . . they're people of standing.' In Gibney's opinion, the high esteem in which coopers were always held was 'mainly due, I think, to two things. The skill that was involved in coopering – I think that it was the most highly skilled craft in the country – and, secondly, the high wages a cooper got in comparison to other tradesmen. A cooper was always looked up to and if you married a cooper you could consider yourself all right for the rest of your life. You wouldn't have to worry about getting bread on the table or worry about clothes and things like that because of the high wages they had.' This is confirmed by a document which James once came across at Guinness' which listed the comparative wages for all the different crafts within the brewery from the period 1840 to 1965. 'It was all done in pen and covered forty or fifty different trades – the blacksmith, the farrier, all the trades, and the cooper was the highest paid.' It was for this reason that Vincent says the coopers were always regarded as the 'aristocrats of labour'.

Up until the last generation, coopers delighted in flaunting their status by promenading about in bowler hat, hard collar, long black coat and dress boots. Their admired stature in the community also carried with it a keen sense of social responsibility. Coopers were always known for being highly generous and charitable. Whatever the good cause, coopers were usually the first craftsmen to contribute and their donations often set the standard for others to follow. In fact, when the Coopers' Society was dissolved in 1983 it was voted to leave about three hundred pounds in an account for charitable purposes. Thus the great respect that coopers commanded was due not only to their skill and income but also to their sense of social responsibility.

They always had a strong liking for music. Many were gifted vocalists, and group singing was common at some cooperages. Others prided themselves on being connoisseurs, regularly attending concerts and operas. Coopers even had their own band. Eddie recalls with some amusement that they seemed to know 'only one tune, "Hard Times Come Again No More", based on the idea that some weeks you'd have good money and the next week you'd have nothing. . . it was a lovely old Negro spiritual.' His brother remembers back in the early 1960s a young apprentice cooper by the name of Phil Woodnut who was quite fond of Irish ballads and formed a small group to perform in local pubs. He emigrated but the group went on to become the internationally-known Wolfe Tones.

Certainly no other craft could match the imaginative and amusing array of nicknames that coopers adopted. Because it was a closed craft and many members of the same family worked together, it was necessary to distinguish between them and avoid confusion by using nicknames. Usually, the label would stem from some particular or peculiar personal feature, trait or habit. It might be assigned in early years but generally

stuck for life. Certain names were especially intriguing, such as 'The Ducky Woman' Byrne, 'The Tapeworm' Tyrell, 'Jellybelly' Lynch, 'Ya Ya' Corrigan and 'The Laughing Cavalier' Branigan. Some coopers became such characters that they were known by name and reputation throughout all the cooperages in Dublin. Over the years many of these jaunty nicknames became obscure in origin or were lost altogether. Therefore, in their last years the Coopers' Society compiled a list of the more memorable ones as an historical record:

EXAMPLES OF COOPERS' NICKNAMES
USED FOR PURPOSES OF DIFFERENTIATION BETWEEN FAMILIES

NICKNAME	SURNAME	NICKNAME	SURNAME
Banjo	Ryan	*Jellybelly*	Lynch
Battler, The	Quinlan	*Jibber, The*	Simpson
Bootlace, The	McCarthy	*Laughing Cavalier, The*	Branigan
Bucksie	O'Connor	*Looney, The*	Byrne
Chinstrap	Curran	*Nizzler, The*	Joyce
Doggie, The	Kavanagh	*Rowdy, The Little*	Higgins
Draper, The	O'Connor	*Sailor, The*	Higgins
Duckegg	Byrne	*Snowball*	Murnane
Ducky Woman, The	Byrne	*Snowwhite*	Kavanagh
Dummy, The	Quinn	*Swank, The*	Nolan
Fiddler, The	Quinn	*Squealer, The*	McCarthy
Game Bird, The	McCarthy	*Tapeworm, The*	Tyrell
Gilly Gooley, The	Boylan	*Twitters*	Kavanagh
Gorgeous Gus	McCann	*Wagger, The*	Maloney
Harpo	Higgins	*Ya Ya*	Corrigan

Beginning of the End

In a 1947 article in *Guinness Time* magazine it was confidently declared that 'mass production has not invaded the realms of this fine old craft and the skill of the journeyman cooper is still at our service to ensure that we get our pint of beer'.[9] Such assurances by the parent company instilled security in the coopers. It was unthinkable that their craft could be threatened by modern technology; they were indispensable to the brewery. Then, in the 1940s, came a subtle harbinger of change – the seemingly innocuous appearance of a few metal beer casks imported from England. Most coopers paid little heed but in the minds of some it stirred an ominous foreboding. Gradually, the implications of this new development came to be openly discussed among coopers themselves, with widely varying views. Vincent was in the middle of his career at Guinness' at the time. 'I can remember during the last war the transition from wood to metal. It was argued among coopers themselves that it couldn't be, that beer didn't belong to metal; it was a happy marriage between oak and beer. But the argument was that if they could put milk in metal they could put beer in metal. But, of course, there's no affinity between milk and beer. . . beer and wood complimented one another.'

Many coopers initially accepted the logic of this contention, certain

that the metal casks would prove a failure. Some dismissed them as merely a harmless experiment or fad, but during the late forties and early fifties the influx of steel containers accelerated and what had been a curiosity became a genuine concern. Eddie recalls the reaction. 'They really began to appear in the fifties. Coopers didn't like them. They called them "depth charges" and "iron lungs". Coopers saw them as a threat to the old craft. . . saw their world changing. They were going into Guinness' and there was no way to stop them. Things were becoming increasingly slack and the men would know that some would have to be let go.' As the emergent trend became painfully clear it crept into the consciousness of coopers that they were passively, and helplessly, witnessing their own obsolescence. It affected men in different ways. Some were overtly fearful, agitated, angry. Others remained hopeful, optimistic. However, with time more grew stoic and pessimistic, viewing themselves as pawns amid technological change. They felt impotent to defend themselves.

There was a discernible difference in attitude between the older coopers nearing retirement and the younger ones with their future still ahead of them. 'The writing was really on the wall for coopering at Guinness' around the early 1950s,' recounts Gibney, 'when they started to get in metal containers. The majority of coopers saw the end coming but looked at it from the point of view that "Well, I'm working for Arthur Guinness and Arthur Guinness will look after me". They weren't really worried in the sense that a younger cooper might be worried. It was the beginning of the end, we could see this. . . the end of coopering in Guinness' and other breweries around the country. They dwelt on it an awful lot. You could see it in their manner. The older coopers, they felt that Guinness would look after them. It was really the younger generation of coopers who looked scared.' By the late fifties there was no mistaking the acceptance of the infernal contraption; metal casks were there to stay. This heightened anxiety and generated open speculation over the future. Vincent declares, 'Everybody was dismayed. We knew that whatever Guinness' decided to do it would come to fruition for the simple reason that they were a very powerful firm. . . men were dismayed and bewildered.'

Guinness' decision to shift from 'timber to steel' was a matter of sheer economics. Wooden casks have always been expensive to clean, repair, and generally maintain. A percentage of all casks returned to the brewery for refilling needed some repairs due to rough handling or wear. Wood barrels were also subject to shrinkage and had to be regularly measured and gauged for proper content levels, and with new brewing processes and chemicals the barrels were not as sanitary and easy to clean as in the old days, with the result that the pint often was not as consistent as desired. To understand Guinness' dilemma one needs to realise that there were literally hundreds of thousands of casks piled in the yards in mountainous pyramids. During the summer months they would dry out and the hoops would loosen and staves part. This resulted in costly repairs. Men had to be employed to constantly hose down the pyramids to keep the barrels moist. Thus, there was an interminable cycle of maintenance which became increasingly costly with rising labour wages. In contrast, the metal casks required virtually no special treatment to keep them fit for use. They were durable, sanitary, easily cleaned, and were constant

Robert Dunne, who still works about twenty hours a week in the yard making a few real casks on special request, creating barrel garden tubs for sale and repairing some small casks for local wine merchants

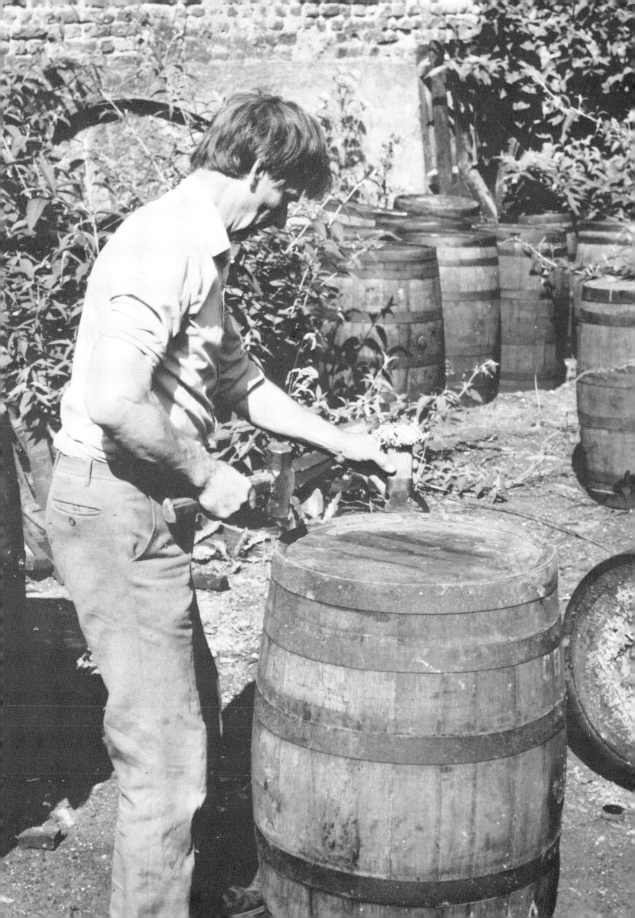

in size and content taste. Metal kegs were an invention whose time had clearly arrived. The economic logic was indisputable. By 1961 they had proved so successful that Guinness' made the fateful decision to close their cooperage.

One legitimate argument against adoption of the metal casks (though it carried no weight in Guinness' final decision) was that beer lost some of its original heartiness and rich flavour. Gibney deciphers this change. 'I personally feel that the pint was certainly different out of the metal container as against the wooden cask. There was always a kind of brown, creamy head on the pint because Guinness' used to leave it in vats for a couple of days before they'd fill it into wooden casks that were shipped out to the public houses and those barrels of stout would have to mature in the cellars for about ten days. Whereas, with the metal containers it was made today, thirty pounds of gas and thirty pounds of air were pumped into it, and it was sent out that day to the publican where he could use it straight away. So, in actual fact, it was being forced into condition as against the natural process of maturing in the wood barrel. So, obviously, there had to be a different taste. The old people particularly noticed it. I've heard them say, "Ah, the pint is not the same, I'm not going to drink any more of that". But I think that Guinness' at the time were more or less depending on the younger generation with fresh tastes coming along and they achieved their aim at this because the people kind of went for it.'

The closure of the brewery cooperage was accepted by most coopers with grim resignation, as they could do little but await their fate. However, a number (especially in retrospect) felt that they should have been more unified, better organised and more aggressive in protecting their future. During the last days, Benjamin Guinness visited the cooperage to bid farewell to Vincent and the other coopers. 'We were personally introduced to him. He came to say goodbye to us. Afterwards I thought that if we'd spoken to him as regards who we were and what we had been. . . maybe he might have taken a more personal interest.'

Guinness' initial solution to redundancy was to offer each craftsman a flat sum of two thousand pounds to sever all connections with the firm. Though this was a sizeable amount at the time, only a small number of men accepted it. This meant that an alternative settlement had to be devised. It was decided that the coopers would be retained but shifted to different forms of employment. Many were sent to work at the Guinness subsidiary CAMAC which manufactured the metal kegs – what cruel irony in coopers being put to work making the very articles which brought about the fall of their craft. Others were transferred to an industrial mouldings firm specialising in plastic products or to the furniture factory turning out umbrella stands, miniature barrels that hold about a pint, turf buckets, little stools and rocking horses. At first it seemed a reasonable settlement financially because they carried their cooper's wages with them. Men in the furniture factory seemed to adapt best because they were at least working with wood but, as Vincent observes, they eventually came to realise that 'it was really just physical therapy'. After about a year this enterprise collapsed due to lack of demand for the products. Soon after, the coopers were transferred from the Dublin Coopers' Soc-

iety to the Workers' Union of Ireland at Guinness' behest. Their demotion to general workers resulted in diminished wages but, more importantly, the proud old craftsmen felt demeaned when reduced to serving as assistants to carpenters and fitters. Many became disillusioned and dispirited.

Nothing better epitomises the psychological and emotional trauma of losing craft, pride and dignity in one fell blow than the experience of cooper Dick Flanagan, as recalled by his close friend, James Tyrell. 'We had one craftsman, Dick Flanagan. Dick had huge arms and pearly teeth, he was a giant in his own right. . . a quiet giant. We went into plastics, Dick and I. Now remember, he had spent most of his life making casks. All he knew was making casks. You can imagine this big giant put into a modern factory. He was a pieceworker all his life and Dick was always used to his pint. It was either brought to his bench or he went over for it. Now these plastic bottles were coming out at him (on a conveyor belt) and with his great big hands, like a giant's, he'd try to use the trimming knife on the mutants that came out. So Dick would occasionally come over and say, "Take over this bloody thing, will you, I'm going for a pint". But one day the German manager got "on his house" and made Dick very sad, really turned him upside down. So I went to him (the manager) and I said, "Do you realise who you're checking for this kind of absenteeism (going out for his pint) that you're talking about?" I said, "If you want the factory moved in the morning, he'll move it for you, he has such strength and everything. . . don't be so hard on Dick, you can't do that, we must all live together". You can't just take a tradition and change it overnight, you know. Dick was used to creating and the ironic part of it all was that he was sitting in the same building, on the same site, just a few yards from where he had made the casks and now he was subject to this terrible discipline. It was mentally disturbing to him. It killed his spirit. He didn't last any time, poor man. It killed him. He died and I witnessed it. It was terribly revolting. . . it was a pity.'

Loss of Distillery Cooperages

With the closure of Guinness' cooperage, the only coopers left were employed at the distilleries, jam factories and Dunne's (Lemass' splank yard folded in the fifties). Then, in the 1970s, the jam factories converted from wooden barrels to plastic containers. When the Dunnes lost their jam business they managed to survive only because they were fortunate enough to get some regular orders for casks from Scottish distillers who were short on supply. They also did a small amount of work repairing or replacing barrels for some local wine merchants. The fifties and sixties had been fairly prosperous years but things became lean in the seventies and they could only keep a few men on.

Distilleries stood as the last bastion of the craft. Here the cooper thought himself invulnerable to the technological changes which eradicated his counterpart in the brewery. Surely whiskey could not be put in metal kegs. There were about fifty coopers working at Power's and Jameson's in the seventies when the two firms were amalgamated into Irish Distillers and concentrated at the cooperage in John's Lane. They no longer made casks but assembled ones imported from the United States

where, by law, oak barrels can only be filled twice. Irish Distillers adopted the practice of bringing them in by ship in disassembled, or 'shook' form and having their coopers reassemble them. The 40-gallon bourbon casks retained flavour in the staves and blended nicely with the Irish whiskey they held. However, in the early 1980s Irish Distillers decided that it would save time and money and better retain the bourbon flavour if they brought in the barrels intact. Gibney and his mates at the firm immediately recognised the dire consequences. 'That was the death blow – the importation of standing barrels. They discovered that they would be better off importing the barrel whole and just bring it across to Ireland and fill it.' Yet they were secure in their knowledge that 'we had an agreement with Irish Distillers whereby we wouldn't be made redundant, that was in *writing,* and in discussing this with management we told them, "You can't sack us".' To circumvent this legality, the company decided to buy the coopers out by offering them financial settlements.

There was considerable disagreement among coopers over the justice and acceptability of this proposal. To exacerbate matters, there had been some dissension among the men in recent years when Irish Distillers placed everyone on a standard rate. For those long accustomed to piecework this was an alien and distasteful system. Prior to being brought together at Irish Distillers, some had been making three hundred pounds a week on piecework while others on time rate earned half that. Predictably, when pooled on a standard rate there were ill feelings and dissatisfaction. So, the last days of coopering in the distillery were not harmonious ones and when the company came forth with their financial proposal the coopers' responses clashed.

Gibney is convinced that the firm shrewdly calculated that the offer would be attractive to the older coopers nearing retirement but strongly opposed by younger men with years ahead of them. 'They knew what they wanted and they knew that by putting "the carrot" out, sufficient money, that it would be accepted because of the ages of the coopers. The majority were within ten years of retiring age and the younger coopers who were kicking up and complaining and wanted their jobs, they were in the minority. Irish Distillers knew this and they manipulated in such a way that by putting the carrot out it would go to a vote and it would be carried. I fought tooth and nail to remain a cooper. It was really the only thing these lads had. . . just the skill of our hands as a cooper.'

Opponents of the plan considered taking their case to court but they were legally advised that such action would be very costly, that many would have to financially pledge their home to raise the legal fees, that it would impose emotional strain on themselves and their families and, ultimately, they might well lose the case. Taking into account these risks, they decided not to challenge the corporate giant. 'Let's face it,' Gibney bluntly confesses, 'Irish Distillers have plenty of money behind them and they could get the best brains in the country to fight you. I've no doubt that we would have won if we had gone to the High Court because of the agreement we had. . . if there is any justice at all. We threatened Irish Distillers with going to court and it probably helped in boosting payments because their initial offer wasn't anything like what we finally got.' As it turned out, the average settlement was around £50,000 and the highest

£70,000. Younger coopers earning between £200 and £250 per week and with twenty or thirty years working life left couldn't expect to invest their settlement funds and realise a standard of living like that to which they had become accustomed. They felt badly betrayed. Says Gibney, 'I worked up to the very end. The last working day was the tenth of December, 1982. The mood of the coopers that last day was very, very sad, and rightly so, because these were coopers who were told that they would be working for the remainder of their lives at Irish Distillers.' Most of the ex-coopers invested their money as best they could. A hapless few squandered much of it on drink and gambling. For a time after their dismissal some of the men would meet regularly in the unemployment line to see old friends again and have a chat – but it was a depressing setting.

It appears that coopers were merely victims of modern technology and economic expediency, cast off by two corporate behemoths. Doubtless these external forces were largely responsible for their ultimate doom. However, Eddie, who has perhaps a better perspective on the craft than anyone still around, speculates that there were also internal degenerative developments which had served to undermine the craft for decades. He specifically blames a breakdown of the traditional separation of management and labour which he believes led to an overly-casual working atmosphere, declining quality control and an eventual loss of pride. He puts it this way: 'In my opinion there have been a terrible lot of bad coopers. . . that's what finished the trade. There were a lot of coopers there in the distilleries who didn't care about the quality of their work. They sent out casks which wouldn't seal properly and many would eventually become empty. That should never happen. You will get the odd case where a stave might snap and the cask might lose a certain amount of its liquid but these casks were at warehouses which were examined by coopers nearly every day and every cask would be "sounded", you would tap your cask with a hammer or mallet and you'd know by the sound whether it had dropped its contents. If it leaked you would repair it. Well, apparently these boys didn't bother with that. The problem was that the whiskey was at their hands there. A lot of coopers became alcoholics and the standard of their work deteriorated because they weren't in their proper senses to do the job right. At Guinness' there was an awful lot of what we call "backhanders", a foreman who has to check out your work, but if you saw him after hours and you were in the pub and treated him to a few drinks, you knew that the following morning your casks would be passed. That wasn't good for the trade. The old pride had left and it was money. . . money took over, money ruled! Coopers were all the time looking for more money, more money, more money. And the more money they got the more money they had to spend and consequently many stopped coming into work regularly and when they came in it was only when they were short of money and then it would become a rush job. In my father's and grandfather's time the cooper looked up to his foreman and he was a man a step above you and he didn't knock around with you at night time, going to pubs and all. . . he was the boss. But by the sixties the workers would hobnob with their bosses and foreman.'

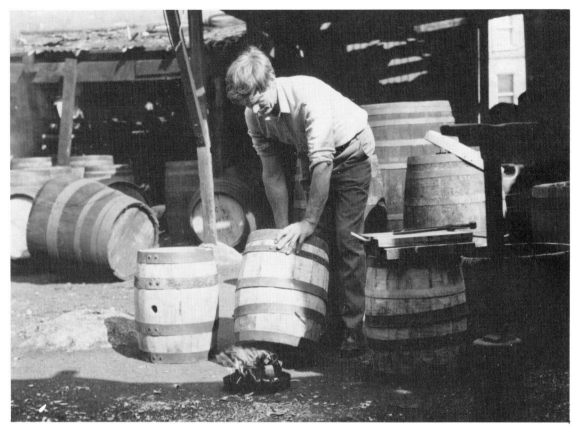

A Last Gathering

Robert Dunne at work on a barrel. He still retains all the original tools and techniques of his craft

The final meeting of the Dublin Regular Operative Coopers' Society was held on March 24 1983. The minutes of the meeting were mercifully brief, covering only two handwritten pages. It was moved that the Society's charter, banner and oldest minute book be presented to the Guinness Museum for historical safeguarding and that all other records be given to the Labour History Society. Regarding dissolution, the final vote of the remaining members was thirty-seven in favour, none against – there was no denying the inevitable. It was then generally agreed that the decision to dissolve the Society should be marked by way of a dinner party. In closing, both the President and Secretary thanked members for attending and termed their collective action 'sad but necessary'.[10]

The 'last supper' was held at the Clarence Hotel and was attended by about fifty coopers. Nostalgia hung heavy over the gathering. 'We had a most enjoyable night,' recounts Gibney, 'and ended up with a sing-song but we had a lot of sentimental speeches. I mean people were going about their own way in life now and they'd probably never see these people again that they had worked with. It was sad really in that it was a way of life just gone, pulled out from under their feet. . . never to be resurrected again. You're talking about from 1501 to 1983 which is a great span of years and a lot of history. So it was sad to see it go. . . and the

way it went.' The death of coopering in Dublin was a silent, personal affair unheralded by the outside world. At their closing meeting and last dinner there was no press coverage or media attention. Says Vincent, 'Nobody knew we were going.'

Dunne's Cooperage : The Last Relic

Now there is only Dunne's cooperage. It is but a relic. Sitting at his desk peering wistfully out into the desolate yard, Eddie speaks softly: 'They were very, very good times. You'd show up in the morning and the fires would be lit up in the yard and all the banging was like music to your ears. I'd walk about the place and have a chat with all the men. They all got on well together and with me. . . we're practically down to nothing now.' The cooperage has become something of a shrine for some old-timers who occasionally visit just to see and touch the barrels again, maybe have a chat.

In the weed-entangled yard amid the crumbling sheds where once thirty coopers pounded away, Robert now spends about twenty hours a week making barrel flower tubs for the Royal Dublin Society (RDS) Horse Show or garden centres. He still makes a few 'real' casks at specific request, but not many. The staves dwindle as do Smithfield's days, numbered as they are by redevelopment plans. In melancholy mood, Robert puts down his hammer and ruminates, 'It's sad, isn't it? Back when I first started it was really a great craft. The money you earned was good, they were great times, you worked hard. . . put in a lot of hours for Ireland, but you got great satisfaction out of it, out of completing a wood barrel, having something that's lasting. I'm the last cooper doing coopering now. When I die the craft will die with me. . . I'm the last of the tribe.'

2
Signwriters

There is no more fascinating craft than that of the signwriter.[1]

The whole traditional art of signwriting is in danger of disappearing completely.[2]

There aren't many old signwriters like myself left.

<div align="right">Kevin Freeney, 1984</div>

Signwriters are elusive, enigmatic figures. They arrive unobtrusively at a pub or shop and through their wizardry with paint and brush spin magic upon the fascia board, leaving behind a wondrous display of colourful lettering and ornamentation. Then, affixing no mark of identity, they quietly fade into oblivion. These anonymous craftsmen have lovingly etched the character lines into the face of Dublin, imbuing the old city with a personalised ambience, spontaneity and intimacy seldom found elsewhere. Indeed, Dublin has long been renowned for its 'flamboyant public houses and shop fascias'.[3] No other craftsmen have left so personal an imprint on Dublin as the signwriters. Yet, of all the craftsmen in this book, the signwriter is the most unrecognised and least historically documented.

To appreciate the role of the signwriter in Dublin's history one need only examine old photographs of the city when it was lavishly decorated with their artistry. In Peter's *Sketches of Old Dublin* we find that the city has for centuries been a treasury of shop and street signs.[4] Personalised pubs and shopfronts have traditionally been one of the most distinctive features of the urbanscape. To be sure, these façades are the product of many craftsmen, but after the carpenter, plasterer and mason finish their work it is the signwriter who appears on the scene to provide the most elaborate touches. As Rothery attests, 'Irish shopfronts make their most individual and vital contribution to the street scene in the art of hand-painted lettering.'[5] An imaginative signwriter can give a dowdy little shop or stern pub a dramatic facelift. An elegantly written fascia is a good investment for the proprietor because it visibly enhances his image and prestige in the community. It can reap wonders for his pride and ego. As MacMahon puts it, 'Plebeian butchers become "Fleshers" or "Victuallers" while the owner of an all-kinds-of-everything store. . . gazes up in jubilation to find himself described as the owner of an "Emporium".'[6] Handcrafted signwriting confers a sort of visual dignity for all the world to see. It also humanises and enlivens the streetscape. Irish signwriters have always had a special flare for the art. Bartram, in his book *Fascia Lettering in the British Isles,* praises their originality, noting that the 'signwriting tradition still flourishes there [in Ireland] with weird and eccentric examples reflecting some aspects of the Irish mind.'[7] *An Foras*

Forbartha regards traditional shopfronts and handwritten fascias as an integral part of the national heritage. Hence, the contributions of signwriters to Dublin art and architecture are manifest.

Origins of Signwriting

By direct descent, the old signwriters were heirs to the lettering cut in stone above the great buildings in ancient Rome. Thus was SENATUS POPULUSQUE ROMANUS *linked to* PADDY MURPHY, LICENSED TO SELL BEER, WINE, AND SPIRITS.[8]

The origins of signwriting are more ancient and illustrious than many might imagine. It probably began with the practice of painting or writing texts and inscriptions on churches, other religious edifices and great public structures. Greek and Roman writers have made reference to the craft, and excavations at Pompeii revealed the use of signs over the shops of tradesmen. Actually, the first signs for public consumption were not written but were carved or had a picture, emblem or symbol drawn on them. Centuries ago, when the populace was largely illiterate and streets unnumbered, signs were necessary to identify the abode or workshop of the craftsman, merchant, or innkeeper. Therefore, signboards with symbols became an indispensable feature of towns and cities, a 'relic of the good old barbarous times when reading and writing were the gifts of the few'.[9] These visible directories had symbols clearly understandable to customers and travellers, such as an optician's spectacles, a gold-beater's arm and hammer, an apothecary's pestle, a locksmith's lock and key, the three brass balls of the pawnbroker, a golden canister for the tea dealer, a striped or bandaged pole for the barber, a hat for the hatter and a fish for the fishmonger.

Up to the eighteenth century, most Dublin establishments were identified by hanging signs, some quite large and elaborate. They added colour, visual variety and movement to the streetscape. In an article depicting 'The Street Life of Old Dublin' the author nostalgically speculates about 'how picturesque must, say, Dame Street, have looked on a blusterous day in the mid-eighteenth century with all its motley signs a-swinging and a-creaking in the wind' (it is said, by the way, that the locution 'where do you hang out?' owes its origin to this old custom).[10] But as these swing signs proliferated they became annoyances, obstructions, even hazards. They would project into public thoroughfares, drip water, creak noisily and occasionally fall upon pedestrians. By the mid-1800s signs on some Dublin streets constituted a serious nuisance and public danger. Their regulation became a contentious issue. An 1864 issue of *The Dublin Builder* addressed this perplexing problem in a forthright manner, openly criticising the Dublin Corporation for overreacting to the hazards of hanging signs. The writer conceded that a shop owner had no right to 'encroach injuriously on the public highway, or in his audacity of bad taste, obtrude some monstrosity into the very noses of passers-by' but he went on to castigate the Corporation for its 'crusade against the time-honoured custom of indicating to the public by a projecting sign, the nature of the trade, calling, or occupation of the owner who dwelt under

its shadow'.[11] He further accused the Corporation of attempting to eradi-
cate all signs, thus 'reducing our streets to Quaker-like uniformity. . .
and the loss of street character'.

In the last quarter of the century literacy increased and houses and
shops became more commonly numbered. The old hanging signboards
began to disappear and new affixed signs came into vogue. Gradually,
there was a shift from symbols to informative titles. Consequently, as
people roamed about Dublin streets they would logically expect to find
hosiery at *The Royal Leg*, cloth at *The Golden Fleece* and could deduce
that *The Spinning Wheel* in Francis Street was a fashionable mercier's
and that *The Blue Hand and Rainbow* in Watling Street was a firm of
dyers, while the sign of *Adam and Eve* normally indicated a clothier's or
tailor's. Over the years, taverns, more than any other type of business,
retained their signs, the oldest remaining one in Dublin being *The Brazen
Head*. With the obsolescence of hanging signs, fascia boards became the
masterpieces of signwriters. However, as with the earlier swing signs,
over-exuberance sometimes led to excess as many signwriters simply got
carried away with their artform. This was especially pronounced during
the Victorian period, when 'every kind of design became debased while,
curiously enough, the standards of craftsmanship reached an astonish-
ingly high level'.[12]

Through experimentation, signwriters found that by making letters
written on a flat surface appear as though they were raised from that
surface, and by imitating the shadows which raised letters would cast,
they were able to 'develop and display a truly marvellous skill'.[13] So
highly elaborated by shadows was the work of one old craftsman that
an admiring apprentice swore that it seemed possible to 'see round to
the back' of the letters. Such optical illusions became a great achievement.
In quest of sophistication, signwriters began to distort letters in bizzare
fashion, tilting them, bending them, linking them together and adding
flowing, curling appendages. This exotic trend was especially conspicu-
ous in advertisement, which developed in flamboyant form during the
Victorian years. It was common for Victorian cities to become smothered
with advertisements, either tasteful or gaudy. Windows of shops, fascias
and entire building façades were 'clamorous with messages'. An obser-
vant pedestrian in present-day Dublin can still decipher on some buildings
the old signs advertising tobacco, dyes, foods, boot polish and the like.

With their enthusiasm for embellishment, signwriters seemed to forget
that lettering is intended to be easily read, not interpreted as abstract art.
Their elaborate letters reduced legibility. This mystification of lettering
was eventually criticised by experts and public alike. One articulate critic,
writing around the turn of the century, deplored 'lettering tied in an
inextricable knot, dancing drunkenly across a portion of the design or
in great mis-shapen masses that make it top-heavy. . . letters like H, M,
and N set upon ungainly stilts'.[14] He lambasted overly-zealous signwriters
who exceeded the bounds of legibility and good taste:

> There is nothing to prevent the craftsman from getting his character into his
> lettering. . . (however) I am convinced that craftsmen seem to be continually
> getting it into their heads that they have to design letters on the inscriptions
> of their works. Now that is precisely what they must be warned against. You

cannot design a letter. You may burlesque it. You may mutilate it by breaking its back in unexpected places. You may complicate it with weird growths of a more or less fungoid nature. But you cannot *design* it, for designing implies invention and no one can be said to invent what already exists. I do plead for simplicity and modesty in letters made for public use.[15]

Mercifully, the superfluous lettering of the Victorian era ran its course, and signwriters adopted more traditional and conservative forms digestible by the public.

Obscurity of Irish Signwriters

There are only three of four notable signwriters in Dublin.[16]

Long famed for its rich signwriting tradition, Dublin has had its share of master writers, but they have been lost in an anonymity and there is no record of them. Over a century ago, Callingham noted with some frustration that 'it is curious that the term "signwriter" is not to be found in any encyclopedia, ancient or modern'.[17] One reason for this omission is that the term was not commonly used until the latter part of the nineteenth century. They were more often known simply as 'letter painters', 'letter writers' or 'letterers'. The principal explanation for the obscurity of signwriters is that they were immersed in the general painters' and decorators' trade. Indisputably, they were the elite of the craft: 'The position of the signwriter among craftsmen operating with paint is analogous to that of the watchmaker in the mechanical world.'[18] Yet, despite their specialised skill, they were never singled out for distinction and, being few in number, they were not organised or classified as a special group. A large painting firm with thirty or forty employees might have a single signwriter on the staff. Unlike coopers, shoemakers, tailors and most other craftsmen, signwriters never had their own guild, society or separate identity. For precisely this reason, they have been lost in history and missed by historians.

Around the 1930s, when the demand for traditional signwriting began to wane, painting and decorating firms could not always afford to keep them full-time on the staff. As a consequence, many found that they could work more profitably on a freelance basis. They became highly independent, had no need for a workshop or office and never had to advertise. They worked out of their home, lived solely by their reputation and were not registered in any directory. This condition of relative obscurity has remained unchanged for the past fifty years. Hence, it was a challenge to find the surviving masters. The most reliable research technique proved to be exploring the streets in search of authentic handwritten fascias, then inquiring with the proprietor of shop or pub as to who did the lettering. This empirical method invariably elicited the names of the same five men: Con O'Sullivan, Willie Robinson, Kevin Freeney, Jimmy Mezzetti and Paddy Gordon. Initial contact with Freeney via the general telephone directory led circuitously to communication with the other four, because for the past five decades they have comprised an exclusive fraternity bound together by close friendship and mutual respect.

Willie Robinson, whose father was, by popular consensus, the premier

signwriter of this century, is still working at eighty years of age; he is the grand old man of the craft. Kevin Freeney, born in 1919, began his apprenticeship at the age of fourteen and, after more than fifty years of signwriting, is the most active of the old masters today. Both his father and grandfather were signwriters and the heritage probably extends back farther. Jimmy Mezzetti, now seventy-five, retired recently but does an odd job now and then just to keep his hands entertained. He has always been considered a pure artist as well as a gifted signwriter. Paddy Gordon, the youngest of the group, started serving his time in 1934 at the age of thirteen. In recent years he has mixed management with signwriting. Taken collectively the four have well over two hundred years of experience. Freeney, Mezzetti and Gordon are so close that they are affectionately known as 'The Three Musketeers'. Con O'Sullivan, a brilliant writer of Gaelic lettering, retired and emigrated to Canada in 1983. Correspondence with him verifies that the remaining four are incontestably the last of Dublin's great signwriters. Wrote O'Sullivan, 'I know of no others.'

They are the last of what has long been a surprisingly small coterie of Dublin signwriters. Recalling the past six decades, Robinson contends that 'there were no more than five or six really good ones in Dublin'. Freeney agrees, noting that as far back as the 1930s you 'could count the capable signwriters on your two hands'. These essentially consisted of the present survivors and their fathers. Robinson and Freeney have the

At eighty years of age, signwriter Willie Robinson is the grand old man of the craft. He claims that after sixty-six years at the craft 'I wrote every shop in Dublin.' His hand is still stone steady and his eyes keen for every detail

greatest experience in writing pubs and shopfronts. By his own estimation, Freeney has done 'at least 700 pubs and shopfronts'. Robinson, in less precise fashion, simply claims that at one time or another during his sixty-six years at the craft, 'I wrote every shop in Dublin.' For each, signwriting has been not only a craft but a way of life – one that is now nearing extinction. As Whittaker lamented in 1980, 'the craft of the signwriter has almost disappeared.'[19]

The Education of a 'Scrubber'

In the old days apprentices to the signwriting craft were known as 'scrubbers' (probably because one of their tasks was to have warm water ready for the men at the end of the day to wash their hands with a big lump of carbolic soap). The seven-year apprenticeship began around the age of fourteen and normally involved attending Bolton Street Technical College to learn the academics of lettering, and working at a painting and decorating firm such as J. F. Keating's for on-the-job training. The balance between the two varied. Mezzetti attended technical school three nights a week for seven years while doing his practical apprenticeship during the day. Gordon entered the school at the age of thirteen and went two full years from nine to five; then, for the next five years, he went back several nights a week while doing signwriting during the day with a master. At technical school, apprentices learned mathematics, geometry, geometrical drawing and freehand drawing. They became versed in all types of script. Another requisite for the signwriter was accurate spelling and punctuation. A solid knowledge of orthography would prevent any 'dying done here' signs being put up at a dye firm. A great deal was also taught about religious symbols and scripture because of the importance of church decoration years ago. At least one hour each day was devoted exclusively to signwriting, and initially one had to practise on paper. Only after a year or two were you given a wooden board to prepare and write. Some individuals, such as Robinson, skipped the technical school experience; he learned the craft entirely from his father, for whom he was doing second-coating on letters at the age of seven.

Humble beginnings marked a signwriter's apprenticeship at the painting and decorating firm. The first year was spent mostly in the shop handling ladders, cleaning pots and brushes and becoming familiar with paints and implements. The apprentice quickly learned the vernacular of the craft – the ordinary painter was a 'dubber', the grainer a 'scratcher' and the signwriter, held in high esteem, a 'scribe'. After an introduction to the preparation and mixing of paints the practice of lettering began. One also had to master graining, marbling, gold gilding, heraldry and church ornamentation. Each was a speciality in itself. Graining is the process of dipping a cloth in dark brown paint and going over a ground coat of a lighter shade of oak or mahogany to produce the natural pattern of wood. Similarly, mock-veins of green marble could be created on wood or plaster surfaces. However, as Gordon observed, it was gold gilding that separated the potentially great signwriters from the average: 'I must say that a lot of them fell by the wayside when it came to gilding. Gold was so expensive that you're not going to give it out to boys to

play around with. You had to be selective about it.' Only the most prom-
ising youths were given the full opportunity to learn the art.

Years ago, gold gilding adorned the city. The gold comes in the form
of ultra-fine leaves in books and a signwriter could use hundreds for a
single job. Great care is therefore taken in application. It is extremely
tricky to work with because one ounce of gold may be beaten into 1,600
leaves light as a feather. Dublin signwriters used to obtain gold at an
establishment called 'The Golden Fleece' on Essex Quay, one of Europe's
finest gold-beating firms, owned by the Phillips family. Their proud boast
was that they could beat out a gold sovereign into a leaf which would
stretch from Capel Street to King's Bridge. They were so guarded about
their gold-beating techniques that they refused ever to take on any
apprentices and, since the sons remained bachelors, the business eventu-
ally died with them.

During the war years when gold was scarce Mezzetti, considered one
of the finest gold gilders in Dublin, would bring in a gold watch, ring or
tooth filling and have it hammered out. 'A good signwriter was a man
who could do gold gilding,' he says, 'it involves a hell of a lot of skill.
The method of beating and applying gold hasn't changed since the days
of the Pharoahs. Gold should never be varnished but many (signwriters)
varnished it. Varnish will deteriorate where the gold wouldn't and when
varnish is attacked by weather it cracks and pulls the gold off. Gold never
deteriorates. If it's put on right gold will outlive man.' Testimony to this
is his gilding job on Bourke's Pub on Camden Street which is as fresh
today as when applied more than forty years ago. Owing to the inflated
value of gold, gilding today is usually found only on the windows of
solicitors and stockbrokers.

Around the third year, an apprentice would finally be sent out with a
master signwriter to learn first-hand how a fascia board is written. This
was always a long-awaited event and it was with some anticipation that
the young lad showed up on the first day. In the 1920s, when Mezzetti
served his time, the standard means of getting about was by foot, bicycle
and handcart. Funds for public transport were scant. 'When I started my
time I got only a half crown a week, the equivalent nowadays of only
twenty-five pence, and the second year you got ten bob, that's fifty pence
now and then on your third year you got a pound a week.' He refers
light-heartedly to these early years as 'my punishment – they were long
days and tough days. They were tough in that you walked everywhere
or if you had a bike you were really something. So you walked everywhere
and carried a little box with you. Now there was a circle drawn on the
map of Dublin (by painting contractors) and the centre was supposed to
be Nelson's Pillar. Anything outside of that perimeter, you got tram fare.
We had tram fare in those days for tuppence. I can remember having to
push a handcart as far as Howth. You'd sometimes be sent out with
another boy pushing the handcart and one fella would push the other
for a while in the cart. Sometimes, coming back, if there were ladders
along, you might see a job maybe to clean out gutters or something and
there would be a few bob and that was for ourselves. It was a bit of fun,
you could buy cigarettes.' As an apprentice, Freeney once had to bicycle
twenty-eight miles to and from a job to do a fascia board. Nothing was
thought of it back then.

Once on the site, apprentices found that old signwriters were often secretive, eccentric and irascible souls, concerned more with preserving their own security than passing down the mysteries of the craft. Even back in 1876 Callingham tells us that 'the art of forming letters was regarded as a secret, the few who were able to do it at all satisfactorily being most watchful lest they should be the means of communicating their knowledge to others'.[20] Only grudgingly would some craftsmen share their techniques with a novice. This is why many signwriters had to learn directly from their fathers. Gordon found that 'it was absolutely essential to go and watch some of the old signwriters at work, but then they didn't want you to learn. In those days they weren't very "givish" with information because you were always a threat to them. In the setting-out stage they might send you out for a message or something, making their marks where the letters fit (when you were gone). They all had their own system of doing that and they were reluctant to share it.'

Mezzetti is a good example of a fledgling having to exhibit ingenuity and tenacity to overcome this obstacle. In his youth he was assigned to an old codger who so jealously guarded his secrets that he would regularly send him away on some contrived errand every time he prepared to set out the fascia lettering. 'He knew damn well that you were a potential signwriter and a threat to his continuity. So he'd say, "Oh, Jimmy, I forgot such and such" and you'd be sent out and it meant that by the time I would go back to the shop he would have the most important part of the job done, which is the setting-out. So the next time he would pull a little stunt like that I'd just go around the corner and watch him. I was using the old brain matter. And I'd watch him long enough and wait until I was quite sure of how to do it and then I would practise like hell myself'.

Pens, Paints and Dippers

The delicacy of the instruments used by the sign painter at once suggests work of fine quality. . . the highest degree of precision.[21]

It is more accurate to think of signwriters using 'instruments' than 'tools' in their punctilious craft. They are not encumbered by bulky equipment. Ladders and scaffolding are usually provided by the contractor or shop owner. They need only arrive with a modest packet of precise utensils. 'A signwriter always carried a little bag,' says Robinson, 'he mostly had lettering pencils, rules and chalk lines, palettes and his dippers. That was the sum total of his kit.' Most important are the sable pencils (small brushes). These vary in size and are distinguished by the type of quill on which they are mounted. From the smallest to the largest they are the lark, crow, duck, small goose, goose, extra goose, small swan, medium swan, large swan, eagle, large eagle and pelican. The red sable is the aristocrat among signwriter's pens. Its hairs remain relatively stiff even when loaded with colour and it retains a lively spring which responds well to the manipulations of the writer. Brown sable pens possess these characteristics to a lesser degree. Ox-hair is suitable for work on coarse surfaces such as brick and cement and the so-called camel hair pen (actually squirrel or pony hair) has no spring and is inferior to the others.

Signwriters have always imported their pens from England though a few, like Robinson, have made some of their own from quills, sable and hog's hair. Since pens are fragile and expensive they must be thoroughly cleaned after every job and carried securely in a long cylindrical or oval tin case, all neatly aligned for proper usage. A sable pen that twenty years ago cost only three pounds today sells for thirty-two pounds and the larger ones exceed fifty. Perfectionists like Mezzetti modify them to suit individual needs. 'The brushes we use,' he explains, 'are pure bristle hairs and at the end of these is what we call the "flag", where the bristles open out. If you would get brushes that were too long to paint with, it would be too floppy, so you would have to learn how to bridle it with twine. You would have to bind your brush down to a good working level and as the brush would wear down you would release some of the binding. At a certain stage, after it wore down, it would be ideal for marbling.' Today pens are usually sized by number rather than by their original bird titles. Signwriters complain that the sable hairs are not as long as they used to be, preventing long, grand strokes.

Paints have changed significantly, both for good and ill. Signwriters used always to mix their own, having control over colour and consistency. As Robinson relates, 'We used pigment for making our colours. If we were going to use maybe a pound of Van Dyke brown or orange-red, red, yellow or black, it was all in powder form. We'd put the ground powder into a tin and at night time pour the turps on it and that's what we called "mulling it". Then we got a palette knife the following morning and we'd grind it on a slate or glass bed until it became cream, like a paste. We made it up into a pulp and then we thinned it out as we needed it. All those pigments used to give us brilliant colours. We could give a job one coat with those where today you must give them two.' Though modern paints lack the deep hues they are faster drying and generally more durable. This allows signwriters to begin highlighting and shadowing on letters sooner; but now it takes two or even three coats. A fascia board, if properly painted, may be left unattended and remain legible for ten to fifteen years. Once cracking and deterioration set in, repainting is not possible and the old paint must be burned off. However, some shop owners call the signwriter back every three or four years for a new coat to keep it fresh. In this way, a board may be kept looking crisp until the paint layer becomes too thick and again must be burned away.

The rules, chalk lines, palettes and dippers (small vessels for the accommodation of thinning mediums and paints) have remained unchanged over the years, but use of a *mahlstick,* once a standard part of most signwriters' paraphernalia, has virtually disappeared. The mahlstick is a 3-3½ft wooden stick padded at one end and used as a rest to steady the wrist while writing a fascia. One could be improvised by taking a cane and attaching a cloth to its end, or a proper one could be bought jointed in three sections and equipped with a chamois tip. The soft tip of the rod is placed against the painted surface to prevent scratching. It can also function as a liner, or straight edge. For some unknown reason, Irish signwriters never relied on the mahlstick as much as did their Scottish and English counterparts. Both Freeney and Robinson feel that it often just gets in the way and impedes the natural flow of freehand lettering.

Master signwriter Kevin Freeney doing an indoor job for a Dublin department store. In more than fifty years at the craft he has written over 700 Dublin shops and pubs

Furthermore, with the introduction of fast-drying, hard paints it is no longer so necessary to protect the surface.

The Masters and the 'Backstreet' Signwriters

One lived by his reputation. A good job spread by word of mouth. . . or eye. I never had to advertise in my life. We'd consider it unethical.
Kevin Freeney, 1983

Probably more that any other Dublin craftsmen, signwriters comprised a small fraternity in which everyone knew each other personally. A man's status and reputation were well established. There existed a clear dichotomy between what Freeney terms the 'inner circle' of master signwriters (of whom there were not more than about ten) and a fringe group of perhaps fifteen others. The top craftsmen invariably got the best shops and pubs on the main thoroughfares. Second-raters were relegated to the backstreets. Any ordinary painter, of course, could call himself a 'signwriter' and slap up lettering. 'You must remember,' explains Gordon, 'at that time you had men who weren't educated at all and they'd become signwriters and they could barely read a rule. They couldn't set it out properly or snap lines properly. Then you had the fellas who tried to do it, like the Behan's – Brendan, Dominic, and his father.'

This schism was not the result of the most gifted signwriters attempting to exclude the rest and monopolise the craft. It was simply that the quality of signwriting by the inner circle was so highly renowned that proprietors and painting contractors would not accept inferior work. Reputations ruled the trade. As Mezzetti put it, 'If you weren't a good craftsman, if you were just the ordinary run-of-the-mill, we used to refer to them as "benners", an abbreviation for Bengal Lancers. . . it was a kind of slur.' It implied that they would stab at their work with the brush, that they lacked a soft touch and smooth stroke. Especially sloppy signwriters were known as 'muckybeggars'. Despite the mild derision, the elite did not resent their lesser-talented brethren because they recognised the need for lettering along backstreets which they eschewed.

Twice a year Dublin signwriters would congregate at the RDS Spring Show and Horse Show, where all the posters and signboards used to be done by hand. These rendezvous in Ballsbridge were both a financial boon and a social event for the craftsmen, many of whom would have to start working on the projects seven weeks in advance. Being independently employed during most of the year, they relished the camaraderie and exchange of ideas. One year at the meeting of the clan, Robinson attempted to form an association of signwriters so that they could collectively establish a standard rate for their work but, owing to their inherently independent spirit, several resisted and the idea failed. They no longer have the RDS events to look forward to since today everything is efficiently done with applied and mechanical lettering which has conspicuously diminished the charm of the setting.

Considering the relative obscurity and anonymity of signwriters down through the years, it is ironic that in Dublin probably the most noted – and notorious – were the Behans, who were really painters masquerading as signwriters on occasion. Freeney, Mezzetti and Gordon all worked with the Behans and knew them well. Underlying their disapproval of some of their personal and working habits is a genuine fondness for the family. Each has his own recollections. Gordon had Brendan, his brother Dominic, and their father Stephen all working under him at the same time. 'The father would do funny things. Now I wouldn't put him in the category of good signwriters. He was a fella who could do backstreet signwriting.' Once he watched Stephen do a lettering job on 10 x 10ft wooden gates at a scrap merchant's yard. The owner would not allow him to close both gates at the same time because he feared that it would cost him business, so he had him do one side at a time. In those days scrap dealers took in every imaginable item, from scrap and cast iron to rags, clippings, horse hairs and feathers. Behan decided that it would be sensible to list all the metal items on one gate and everything else on the other, with the result that when he had finished and the two gates closed together it read 'Cast Iron Rags and Clippings' and 'Corrugated Horse Hairs and Feathers'.

Indeed, the father would do funny things. Freeney was wise to his tricks. 'He was fond of the drink, you know, and he'd come up when you'd be writing a fascia board and he'd inevitably touch you for a loan of a few shillings but it wouldn't be a loan, you'd be giving it to him. So I'd always try to avoid him or if I saw him coming down the street I'd

get off the plank and go into the house.' He particularly remembers him given to exaggeration and fabricating tall tales. One evening, to Freeney's astonishment and dismay, Stephan Behan appeared on the Gay Byrne Show in a programme allegedly featuring 'The Last of the Signwriters'. Prince Rainier and Princess Grace of Monaco were about to visit Ireland and he boasted that he had gilded their bed in Dublin Castle with gold. 'Now Stephen, he wouldn't know how to apply the gold – he was an atrocious fibber. I'll say that he impressed enough people around the country, all right, but he didn't impress us who knew.'

Freeney had occasion to work closely with Brendan. 'He was always a renegade. He'd come in in the morning and he'd throw on his overalls and read the paper first on the boss's time and he wouldn't start work until about ten, whereas we were in from half eight. . . a very obstinate man, contrary to work with. For instance, when we were serving our time in the painting we had to do what was known as "whiting" the ceiling by applying paint to it. Well, you always worked as a team and I remember working with Brendan on the same plank which was about 14ft long and you'd put the bucket of paint in the middle of the plank and you done your half and your partner done his half. But when I was working with Brendan I done two-thirds of it. Oh, he was a desperate character, that man. You'd be doing most of his work as well as your own. Oh, he'd never stop talking. At that time, of course, he wasn't famous. He used to read Chaucer, Shakespeare and Dickens. . . all good stuff like that.'

Mezzetti also recalls him vividly as 'a colourful character. He'd often arrive on a job and he'd have no brushes and he'd ask you for a lend of some, so we'd lend him a few. Sometimes Brendan was a bloody nuisance in the sense that you'd be writing a fascia board at a pub and be concentrating and you'd feel a pair of hands gripping you by the ankles and he'd say, "C'mon down now and have a drink" and I'd say, "O.K. Brendan, wait until I've finished these few letters".' Brendan hardly honoured the good name of Irish signwriters when he later went to Paris and wrote a fascia for a Paris restaurateur which read 'There is but one Au Fait Café in Paris and this is fucking well it'.

Monograms to Monoliths

Pub and shop owners used to take far more pride in their fronts and decoration.

Willie Robinson, 1984

Signwriters enjoy variety. One day they could be putting a half-inch monogram on the door of a Rolls Royce and the next be down at the docks drawing 12ft-high letters on a monolithic petrol tank. In the early years Mezzetti seldom turned down a job. 'As a writer you'd have to take on any type of writing. You could be writing a name over a shop or you could be writing numbers in a jail over the cell doors, you could be writing a solicitor's office on glass or you could be doing writing in a factory or in a department store, or in an administration building.' There was also lettering to be done on carriages, vans, lorries and aero-

planes, on the vats at Guinness' Brewery, on whiskey barrels at pubs and theatres, and on plaques at golf clubs, hospitals and government buildings. Years ago, exclusive stores such as Brown Thomas and Switzer's used to call in a signwriter to put names or monograms on expensive cabin trunks, luggage, attaché cases, handbags and golf bags. Signwriters also used to do a lot more of the ornate old English script and Roman lettering on churchboards. All this provided great variety of physical settings and social environments, which they found stimulating. Freeney, who has done everything from the minute quarter-inch lettering on the bye-laws board in St Stephen's Green to the huge showboard on the Ambassador Cinema in O'Connell Street, is so highly reputed that he is called away from Dublin for special jobs. He goes as far as Rosses Point Country Club in Co. Sligo just to put one or two names on their club board each year. 'I arrive in Sligo around one. I'm met in a car and they bring me out and I do the two names. They give me my dinner and I get back on the train at three. They pay me very well.'

Good signwriters have usually earned about twice as much as an ordinary painter. Robinson and his ilk could make considerably more. 'The biggest jump in wages came after the war,' he says, 'when pay for tradesmen went up to three pounds eighteen and ninepence, and signwriters were earning somewhere around six or seven pounds and some of us would earn ten pounds a week and that was an awful lot of money – and then the tax man was after you.' The jobs signwriters find easiest are those that they can take home with them, such as small notice boards, signboards or plaques. Probably the least desirable is ascending a church spire to do lettering or numbering on the clock face.

Whether a signwriter is doing a job at a swanky department store, a neighbourhood pub or the docks, he is generally well dressed. Freeney, Mezzetti, Robinson and Gordon are all meticulously groomed and dapper, reflecting the neatness of their craft. Judging by their daily working attire they could be going to Mass or to an office. Never would they don general working clothes or overalls. They are characteristically in a coat and tie and cap to keep the glint of the sun from their eyes (and perhaps to stick one of their pens in for a jaunty effect). In fact, some are so fastidious about cleanliness that they refuse to use the ordinary paint-stained ladders of general painters and require that contractors keep special ladders exclusively for their use.

Signwriting is normally a solitary occupation. Following apprenticeship with a master or father, most men prefer to work alone. Some, like Freeney, have worked with a brother or relative. There is a code of ethics and sense of territory among signwriters in which one does not infringe on the other's 'turf'. Freeney calls it 'an unwritten thing. If a client rings me up and I know that another signwriter is doing his work I'll ask him why he's not doing it. We don't encroach on other people's territory.' Robinson attributes this tacit policy to a sense of fairness among the craftsmen and the mutual loyalty which exists between signwriter and employer. 'My principle in life was that if there was (another) signwriter who always did your (owner's) work and you came to me, I wouldn't entertain you. So if you were a decorating contractor and you employed Con O'Sullivan, now if you came to me to do something, irrespective of Con ringing me up and saying that he was ill or too

busy, I wouldn't do it. I would never step into the firm that he was working for. You see, my way of thinking was that I wouldn't expect anybody else to come to do my work for my customers. I wouldn't go in anywhere where another signwriter was doing the work. We looked after our own people.' A gentleman's craft, indeed.

Originality of Technique and Style

No two signwriters use the same technique or have the same style.
Paddy Gordon, 1983

Though signwriters perform myriad lettering jobs, their forte has always been writing fascias on pubs, fashionable stores and what Mezzetti terms 'huckster' shops, meaning those which sell 'everything from a needle to an anchor'. Each possessed peculiarities and eccentricities of technique which made his work unique and readily distinguishable from all others. Any of the four can walk down a street and identify the work of their peers. They have in common a placid temperament, concentration and dedication to detail; but they differ in method and style. 'No two signwriters work in exactly the same way,' explains Robinson, 'some sketch out their letters while others just make a tick on the board with a rule. I never sketched out anything. I just wrote straight away.' This flourishing freehand style has been the mark of all great signwriters but was never mastered by second-raters, who would have to draw every letter rigidly on the board before reaching for pen and paint. Freeney considers it as much instinct as skill. 'I just make a few marks and I know where each letter is going. I wouldn't know where to start to teach it to anyone. You just acquire it and that's it. But I see the younger signwriters sketching it out with pencil and rule and compass but I always find that if you see anybody doing that the lettering looks very stiff. There's no freeness to it.'

Master signwriters never stop learning – or experimenting. Robinson, always seeking technical correctness, cuts out letters and places them on a mirror to study reflections and dimensions. He also casts different lighting on wooden letters to discern natural shadows. This is important; as he explains, 'There are two colours in a shadow – a lot of people don't know that – a lighter and a darker. The darker is nearer the letter and the lighter's on the outside as if it's faded.' Gordon, on the other hand, prefers to use visual symbolism to bring life to letters and shapes. 'If you take the letter "O" and put a thickness and a shadow on it, immediately you have the basis for a bull ring with sunshine on it. Just think of it that way. Forget about it being a letter.' The style of lettering is not so important as balancing and spacing. Robinson believes the first to be paramount. 'The balance of letters is the most important thing. All round letters have to be a certain shape and when you've got "D's" and "P's" and "e's" you've got to have that little balance at the centre leg which is always a little above the centre line. There's too many people who do not consider this and they just write it and measure it bang on in the middle and it doesn't look the same as if it's a quarter of an inch up. It looks completely different. You see, balance of letters such as height and width, unless you get it in proportion, it doesn't look right.'

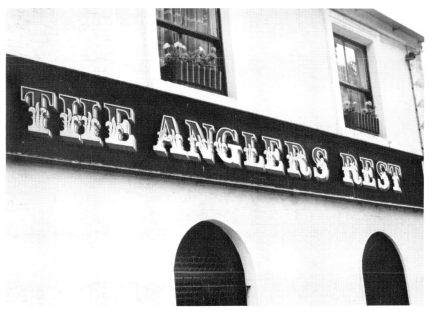

Samples of Kevin Freeney's three-dimensional signwriting techniques. For more than half a century he has been recognised for this specialised art of visual relief on fascia boards. His OMAN sign in Merchant's Arch is regarded as a peerless masterpiece

Certain letters are particularly troublesome and have to be balanced and spaced specifically in terms of those that precede and follow them. Gordon explains, 'An "S" is always the one that is difficult, and "O". All curved letters. It has to be geometrically correct. An "S" has to have the right balance. There is a difference between the top of an "S" and the bottom. The bottom would be a bit heavier. Now, today with plastic signs the "S" is often turned upside down. And spacing, I always thought that was very important. It's not like you can put the same distance between each letter because it would look wrong, especially if you had an "A" coming against an "L" on one side and a curved letter on the

other.' The fine nuances of the craft allow a signwriter to stand back from a blank fascia and visualise precisely how the lettering will fit. Mezzetti meticulously arranges everything in his mind before setting foot on a ladder. 'It's an optical job. You become very slick at writing. You see, a long hair sable brush can almost carry its own weight in colour. So when you put it on a line and bring it down you're actually controlling the flow of paint. You're in control of the medium. . . the medium is not in control of you.'

Creation of visual relief through highlighting and shadowing is the highest achievement of the signwriter's art. This has become Freeney's speciality, his trademark. His OMAN sign in Merchant's Arch is a masterpiece of three-dimensional lettering. There is no finer work in all Dublin. Some years ago there was a pub at the corner of St Stephen's Green and King Street that had a fascia done in carved wooden letters which were brought to a 'V' shape, giving great dimension. The fascia on one side of the pub was destroyed by fire and no-one could be found to carve a replacement, so Freeney was asked to try and duplicate it in paint. He took photographs of the surviving fascia, studied the highlights and shadows and did some experimentation. When finished, his signwriting replica so perfectly matched the original that passers-by did not notice that there was any difference between the raised wooden panel and the other one. Perhaps the ultimate compliment came when he sent a signwriter friend in the United States some photos of one of his lettering jobs and he replied with the query, 'Is that relief or is it in paint?'

Freeney confesses to one idiosyncratic habit (shared by few others) which always befuddles observers. 'A bad habit I have is I start at the back rather than the front when I'm signwriting. I noticed that in the past ten or twelve years I tend to do it and don't ask why because I can't give you an explanation. I've started in the centre as well but I got out of that habit. My wife is always getting on to me and she says, "You do that to mislead people." I don't.' A habit traditionally shared by signwriters is that they rarely sign their urban artworks. Like advertising, the great signwriters would consider it unethical and egotistical. Freeney and Robinson have never put their names on a single work. A few exceptions exist; Mezzetti inscribed his name in small gold lettering just below his masterful gold gilding job on Bourke's pub and it can be clearly seen today, while Gordon has sometimes used ('as my mark') three tiny inverted balls, like a reverse pyramid.

Speed seems incompatible with patience and perfection in signwriting, yet a few craftsmen like Robinson have achieved a remarkably swift pace without sacrificing accuracy or quality. He confides, 'Now I'm going to say something that might seem a bit high-hatted but there was nobody who could touch me for speed, even my father and he was known as the fastest signwriter in Dublin. I reckoned that 90-120 letters in an hour was my pace. It wouldn't matter what size they were. I would do over a hundred letters an hour.' Often he did corner shops and pubs with fascia boards on two sides totalling 60ft or more and finished all the lettering, highlighting, shadowing and ornamented trim in one day.

Apart from writing skills, a signwriter must possess agility and dexterity on ladders which range from a few feet above the ground to perhaps

40ft. Freeney feels like something of an acrobat when perched precariously on a teetering ladder on a blustery day. 'What we do is put our leg through the rung and with the inside of our leg hold onto the ladder and then you have both hands free. It's usually held on top (over the parapet on the roof) by a 56lb weight tied with a wire rope. On a very wild day now it could shift. It didn't always hold the ladder in position. You'd get the fright of your life when the ladder would move.' Suprisingly few have suffered serious accidents.

Perfection and Public Curiosity

Woe betide him if, when the job is done, he is found to have made the slightest error. Ridicule is then his portion.[22]

No other craftsmen exhibit such obsession with perfection as signwriters – and for good reason. Their work is blatantly displayed for all the world to admire. Or criticise. The sight of a signwriter doing traditional lettering often draws the rapt attention of the public, especially today when the craft is less in evidence. It is flattering to receive acclaim in so intimate a forum; most artists must complete their work before reviews are rendered. One admirer, marvelling at the smooth and natual flow of the signwriter's hand and brush, was moved to exclaim that it appeared as if the 'letters were coming out of his sleeve'. However, not all attention is welcome. Passers-by can be an annoyance and serious distraction. Some take mischievous delight in pretending that they notice a spelling error. It is just one of the trials and traumas signwriters have to cope with in practising their craft openly on the street. Most customarily take such comments in good humour, reacting as if it were an orginal remark, pleasing the perpetrator with his wittiness.

Especially distracting to Robinson is when a cluster of faces only a foot or two away peer at him through the glass when he is doing gold gilding. 'It's fascinating for people to stand and watch me blow the gold and cut it and pick it up with the tip and put it on the glass. . . (but) they sometimes get in your light.' One time when lettering a pub fascia along Abbey Street he drew such a crowd that it impeded the flow of pedestrian and vehicular traffic and police had to be called to disperse them. Though signwriters welcome the approval of the public, they more highly value the respect of their peers. It is customary that they criticise each other's work in a constructive and friendly manner.

Knowing that their work is open to public and peer scrutiny, they dread committing some horrific blunder. In actuality, this rarely happens. Occasional misspellings are inevitable but more common is the simple omission of a letter. When working there is a tendency to mentally project ahead to the next letter, sometimes leading to the belief that it has already been done. Once Freeney was doing a job on Dawson Street which called for the word 'Needlecraft', when a group of young persons on a passing bus shouted for all the world to hear, 'You don't know how to spell.' Indeed, he had written 'Nedlecraft'. 'It's a psychological thing, that you will leave out a letter, not conscious to yourself.' Such errors are timidly eradicated with a mixture of oil and white spirit.

Writing pub fascias is especially conducive to unsolicited public commentary and criticism. Patrons feel free to grace the captive signwriter with their artistic utterances. Some are more lucid than others. Luckily, the publican himself usually leaves the judgement up to the craftsman as to what looks best on his establishment. 'Funny thing about it,' says Freeney, 'when a nice decorating job is done on it, the man would just come out and have a look and if his name up there looked good, that was the job. They love to see their name up there and the more ornate it is the better.' One benefit of doing a pub job is the tradition that the publican provide liquid nourishment. Signwriters as a group seem to be more moderate drinkers than other craftsmen though Gordon recalls seeing a few colleagues who were a bit 'merry on the ladder'. Since a signwriter's livelihood depends on a sharp eye and steady hand he can ill afford to have his capacities impaired by drink. However, Robinson has known some who 'were fond of their beer. Their hand could be quite shaky but the minute the pen would go on the board it would be like a rock. Once they put the brush on it, dead steady.' Surely they were the exceptions.

Weather conditions are of greater concern than human distractions. For outside work they are at the mercy of the elements. Rain and cold are the major impediments. A damp fascia board won't hold paint, and cold and frost hamper a signwriter's movements and can drive him inside. During the thirties and forties when one had no choice but to accept whatever job came along, Freeney regularly worked under adverse conditions. 'It was very, very difficult in winter when your hands would get cold. Some days you just couldn't work. You'd have to pack up and try to get an inside job. I remember working on a fascia board one time down on the quays by the side of the Liffey. There was as much snow in the pot as paint. But times were hard and you didn't get much money for it. You just had to keep working whether you liked it or not.' Sympathetic owners might bring out a cup of tea to warm hands and innards, but this was temporary relief. On especially cold days mittens or gloves with fingers cut out, allowing for sensitivity of touch, could be worn. Robinson had his own strategies. 'There were times when I used to have to use a blowlamp for to run the frost off the plank. Ladders and planks were kept outside in a yard and the snow would come overnight and it would freeze. For your hands we always had the habit of slapping our hands upon our shoulders. It used to bring life back into them. Years ago we used to use pocket warmers, small things you'd put charcoal into.' Sometimes Freeney found himself working well into the night under the illumination of a street lamp to finish a job. Under such artificial lighting colours take on a different hue and paints cannot be accurately blended, so night work was second-coating work.

Even under good weather conditions there are fine points which a real craftsman would always take into consideration. For example, he would gauge the angle of the sun and the heat of the fascia board. It is best not to apply paint in the direct sun or on a hot surface because it can cause bubbling or begin to dry too quickly, becoming pasty and impeding the smooth flow of the brush strokes. It is better to work on a cool board in the shade. Good signwriters would always schedule and rotate their

work around these environmental factors. September is regarded as the ideal month because the paint has all winter to dry and harden before the strong sun sets upon it.

The Decline of Traditional Signwriting

Buildings have preservation orders on them, and even trees do. . . but no preservation orders safeguard lettering.[23]

The old fascia boards have been discarded now and they've been replaced by plastic signs. Dublin has completely changed. The pubs have changed. There are very few pubs done now in the traditional way.

Willie Robinson, 1984

Dublin's venerable shopfronts and pub fascias are in rapid decline. In the post-war period, plastic, aluminium and formica signs assaulted the city. During the fifties and sixties Dublin was swept up in the quest to become 'modern' and 'progressive'. This meant obliterating Georgian houses and replacing old-fashioned, family-owned shops and pubs with supermarkets and lounge pubs fit for cosmopolitan crowds. In the minds of many progressive Dubliners there was a stigma of backwardness attached to handwritten fascias – they didn't glitter and shine. Even if the little shops survived, their old fascias were often stripped with impunity to be replaced with garish plastic panels. The result is a honky-tonk mix of gaudy, dehumanised façades, and the sensitive passer-by can hardly avoid being visually brutalised by such sights. As Bartram asks, 'Who, apart from the manufacturer, gets pleasure or benefit from the ubiquitous, characterless, plastic signs of today?'[24] Handwritten signs evoke life, humanity, spontaneity; brittle plastic is dead and sterile. Apart from the desire to appear modern, shop owners found the economics of plastics appealing. A modest-sized handwritten fascia board can cost well over a hundred pounds and after only a few years will show wear. This makes a durable, maintenance-free plastic sign seem a good investment. Proprietors also felt that since bright plastic and neon signs can be seen from a greater distance, they constitute good advertising.

Signwriters are understandably saddened by the crass commercialisation of the city they know so well. Not only has it meant less demand for their craft, but they have had to passively witness the destruction of many of their masterpieces. As an economy measure, shop owners simply cover an old fascia with plastic. As a consequence, beneath innumerable plastic panels are hidden art treasures. Freeney has seen some of his forgotten work unexpectedly exposed. 'I've often seen an old building being demolished and they take down the plastic sign and lo and behold there's a lovely job beneath it.' Regrettably, the Dublin Corporation and developers have scant respect for these art relics; they are crushed and carted away. Robinson detests the changes he has seen. 'The decoration on shopfronts years ago was just fabulous, all the gold and colour work. In the fifties and sixties plastics started coming in and Dublin is not now the same city at all. Shopowners used to pride themselves on the way they got their shop decorated. Its an awful pity that most of the old fascia boards have now gone.'

It is heartening to note that over the past ten years there has been something of a mild counter-revolution, or backlash, against the slick, sleek superficiality of plastic, neon and aluminium. A scattering of aesthetically-minded pub and shop owners have returned to the traditional handwritten fascias but soon there will be no great signwriter to do such work. The so-called signwriters of today who are listed in the Golden Pages directory are hardly capable. Clearly, they lack the classical education, familiarity with script types and dedication of the old genre. Mac-Mahon regards some of their work as 'meretricious aberrations' on the urbanscape, 'unworthy' of the old masters.[25] They confine their efforts mostly to vans and lorries. 'The present-day signwriter,' says Robinson, 'hasn't been properly educated in the blocking and shading of letters so he doesn't have the same skills. We term them just a "van signwriter".' Freeney tells of seeing one shopfront done by a young signwriter which had shading on both sides of some letters, noting sardonically, 'Which couldn't possibly be, of course.' Gordon simply declares, 'The decorative signwriting with all the flourishes is a dying craft.' To avert the death of the craft and pass his experience on to a new generation, Con O'Sullivan a few years ago advertised in a magazine for apprentices. He was disapointed and disillusioned when 'it fell flat'.

Freeney expresses a wish that signwriters be remembered as great craftsmen who 'added to the beauty and character of the city', but he wonders whether they will be remembered at all. Gordon feels that 'signwriters are a part of the history of the city. . . they have left their mark.' When their mark is no longer visible, how are they to be remembered? Their creations, more than those of any other craftsmen, are ephemeral. Fascia boards have a very limited life. Their days are numbered from the moment the paint dries. They are not like a barrel, a saddle, or a pair of shoes which can easily be preserved. Signwriters are acutely aware of this reality. For this reason, Freeney has kept a photographic collection of his work. Pictorial documentation will not suffice, however; there can be no substitute for the preservation of selected fascia boards. *An Taisce* might be funded to assume such a responsibility. Signwriters are entitled to their immortality just as are other artists and craftsmen. Entering his eighty-first year, Robinson quietly confides, 'We in my generation had a love and pride in what we did. The signwriter has never got the recognition or attention he deserved. The old traditional style will die out now. . . but I'll work until my hands become decrepit.'

3
Shoemakers

We're definitely the last. . . the end of the clan. We'll disappear. Shoe-makers will disappear completely. I see myself as a part of history, no doubt about it.

Tommy Malone, 1983

Soon this little shop will be closed and I'll be up in heaven with my little hammer making shoes for the angels.

Harry Barnwell, 1983

Profile of an Old Shoemaker

Everyone in the Liberties knows 'Old Harry' Barnwell. He is something of a local oracle – and a master among craftsmen. Teachers bring young students to his workshop to hear him tell about local history and weave tales of times past. Born in 1905, he is the eldest of Dublin's four surviving shoemakers. He can still be observed through the clouded window of his shop on Castle Street, wedged in a dark space between Christ Church Cathedral and Dublin Castle, stooped purposefully over the workbench. Attired in a long, thoroughly soiled apron, he works in dim light amid walls begrimed, sooty and sometimes stripped to bare plaster. Unidentifiable tools, leather scraps and shoe parts are strewn about the floor and shelves. Over the rear door, laced with cobwebs, hangs a good-luck horse-shoe. On the dark wooden floor are the names of 'Fiona' and other grandchildren printed out with implanted nails. It is a very personal place.

Tourists who inadvertently wander off the beaten path sometimes discover it with wonder. They are immediately struck by the front window, a veritable museum of shoemaking filled with wooden lasts, Victorian shoes, bottles of dye, Kiwi posters and other curios long out of manufacture. The display was not intentionally preserved; it simply has not been meddled with for decades. Once an American barged in and bluntly offered him one hundred pounds for a 1903 print of a shoemaker. Without hesitation, he politely declined. History is not for sale. In the corner of the window is a poem written more than half a century ago by one of the shoemakers in the shop. He had copies made during the Depression years and gave them to customers as a Christmas present. This last parchment-like copy reads:

A Reminder. . .
That the soles of the People we keep in view,
For we are the Doctors of the Boot and Shoes,
We sole the living, but not the Dead,
With the best of leather, wax, and thread.
We can sew on a sole, or nail it fast,

Do a good job and make it last.
There is nothing wrong about what we do,
Doubt not the statement, our work proves it true.
We can give you a 'lift' in this changeable life
And not only you, but your children and wife.
A good many patients have come to our door,
Worn out, run down and feeling 'foot sore'
Though we use neither poultice, Plaster or Pill
We cure all sick soles, no matter how ill.

His entry into the craft was more an act of earthly than divine providence. In those poverty-ridden days, the streets of the Liberties were
children's playgrounds. As a youngster he was mischievous, unruly, a
concern to his parents. 'I was very wild. I would run around and do
things that I probably shouldn't have done, kicking the football on the
street, skirting around horses and cars, getting on the back of them for
a ride. My mother was afraid that because I was so wild I'd be killed.'
One of his favourite pastimes was running up behind and catching hold
of horse-drawn carts and cabs as they clattered over the cobblestones. It
was great sport, the daring bravado of youth. One day young Harry and
a mate scrambled onto the back of a cart and, as was the custom, the
driver lashed behind with his whip to dislodge or discourage the lads.
However, on this occasion his friend's leg caught in the rear wheel spokes
and was severed. He received a fierce and memorable beating on the
backside for his part in the tragedy. It was at that moment that his mother,
in desperation, beseeched his father, 'For God's sake, take him into the
shop before we lose him.' Thus, at the age of fourteen, with not-so-subtle
coaxing, he began his apprenticeship.

One wintry morning in 1919, he peered out of the shop window to
see a barefooted five-year-old girl hobbling up the street. 'Who is that?'
he asked his father. 'Ah, that's young Mary, she has a club foot.' He was
deeply touched by the sight – 'It worried me.' He decided then and there
that he would like to learn to make special shoes for the underprivileged
and deformed. At fourteen he carved his first wooden last and within a
few years had developed a talent recognised by the other four men in the
shop. 'In orthopedic work I was making only half that of the other fellas
making just ordinary shoes but I had the love for it. There's more to a
job than money, you know. . . you must have love. By the time I was
nineteen you couldn't teach me any more about it. Nobody could come
along in this city or in England and show me any more about making a
shoe than what I had already learned, a lot of it through my own knowledge.'

When his father died in 1922 he suddenly became a man – and life a
struggle. He inherited the shop and assumed the role of principal provider
for his mother and five younger brothers and sisters. Apprenticeship was
completed under the foreman who, seeing the opportunity to flaunt his
authority and take advantage of a youth, 'really couldn't have been nastier'. Shortly thereafter, the foreman seized a chance to establish his own
shop nearby and go into competition. Harry feared that he might lose
customers and be forced out of business. 'I remember my mother's words
that morning that he opened his shop. She said, "Don't worry, son, God

*Eighty-one-year-old
Harry Barnwell, the
doyen of Dublin
shoemakers, still works
daily in his crumbling,
decrepit shop in the
Liberties. He is a living
repository of local
history and folklore*

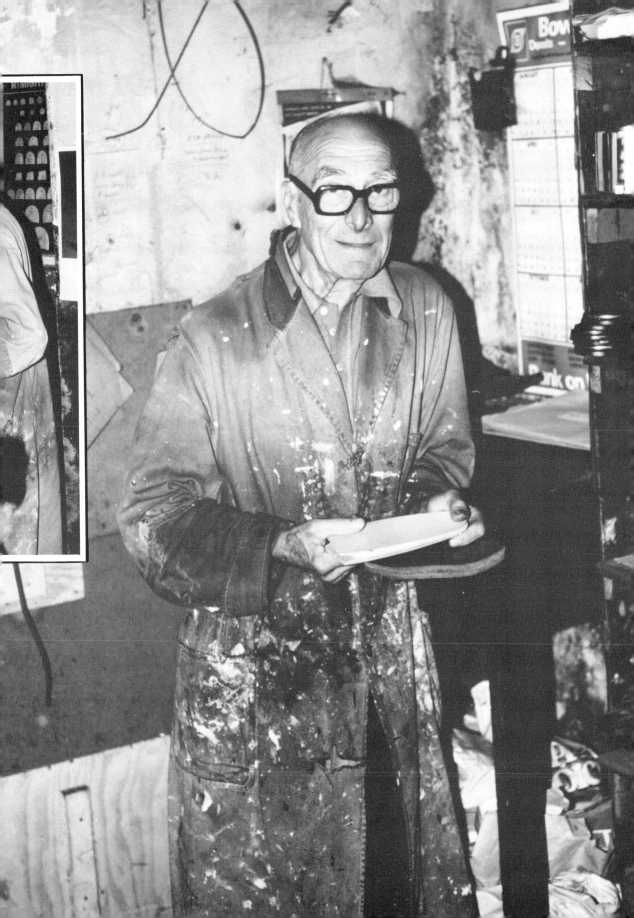

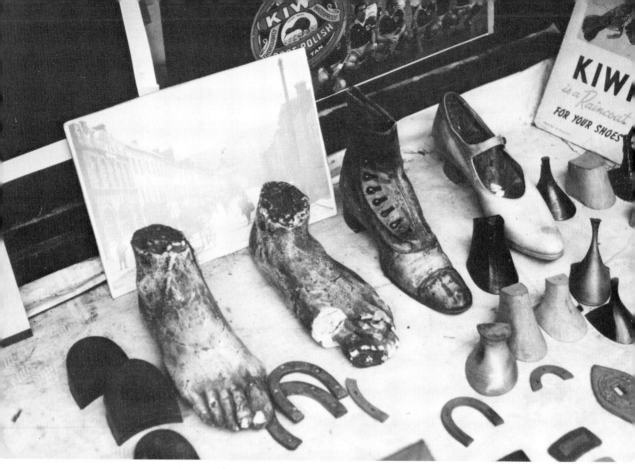

Window display at Barnwell's shoemaking shop

will look after you. God will help you." I put my shoulder to the wheel and never looked back. I stuck to it. I worked until twelve at night and one in the morning to do the stuff that had to be done. Anyway, he lasted up there for a few years but it never paid him. He didn't get the trade he thought he'd get. A funny thing, before that guy died he was a bit kicked around and I used to give him weekend work just to give him a few shillings and when he died we were the best of friends.'

He survived the Depression, the war years and the stagnant fifties but, as the other men passed away, eventually found himself alone and lonely – still in the same shop but amidst a changing city he little understood. In isolation, the shop became his sanctuary. 'I used to work here until one in the morning finishing off a pair of shoes for "Lady this" or "Lord that" for Switzer's and all I'd have was this big clock with two big drums inside. It was made down on Dame Street in 1765. And when the traffic would stop in the night time that's the only thing you would have. . . tick, tick, tick. That's the only company you would have working, stitching, and that clock used to talk to me, would you believe that? That was my company. . . that was my girlfriend when I was back here in the night. That's the only little friend I had there in the world.' In August 1984 he still stood hunched over the same splintery workbench – but now the clock was gone.

Three other Dublin shoemakers have clung to their craft and share a similar sense of estrangement from the outside world. Along Grattan Street, a forgotten row menaced by modern office buildings sprouting

up all around, is a tiny shop with the simple fascia 'John Ryan – Shoemaker'. In his fifties, he is the youngest of the three. Off Dame Street, cramped in a cubbyhole just adjacent to the side entrance of the Olympia Theatre in what is known as Crampton Court, works sixty-year-old Tommy Malone. The shop, in which he has laboured for forty years and which served as a shoemaker's hut for about two centuries, is identified only by a boot painted on the front. Some distance away in Stillorgan village, around the corner and down the hill from a modern shopping mall, is an inconspicuous cubicle that no-one would notice as anything special. It is the shoemaking shop of Paddy Licken, born in 1903, and his son, Sean, aged fifty-two. Only in 1984 did Paddy have to give up the craft full-time due to disability. As the last of Dublin's shoemakers, the four share a common heritage – and face a similar fate.

Shoemaker Harry Barnwell's shop in the Liberties

An Historical Glimpse

Their heritage is deeply rooted. Gilbert records in *A History of the City of Dublin* that at the close of the twelfth century, St Werburgh's Lane was well known as 'the shoemaker's street'.[1] Indeed, recent archaeological excavations in the vicinity of Christ Church Cathedral have revealed considerable physical evidence of the craft. Boot and shoemaking thrived in medieval Dublin, and shoemakers formed their own guild in 1427. The local cobbler was an indispensable figure in the community, catering for all footwear needs from sandals to heavy boots. There used to be a flourishing domestic tanning industry, and most of the leather for boots and shoes was produced in the country.[2] Around 1800 'every boot and shoe worn in Ireland was made on Irish lasts'.[3] City dwellers in the capital wore a lighter and more refined shoe than country folk; urban shoemakers had a finer touch. This was a time when shoes and boots were a

valuable possession. They were well cared for and made to last and look good as long as possible. When Dublin streets were still muddy and messy the fraternity of shoeblacks plied a lucrative trade using a concoction of lamp black and rotten eggs to polish and shine them. In the country people had to be 'generally content with an occasional smear of goose grease'.[4]

In the latter part of the century shoemaking changed. By the 1800s no more than one out of every eight pairs of shoes and boots was Irish made.[5] This was largely due to the immense factories built in England during the 1870s which used machinery and mass-production methods. The Irish market offered imported footwear far cheaper that that produced by local craftsmen. By 1890, factory-produced boots cost about eight shillings as compared with fourteen for a handmade pair. As a consequence, shoemakers faded away or converted to repair work. Nonetheless, there were people, in Dublin particularly, of wealth and discrimination who would not consider wearing a ready-made shoe. They still demanded the luxury and status of made-to-measure ones. This meant that some of the top-calibre shoemakers of high reputation retained a reliable clientele. They carried into the 1900s a craft which has changed precious little over the centiries. In shoemaking, the tools and techniques have tarried longer than in almost any other craft. The dwindled few of the 1980s find themselves using the same implements and performing the same tasks as their ancestors. Only fashion and costs have changed.

At the Cobbler's Craft

Shoemaking has never been a closed craft. Many sons did follow in their father's steps but other boys could also become apprentices if they found a master willing to indenture them. This was a common practice around the Liberties, where shoemakers abounded. St Werburgh's Church played a major role in the perpetuation of the craft in this part of the city. 'There were quite a few shoemakers around the Liberties,' observes Barnwell, 'there's a church around the corner, St Werburgh's. Now seventy per cent of the boys in that parish in my time were shoemakers. See, there were firms in Dublin where the men that ran them were parishioners and when they died they left money in the fund for the boys who wanted to go into a trade. Now it happened to be that at St Werburgh's there was one master shoemaker, my father, and about twelve other shoemakers. If one of these shoemakers would say that he'd take your son as an apprentice he could get, I think, thirty or fifty pounds. That was a lot of money in those days. If you took on a boy you had to indenture him. That would be done in the court and you couldn't break those indentures for seven years. You had to keep him there. Most of the shoemakers around the Liberties were Protestant. Now my father was fussy. If he took on an apprentice it would be some family he knew and he'd take the boy for the sake of helping the family. He wanted a clean, bright boy who wouldn't be watching the clock.'

Apprenticeship followed no set plan. It began with chores like sweeping the floor, making the tea, returning repaired shoes to customers and running other errands. Eventually, the apprentice would be given the task

Shoemaker Tommy Malone at work, always wearing the leather vest for protection against the extremely sharp knives used in the craft

of stripping soles and heels from shoes to be repaired. In this way he learned about the construction of footwear. Next would be some simple repair work, just to give him the feel for the tools. All the while he was expected to observe how men measured customers' feet, drew patterns, carved lasts, cut leather, shaped heels and soles and did nailing and stitching. Gradually, his master instructed him in each process. Respect for the tools and safety in cutting leather were particularly drilled into each young apprentice. Many different types of leather were used; for the 'upper' it was soft and supple but for the sole hard and dense. Since leather can have unexpected spots of toughness or softness, the sharp

knife blade could slice through erratically. As Barnwell himself was taught at an early stage, this could be dangerous because of the manner in which shoemakers cut leather by pulling the knife toward themselves. An apprentice had to take special precautions. 'When you were starting your time you got what was known as the (leather) breast plate. Now you're using sharp knives. . . the knife must be lance sharp. You were always cutting through leather and you were taught a certain way to work your arm and you'd be in trouble if you didn't do it properly. Some of the men were called "hard cutters" and they would pull hard and if it slipped they could be cut badly. Or if you come onto a piece of lead in the leather [a lead or buckshot pellet from the animal's hide] it could cause the knife to slip quickly and out of control. Now I had an apprentice who wouldn't do what I'd tell him and he got a cut across his chest and had to have eighteen stitches.' Following apprenticeship it was up to the individual to decide whether he wanted to wear a leather shield; some did, others did not. Licken once saw a man slice himself savagely across the chest and heard of another who, by holding the knife too high and close, actually slit his throat and died. Minor wounds are common but 'even when you get a cut you never get an infection in leather. Leather work is very clean. . . ah, deadly clean. I've never got an infection out of a cut.'

Once an apprentice gained sufficient skills his work would be set out for him each morning and he was expected to make his full contribution. Days were long and the work tiring. As Barnwell reflects, 'When you came here on Monday morning you had to have a white apron because you had to be clean starting off. You'd see the boys coming along and you'd know that they were a shoemaker or a carpenter if you'd see the white apron. And winter or summer the sleeves would be rolled up. My hours were from eight in the morning to six in the evening. I'd come in and sit down on the stool and there might be a pair for me to stitch right away. There'd be maybe nineteen pairs to be stitched in a day and if I hadn't got me quota I'd have to do them before I'd go. So I'd sit there stitching until nine. You'd be sitting there for five straight hours unless you had to go to the toilet. Then you'd throw off your hand leather, go home, have lunch and wash your hands. You'd come back then and go on until six. There was little time for conversation. Everyone smoked back then, you could get a pack of five Woodbines for a penny but smoking in the shop would affect your stitching. When my apprenticeship started I was paid a half crown – two and sixpence – and on your second year then you got five shillings and then you went up the ladder. Times were hard, make no mistake about it. If you gave your mother your five shillings, well, she'd throw you back a shilling and you'd have to do the best you could with that.' Shoemaking was taught as a craft of perfection and the apprentice was under the constant scrutiny of his master and the foreman and boss. They would regularly come around, take the shoe from his hands and run their fingers steadily across every contour to make certain that the leather was taut, stitches tight and nails hammered flush. 'If he felt the slightest little thing atop that shoe, you were fined a shilling.' However, if the work was good an extra shilling might be handed out as a reward.

Shoemaking is physically very strenuous. Considerable strength is required to cut the leather, bore holes through dense soles, punch the stitches through and pull the waxed threads tight. With heavy work boots the sole leather could be a quarter or half-inch thick and between fifteen and twenty pairs might have to be stitched in a single day. Barnwell found it 'physically hard work. At the end of the day your hands would be sore because you were boring all day through some pretty tough leather. That's how young shoemakers became very powerful with their hands and arms and shoulders, by boring and pulling down the threads. And a lot of shoemakers used to be good boxers.' He was himself a fine, scrappy pugilist in his day. Thursdays and Fridays were particularly gruelling as the shop remained open until eight or nine. This was because people would not know until the end of the week how much money they had left for such things as shoe repairs. Then there would appear a flurry of customers needing quick work. Most shoemakers worked on Saturdays but took a half day or full day off on Monday.

Shop conditions were austere and have changed little over the past half century. From the 1920s to the 1940s each shop usually held two to four shoemakers, but a few were larger. The most prominent families in the craft at that time were those of Michael Edge and Thomas Barry, whose shops employed between a dozen and twenty men at any given time. There was also Watkin's of Dame Street which kept eight or ten men on the premises but employed mostly 'outworkers'. All are now gone but Barry's of Capel Street, a fifth generation business, lasted into the sixties. The typical shop was small, congested and poorly illuminated. There was not enough space for shoemakers to have their own workbench so each sat on a wooden stool about 3ft in length. The shoemaker sat at one end and placed his tools at the other, though some preferred to keep them on the floor beside them for extra space and better manoeuverability. Malone, who once worked at Watkin's in the forties with nine other men huddled tightly on stools making leather leggings for the British army, still prefers his stool to the workbench – as does Ryan. No two men worked in exactly the same way; each developed his own peculiar techniques. Barnwell perfected the system of stuffing his mouth with from fifty to one hundred nails while hammering. He would turn them with his tongue, point facing out, extract them with precision and rapidity and drive them cleanly; over the years he swallowed only two.

Lighting was archaic, especially for a craft in which one must focus the eyes precisely on fine points while stitching hour after hour. 'We had candle power,' says Barnwell, 'there was no electric so you had a candle on your stool.' For what seemed interminable hours he would sit on the hard stool doing 'knee work' and straining his eyes. Licken has always marvelled at these primitive conditions under which his father also laboured. 'I'll tell you, what always striked me about the comparison with the olden times is how remarkable it was what the older generation of shoemakers could do under poorer conditions, poorer lighting particularly. You take the stitching on a shoe. Now we're stitching approximately six to the inch. That's not a particularly small stitch on a man's shoe and we used to do eight. . . with no electric lighting my father used to work late at night time stitching on soles with an oil lamp. I often

wondered if they were damaging their eyes by doing that or strengthening them by the exercise. Later, my father worked here at the bench with an old bulb hanging overhead. They worked under more difficult conditions but did as good a job.' Today a dangling fluorescent tube light is standard – better, but still minimal.

Shoemaker John Ryan at work in his cramped shop on Grattan Street. Amid the litter are scattered assorted tools gathered over a lifetime of work

Shoemakers' tools have remained virtually unchanged for centuries. They are now safeguarded because most can no longer be replaced. Having been inherited from fathers or bequeathed by old-timers, most have a sentimental value. To the public they are already museum pieces but to the remaining craftsmen they are the implements by which they still earn their daily livelihood. Licken was amused to visit a museum and find a set of shoemakers' tools displayed. 'They are exactly what I'm using today. The tools of today are the tools of yesterday. Ah, you respect your tools. Most of these tools [on his bench], they're all there as long as I can remember. There was none of them bought in my time. I'd say there was great steel in these tools. If anything happened to them I don't know where I'd go to replace them. Most of the tools are older than I am and it would be impossible to replace them.' Malone shares his concern. Having had several tools snatched by young thieves in recent years, he now takes great precaution, scattering them all about the shop under heaps of debris deliberaely left for camouflage purposes when he leaves. 'It's one thing I fear, losing my tools. Oh, I'd be in a very bad way. I'd be lost. There's no demand for them. There's no substitute.' Fortunately he has duplicates of those stolen. Even materials are subject to obsolescence. Licken still uses wooden pegs for setting some heels because, unlike nails, they don't rust. However, once the boxes on his shelf are emptied he doubts that others can be found. At least thread can still be handmade from straws of hemp and flax twisted and waxed together, and leather can be imported from France and West Germany.

Barnwell believes that in another twenty years people will no longer be able to identify the specific use of different shoemakers' tools. Already, some shoe repairers cannot even tell. Licken delights in relating the account of his father's visit a few years ago to the folk museum at Glencolumbkille in Donegal. 'The girl who was doing the guided tour was talking about all the tools and she picked up this tool and said it was for rasping down horses' hooves. And so my father had a look at it and went to the girl after the tour was over and says, "You know, I don't think you were right about something you said" and he explained that in fact it was a shoemaker's tool. He knew the tool because he was still using the darn thing. She became a bit nettled over it.'

He has great affection for his father's tools, which have only come into his possession in the past year. There is a strong attachment to one in particular. 'That hammer goes back to the early part of the century. It was my father's hammer. I don't know whether or not to perpetuate it by using it myself from now on or whether to bury it with him when he dies. It was part and parcel of my father. The hammer, above all tools, is a very personal thing. My father over the last year while his mind was beginning to slip would inevitably pick up his hammer to bring home with him most nights. It was so personal to him. His hammer was his stock and trade. That was more personal to him than any other tool he had. It was something he understood. When he had the hammer he was all right, you know? That's why I have the notion of having it buried with him. I'm inclined to think that it would be a beautiful tribute to him. But I don't know if the clergy would have any objections to it.'

Journeymen and Outworkers

Shoemakers have always been a scattered and secretive lot. It is difficult to know how many there were in Dublin at different periods. In 1835, when everything was still made by hand, *The Dublin Almanac and General Register of Ireland* listed 191 boot and shoemakers in the city. By 1892, when some machinery was being used, *Thom's Official Directory of Dublin* placed the number at 101. The 1911 Census records 1,271 'Shoe-Boot Makers, Dealers' lumped together in a general category. Since this included merchants and factory workers there is no way to identify handcraftsmen. Enumeration has always been problematic because of the itinerant and erratic practices of many. Journeymen shoemakers, once plentiful, were peripatetic, shifting from town to town and, within Dublin, from one shop to another. Such vagabonds cannot be pinned down for a count. To complicate matters, most Dublin shoemakers, at least in this century, did not work full-time in a shop but part-time in their flat. They were known in the craft as 'outworkers'; how many there were will never be known. By the twenties and thirties the matter was further clouded by the fact that many so-called shoemakers had, in actuality, largely converted to shoe repairers. Paddy Licken reckons that sixty years ago there were only about twenty-five 'real' full-time shoemakers left. Barnwell, his contemporary, contends that there could have been 'fifty or sixty'. Both agree that outworkers were numerically greater.

Journeymen shoemakers who tramped from place to place according

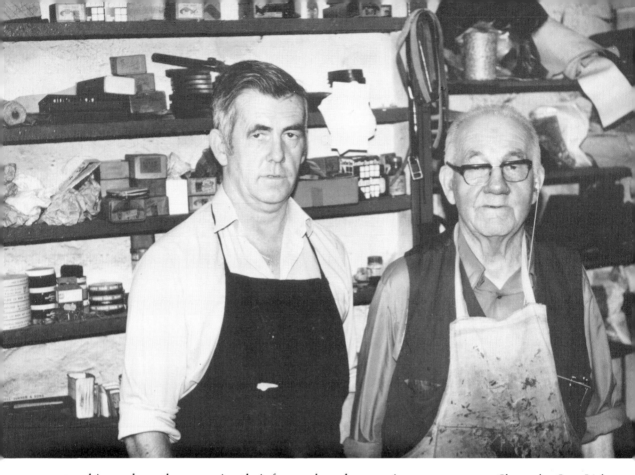

Shoemaker Sean Licken and father Paddy

to whim and weather, carrying their few tools and possessions, were once commonplace in Ireland. Summer was the best season for countryside rambling but in harsh winter months they might settle into a town. In large cities such as Limerick, Cork and Dublin they moved from one shop to another as work was available. 'They died out just around the time I came into the business [the 1930s],' remembers Malone, 'they'd be "on tramp" as it were. They used to come and stay in a landlord's [meaning the owner of a shoemaker's shop]. He'd put them up and they might stay for a few weeks if he had the work for them and then they'd move off.' They could be beguiling souls, carrying news, stories and gossip with them on their trudgings. Their presence for a short spell might enliven a sombre little shop. For this reason, the Lickens used to welcome their appearance. 'They'd come in and be very respectful. They'd be good craftsmen. And they'd work for maybe six weeks and then the humour would take them and they'd want to move on again, but they could always command a job. If you could put them up you would or you might help to find lodgings for them.' The last of the breed disappeared in the 1940s.

Outworkers, an equally curious bunch, existed all the way into the 1970s. They were hidden throughout Dublin but seem to have been concentrated in and around the Liberties. Their approach to work was highly sporadic. Back in the first quarter of the century, Barnwell used to see them straggle into the little shoemaking shops along Francis, Meath, Bride and Thomas Streets seeking work. There could have been 'a

hundred fellas in their homes taking in work off shoemakers and doing it on their own'. A small number worked out of their parlour and managed to cultivate their own customers. 'They would have their name on the window of the parlour and you could see them working away, just one man.' Ryan knew them as an eccentric sort, 'like Mr O'Shea who used to sit around making shoes in his underwear in his home wearing a cap. They'd go to the shoemaker's shop and were given a set of stuff, materials, for making the shoes and they brought them away and made them at home. That was the general way they worked. They'd go into Watkin's and take the work home and bring it back when it was finished and get another set of stuff. Trouble was that there mightn't be a set ready for them and they'd be told to come back. They never really made a full week's wage. It was a terrible struggle. A lot of them were hard drinkers. I think it was hanging around waiting for work and they'd go into the nearest pub killing time. There was always a pub around the corner from the shoe shop, and they would work sort of haphazard. They might work into the early hours of the morning and maybe through the night sometimes.'

It is uncertain whether their drinking resulted from lack of steady work, insecurity and excessive time on their hands or, instead, established drinking habits prevented them from obtaining regular employment. Barnwell tends to attribute it to the latter, vouching that many outworkers were fine craftsmen who, through their addiction to drink, just could not handle regimented working conditions in a shop and were thus forced to work irregularly in accordance with their own temperament and tempo. 'These men were every bit as capable and as good as I was but just through their own folly and their own stupidity and their own drinking habits they just couldn't handle it.' Some were real curmudgeons, better suited to working alone than dealing directly with customers. Either they might come to a shop asking for work or the shoemaker, during busy periods, could seek them out. Those with a reputation for reliability and quality were the most sought after. On the other hand, there were those so plagued by drink and unstable that they became charity cases. Sympathetic shopowners like Barnwell and Licken would help them out whenever possible with bits and pieces of work to perform. Outworkers managed somehow to survive on their occasional piecework and if they were not labouring in their dismal room they could sometimes be seen on nice days in a churchyard or sitting on a park bench contentedly stitching away on a pair of shoes. They finally faded from sight in the early seventies.

Traits of the 'Townie'

There was always a difference in the type and quality of work done by the country shoemaker and the 'townie', as the city craftsman was known. Country shoemakers catered to a rural and farming clientiele needing mostly heavy shoes and work boots; their concern was durability, not style. Townies, like Malone, had to be more versatile, making men's and women's shoes, work boots, dress boots, sandals and even leather house slippers. They generally turned out 'lighter shoes, smarter

stuff, more refined'. Fifty years ago shoemakers' customers were even more appreciative of their craft because shoes were so valuable a possession. In fact, long ago in Ireland it was customary that whem a man died the family would often ask the local cobbler who most needed his shoes; they were not to be wasted. When Barnwell was a boy he knew of many children around the Liberties who had no shoes at all and their parents owned but a single tattered pair. It was only a few decades ago that most Dubliners had one pair of shoes for work and another for church, weddings and funerals. If they had just the one pair and they needed repair they would have to 'send one of the kiddies up with them' to Barnwell's shop while they remained house-bound awaiting their return in a few hours. Back then people 'cared for their shoes. . . not like today. They'd keep the shoe in shape and use a shoe horn when they'd be putting the shoe on in the morning. They wouldn't just get out of bed and shove their foot into a shoe.' To make factory shoes last longer the customer would take them to the local shoemaker to have the bottoms built up. 'We used to do what was known as a "clump". Sometimes a half-inch or even one-inch thick sole was fixed on.' Extra heavy heels could also be attached.

Dublin shoemakers developed specialities and established reputations. They had to be skilled enough to produce practically anything requested but some had a natural knack for 'heavy' or 'light' work and it became their *métier*. As Ryan explains, 'Shoemakers in Dublin have always known each other and there were always those who were considered a cut above the rest. . . "so and so was a top class shoemaker", you know. And some men specialised in working on ladies' shoes and all the ladies' orders would be given to that particular man because it's a bit awkward if you're mixing heavy men's shoes and boots and a lady comes along and wants a nice dressy shoe.' Licken puts it a bit differently. 'Some men were particularly good at making heavy men's shoes and boots and others specialised in lighter ladies' shoes. But a good craftsman, no matter how heavy a material you'd give him, he'd have it lightened down into a fine piece, made into a really fine shoe. Similarly, another man who worked for us, Tommy Martin, if you give him the lightest in materials he'd somehow contrive to make a strong shoe out of it.' It was the genius of the craftsman more than the materials. Certain shops would attract special types of customer. For example, forty years ago when Malone was starting out he worked at a shop in Stoneybatter where many boots for cattlemen were made but when he opened his own business off Dame Street most orders were for lighter and more stylish footwear.

Men worked mostly on the piecework system, paid solely by the number of shoes and boots they produced. Some could make eight pairs in the time it took others to produce five. Only in a place like Barry's, which used some machinery and operated like a small factory, were they put on a weekly wage. Shoemakers have always been poorly paid compared to carpenters, plumbers, masons and most other crafts and tradesmen. They seem to have forever lived on the financial edge, struggling from week to week. None can explain why they have historically been so miserably rewarded for their labours when fellow craftsmen lived at a higher economic level. That they were destined to be poor has always

been a part of the shoemaker's craftlore as far back as any of the four can remember. To illustrate, Licken recounts a story: 'There's one now that dates very far back, to around the fifth century. Now St Patrick, who came to Ireland to convert us in 432, is supposed to have gone into a shoemaker's in the Limerick area and needed maybe a pair of heels on his boots or shoes and he'd only the one pair apparently and he wanted it done while he was waiting and the shoe repairer wouldn't have any of it, no way was he going to do it. So, St Patrick as a result of this inconvenience is supposed to have put a curse on all shoemakers and the curse reads that "they'll always be busy but they'll never be rich". And I can think of my father now who was always busy but he never got rich. And they never had any backup money when times were rough.'

Not only were shoemakers badly paid, but poorly shod. 'The old story that the poor shoemaker is always the worst off for shoes is literally a fact. You just don't have time to make your own. Shoemakers' children are the worst shod. It's ridiculous. I rarely get around to making shoes for my kids.' As a consequence, Licken's children must wear factory footwear. However, neither he nor his fellow shoemakers have ever been so sacrilegious as to don factory shoes but they must sometimes stretch their own products out for fifteen years or more. A few years ago he was invited to a wedding and the only pair of shoes he had was a brown pair nine years old. They were discreetly dyed black for the occasion.

Malone tells a sorrier tale – of shoemakers literally shoeless. 'A lot of the old guys didn't even have a pair of shoes. Shoemakers in the city that were fond of drink, they wouldn't have the price of leather to make a pair of shoes for themselves. Some were very heavy drinkers and they wouldn't have the money for the leather because they'd drink their money. They used to pinch a pair for repairs. If you were leaving your shoes for repairs, a full sole or heel job, they would put them on and wear them for a day. You'd leave your shoes for repairs and come back on Monday and they wouldn't be done and yer man would have to take them off and repair them and look for another pair of shoes to put on him. Or they'd make a pair of shoes and might pawn them and the owner of the shop would have to go and redeem them. They squandered their money. . . some were very badly off.'

The economic hardship so long associated with the craft inflicted deprivation not only on the shoemakers but also on their families. Barter and pawning often got them through difficult times. Wives and children did without some necessities as well as luxuries. This could strike hard at a man's ego. Not infrequently, shoemakers' wives would openly vow that their children would not go into the craft that had caused them such sacrifice. For a shoemaker, who lived by his pride, this was a traumatic blow. Malone's personal account of the thirties and forties is testimony to the travails endured by the city's shoemakers: 'Shoemakers were always badly paid, especially for the work which was so hard and time-consuming. It's physically hard work. It takes so long to do so little. Menial jobs are better paid than craftsmen. I used to work long hours, sometimes to eleven when I was rearing a family. My wife (who died in the late sixties) thought I was mad because she never got enough money from me. When other people – shoemakers – were moving into other

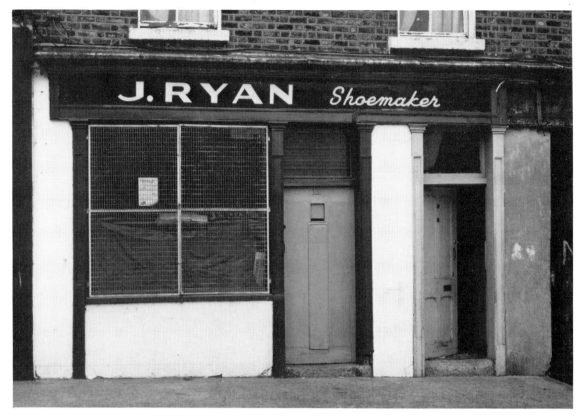

jobs and making big money I was still not making it. There was quite a lot of barter in the old times. I had clothes made for shoes. I traded a pair of shoes for a radio and a loan of cash. Pawning was a regular thing. When I was a boy starting off, they [shoemakers] used to pawn them [shoes] regularly, a pair of finished shoes or maybe a pair on the last. They might put them in half finished and the pawnbroker would know that he'd be back for them – and the last was valuable anyway. I often pawned my watch to get money for leather in the bad days. In the forties I had a young family and things were often difficult. Often I pawned my watch. . . and I'm not a bit ashamed to say that.'

Shoemaker John Ryan's shop on Grattan Street

Shoemakers-Tailors Kinship

There has always been a close kinship between shoemakers and tailors. They share much in common. Both have always seen themselves as underpaid, overworked and held in low esteem compared with other craftsmen. Also, they have a more personal relationship with customers than do other craftsmen. It is common that they even share customers, because the individual who wears custom-made clothes is the type to appreciate handmade shoes as well. Thus, a bespoke tailor might recommend a shoemaker friend to his customers and vice versa. It has even been a tradition that shoemakers and tailors practice reciprocal bartering; it seems a practical exchange. However, the friendship between the two

seems to stem principally from their mutually perceived downtrodden status. The shops of tailors and shoemakers were often in close proximity to each other and at the day's end they would gravitate to the local pub and together commiserate over a drink. Both led an arduous life and it provided diversion and escape. Among the greater fraternity of Dublin craftsmen, the shoemakers and tailors have for centuries been reputed for their alcohol consumption. Barnwell understands their compatability and habits. 'Tailors and shoemakers in the Liberties were the biggest drinkers and they used to intermix. . . they were mixers. Maybe we were so close together because we used our hands so much. It just seemed to be that one was looking after your feet and the other was looking after your body. They were just always known to be together. We respected each other very much. They were always two terrible drinking professions. And the funny thing about it was that the greatest of these craftsmen were the heaviest drinkers. Maybe it was the pressure. I often seen these fellas come along and I'd have a chat with them. I'd ask them why they drank and some of them might say that they had big families. See, that was one of the things – tailors, and shoemakers in particular, had large families, sometimes fifteen children and, well, I mean to say, if you're stuck in a room with six, ten or twelve children, it's going to get you down. So you're going to bed that night full of beer.'

Over the years, Malone has mingled with many a tailor and believes that the heavy drinking which characterises both crafts is largely attributable to the pressure of long hours and constant deadlines as well as the pent-up frustration over paltry wages and low status. Drink provided a release from such bondage. 'Tailors and shoemakers were always a clan sort of thing. I suppose tailoring went with shoemaking. The tailors and the shoemakers were recognised as great drinkers. They were both very fond of alcohol. I suppose that it was an outlet for their frustrations. . . for their worries and troubles. You know, it's such a time-consuming business trying to get work done and get work out and get paid and make a decent living. Some became very frustrated with it. Shoemakers always feel they are behind. I'm behind all the time.'

The close relationship between shoemakers and tailors was most conspicuous on Mondays. This was their day of liberation from schedules and pressures. It was customary to take the day off, devote the morning to purchasing cloth and leather for the coming week, and in the afternoon escape the city for some conviviality. They would regularly join together for such excursions, their favourite destination being the Strawberry Beds, a popular resort area for Dubliners beyond the Knockmaroon Gate of Phoenix Park. It was celebrated for its picturesque, sylvan scenery and strawberry culture. On warm summer days there was a procession of city dwellers strung along the road leading to this pastoral setting. All sorts of horse-drawn vehicles and motor cars created 'blinding clouds of dust extending the whole way from Parkgate Street to Knockmaroon' and, with the crowds in gay mood, 'the strawberry vendors, pipers, fiddlers and publicans reaped a rich harvest and the sound of revelry filled the air.'[6] On Monday afternoons Barnwell's brethren would join the tailors and converge upon the site in high spirits. 'The shoemaker and the tailor would get a hackney car and go off to the Strawberry Beds

and drink there for the rest of the day. You could get a hackney car, a jaunting car, for a shilling and they'd be down there singing – no trouble, no fighting or arguing, they'd just be singing and discussing their trade.'

Shoemakers also had their specially designated outing known as the 'waxie dargle.' As Malone tells it, 'Shoemakers used to take Monday off and had a day called the waxie dargle. You see, a shoemaker was called a "waxie" – we used this wax for waxing the threads – and the waxie dargle was down around Sandymount. They had a big day out there. They'd bring down the old cabbies, horse and cab, and bring their beer and have a proper day out there by the seashore, a bit of a "do"... they were colourful. Every Monday. They might actually work Sunday and take Monday off. The religious ones wouldn't work on Sunday.' The affinity between shoemakers and tailors still prevails today, though to a lesser extent, owing to the sparsity of craftsmen. Just as in times past, at day's end Malone often treks around the corner to his friend the tailor's shop and they share company at the local pub before heading home.

The 'Cobbler' and his Customers

The stereotypical image of the 'little old shoemaker', an elfin, bespectacled man on a stool with hammer and shoe in hand, is well entrenched in the public mind. In some cases, it is remarkably accurate. Customers may sometimes quaintly refer to him as a 'cobbler', a term which can be applied to either a maker or mender of shoes. However, to the real craftsman it can have a pejorative connotation. Sean Licken has never much liked the term. 'To me, a cobbler – well, you shouldn't call a good shoemaker a cobbler. A cobbler denotes a little bit of disrespect to my way of thinking. The saying "You're only a cobbler", that you're not a proper tradesman, you just "cobble out" the stuff and do it poorly, so to speak, that's the inference with a cobbler. It was never looked upon as a complimentary term, really.'

The relationship between shoemaker and customer is a very personal one, especially so over the last few decades as craftsmen have declined. Now, solitary shoemakers or a father-son team must deal even more intimately with those they serve, but in Barnwell's early years when there were typically several men in each shop the contact was less direct. A customer might have his measurement taken by one man but the shoe made by another. He could not be certain which shoemaker was actually 'his'. However, 'Sometimes customers, upon picking up a pair of finished shoes and being pleased with them would ask the boss which man made them so he could give him a tip. And sometimes the boss would call the shoemaker over and the customer would slip him a half crown and order two more pairs. So, customers often fancied one man in the place and would ask the boss if he could work on his shoes.' As Licken attests, now that shops have become one-man establishments the association between craftsman and customer has grown even closer. 'It's very personal. We get to know our customers very well. It's, "How's your family?" and all... very different from a normal business relationship. We're into the fourth generation of one family here now. The satisfaction you get from your good customers is a tangible thing.' Much pride is derived from the

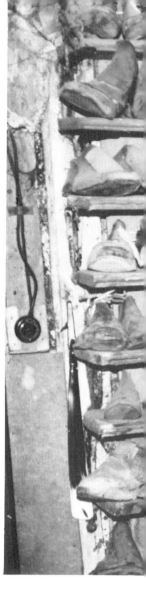

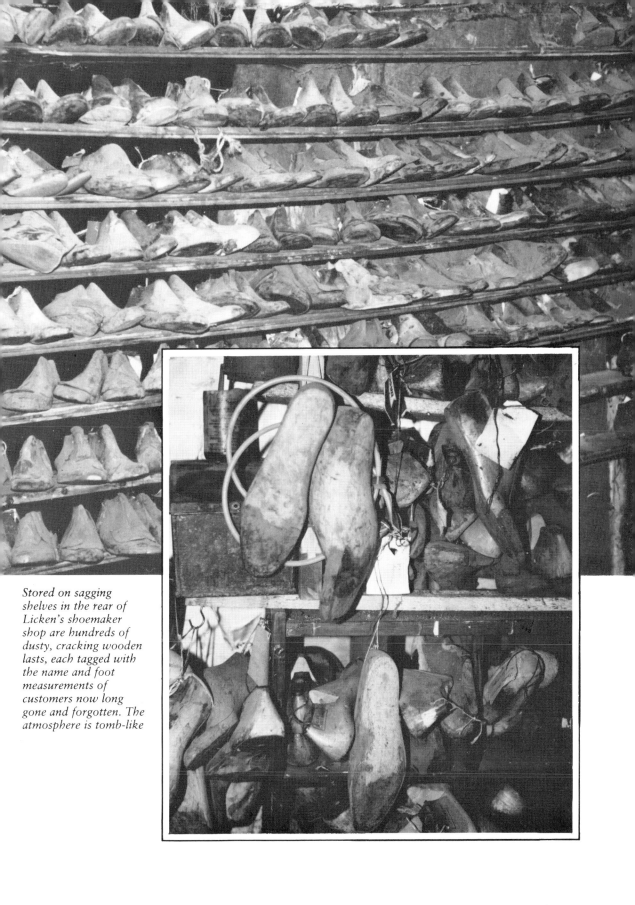

Stored on sagging shelves in the rear of Licken's shoemaker shop are hundreds of dusty, cracking wooden lasts, each tagged with the name and foot measurements of customers now long gone and forgotten. The atmosphere is tomb-like

succession of grandchildren and great grandchildren who enter the shop in family tradition.

The very nature of the craft, fitting shoes perfectly to someone's feet, is conducive to personal rapport. First, both feet have to be measured, there being a slight variation in size and shape in almost everyone. The shoemaker has the customer place his feet on a piece of paper so that he can sketch the outline. Then, with tape, he measures around the foot itself. From this a pair of wooden lasts, or replicas, is made. Shoemakers used to carve their lasts or they could buy them in rough form from a factory in Ireland or England and build them up or cut then down to size. When the Irish factory closed they had to be imported. Beech wood is normally used because it does not warp. This is important because a shoemaker must identify each last with a tag and keep it on his shelf in a dank room for the lifetime of the customer. Ryan, Malone and Licken have customers in such distant lands as Australia, South Africa and the United States who need only write and place an order specifying style and colour. Lasts are a very human record, invaluable to Malone and the others. 'If my lasts were burned up I'd be in a bad way. I'd have to start from scratch re-measuring and all. I have one customer in America who I haven't seen in thirty years and I'll probably never see that man again.'

Another reason for the intimacy over the counter is that the shoemaker's shop, like the forge, has traditionally been a place where people naturally gather – though in small number of two or three at a time. The four remaining shops, typical of those in bygone times, are enticing, intriguing haunts. Cramped but cosy, they are conducive to socialising and 'nestling in' on damp, dreary days. Scents of leather and dyes are alluring. Walls are lined with shelves from floor to ceiling littered with leather fragments, rubber, cork, shoe-laces, tools, dyes and bottles of Gripso rubber solution. The rear room, more like a large closet, is especially fascinating – even eerie. Here the dusty lasts are stacked by the hundred, dry and yellowed like skeletal remains in some ancient catacomb. To the inquisitive it is an exotic sight. Customers and visitors alike find it tempting to dawdle about, making the shoemaker something of a captive in his own castle. Most want nothing more than a bit of chat to pass the time. As with the forge, it is man's domain, and conversation ranges from sports to politics, with all assorted human infirmities between. They often fail to realise that shoemakers constantly feel pressured and behind in their work. So, like Malone, the craftsman may welcome the intrusion and company for a spell but some of the 'regulars are hard to get rid of ', occasionally becoming such a nuisance that they must be tactfully 'thrown out'.

Licken's shop has long been a lair for local folk, especially on frosty days when the little fireplace glows with scraps of leather and cork emitting an enticing scent. Both Licken and his father have always regarded the shop as a neighbourhood niche open to those in want of some company. Looking back over the years, Sean says, 'The shoemaker's shop was a focal point in the community. People would go there to discuss things and the shoemaker was very well respected in those days. We had people who used to come in particularly if you were working late. I can

remember men folk who used to come in here on Friday night and my father used to stay open on a Friday night and they'd be in the workshop there chatting about business or politics or whatever. This was quite common – maybe the blacksmith had a bigger audience. I suppose in winter time it was a handy haven to come in out of the weather. Just a chat was as much as they expected out of it. One of the things we had particularly was the numbers of guards who used to come in. How it originated, I don't know, but it got to the degree one time that somebody asked my father "was there a guards' barracks in the back of the shop?"'

There is no such thing as a stereotypical, or even typical, customer. The common perception seems to be that they must be people of wealth. In truth, they range from street sweepers to exalted members of government. A fair number are professionals such as lawyers and doctors but many are middle-class individuals who simply regard handmade shoes as a sound investment. Handcrafted shoes have always cost about three times more than ready-made ones but they can easily last through ten or fifteen years of regular use. Licken explains, 'Having a pair of shoes made for you is what I call an economic luxury. It's a luxury in that you pay a lot of money for it at the time, about £100 today [1983], but the economy comes in the wear. In the long term it's a good investment, better than buying several pairs of £40 shoes which don't give you much wear.' As Malone has found, the average Dubliner who has achieved a higher standard of living over the past twenty years is more willing to make the investment if he understands the economics of craftsmanship; regrettably, too few do. 'Working people are better off now than they were in Dublin. They even own fine cars and houses – not like when I was growing up. Middle-class people will now pay ninety to one hundred pounds for a pair of shoes because they like them. One fella came in here, a street sweeper, and he got a pair and he said that he never had such a good pair of shoes in his life and he bought another two pairs.' Ryan, however, feels that some of his 'well-to-do' customers over-indulge, having as many as fifteen pairs of handmade shoes at a time.

Neither Licken nor the others have ever seen fit to advertise. 'We never advertised. Customers tell their friends and that's the way it goes.' For some it is apparently a lifelong ambition to own a pair of handcrafted shoes but they patiently await the propitious moment. Licken had just such a customer. 'I'll tell you a funny story about the type of people who come in. A man came into us one time – we were used to seeing him come in – now this was between twenty and thirty years ago, and this man lived in the lodge of a convent school over in Foxrock and he used to bring shoes over from the nuns to be repaired. He was kind of a rough and ready guy, a character. He wouldn't have had much wages, of course, lodging and enough for a bit of food (he did odd jobs for the nuns around the place), but he was a great man for betting on the horses. Now he wasn't a serious gambler because he wouldn't have had the money for it but he came into us about the Wednesday of Easter Week and he had been out at a big race and had a great run of luck and won several hundred pounds which would have been a lot of money to him. And he came in and said, "I'm going to get something back out of those horses, how much is a pair of new shoes now?" And we told him – it was about

four or five pounds at the time – and he took out the money and placed it on the counter and said, "There now, I don't care when you make them but I'm going to have a new pair of shoes out of those horses." So in due course, a few months, we made the shoes for him and if that man is alive today he still has those shoes. I know he still has them because he wouldn't wear them during the weekdays when he was working around the place. He'd only wear them on Sunday going to Mass and you could virtually see him wrapping them in cotton wool. He would treasure those. They would almost last forever with him.'

Unpleasant dealings with customers, most infrequent, are usually subtle in nature and occur within the shoe repairing end of the business. They result from the presumption on the part of some people that the local shoemaker is a sort of handyman obliged to perform small tasks as a social service. Licken has always welcomed such requests from regular customers but finds them personally demeaning when coming from others. 'I think the shoemaker has been looked down on almost [by this type]. To give you an example, say a customer comes in and a buckle is off a kid's sandal and you might have to sew on a new one and he might be a stranger to you and he'll ask, "Will that be anything?" Now that's making little of you. In any other trade they'd know that they would have to pay. Another case, a person brings in a pair of shoes and says, "I hope you don't mind but I didn't get time to clean them up." And there might be cow dung on them. It's insulting.'

Hard Times and Decline

Even during his apprenticeship days Barnwell morosely witnessed the gradual decline of his craft; it was evident that the children of craftsmen were no longer much inclined to follow in their father's footsteps. Times were changing. 'Funny, all the men I worked with and even trained – no one in their families ever went into shoemaking.' Attrition took its steady toll during the twenties and thirties as the old shoemakers passed away unreplaced. The forties marked not only further decline but a change in the craft as shoemakers had to adapt to hardship and scarcity of materials during the war years. People were frugal; instead of purchasing new shoes, old ones were patched up. Like others, Malone had to concentrate on repairs to eke out a living. 'There were dozens of shoemakers at that time in Dublin and competition was great. In 1939 when the war started there wasn't enough money being earned and there wasn't enough people who could afford to buy shoes so you used to get fellas in getting their shoes soled and heeled. . . get 'em stuck together. So it was more repair work and leather was scarce too. We got a lot of oddment stuff, rubber heels and things that I'd never seen before.'

Licken recalls how both shoemakers and customers had to improvise. 'During the war years times were hard. There was difficulty in getting materials and all sorts of things were used – old motor tyres, for instance. They were cut up and the sides of them which wouldn't have been worn were used for soles and heels. My recollection is that they were quite good, actually. They wore pretty well.' As people devised ways to make things last longer he began seeing shoes and boots absolutely 'sheeted

with studs. They're flat and you used to get pretty good wear. Sheeted all over the soles and heels. You had to wear them down before you got to the leather; the only danger was that it could set up rot in the leather in wet conditions since they were iron. And there would be hob nails which were smaller but stronger. Ordinary working-class men had to try and eke out the footwear as best they could and quite a lot of people did their own shoe repairing in the war years.' For some Dublin shoemakers the war years brought in a grim sort of new business – orders from British firms specialising in making artificial limbs and surgical shoes for wounded soldiers.

As difficult as the forties were, it was, by all accounts, the fifties which spelled doom for shoemakers. The decade saw a proliferation of factory footwear of every imaginable type on the Irish market, and at affordable prices. The quality was also better than ever before. Coincidently, new job opportunities began to appear and craftsmen of all sorts, long squeezed by mechanisation, succumbed to the lure. As Malone witnessed, the consequences were dire. 'Manufactured shoes began to get very cheap and, in fact, at one period in the 1950s you could buy a pair of new shoes off the peg for practically what you'd pay to get them soled here. With the new technology they started to use paperweight insoles and things like that instead of leather. Footwear came in (from abroad) very cheaply and it done away with a lot of the trade. During that time I saw a hell of a lot of shoemakers go out of business. It just evolved that technology took over and done away with all the quality stuff. They started to fizzle out. They went into other businesses.'

Barnwell, who cites the importation of vulcanised rubber boots, particularly from Germany, during the fifties as detrimental to the craft, has his own version of decline and adaptation. 'There was a big change in the trade. Things were falling off and there was men getting knocked off, losing their jobs. See, factories were taking over and they were putting out a reasonably good-looking shoe and people were getting conscious-minded of fashion and all. I knew that I'd make it because I was doing work that others couldn't do [orthopaedic work]. Don't forget that we were coming into the modern traffic and motor cars and there were more accidents than when I started serving my time, with the result that from hospitals and all you had people coming out with deformities and orthopaedic work was coming into its own.' Before long, other shoemakers saw the wisdom and necessity of taking up orthopaedic work.

Though the prosperity of the sixties rejuvenated the Irish economy, it abetted the decline of the craftsmen. The pulsating decade brought more new jobs and higher wages. Struggling craftsmen and tradesmen were drawn into newly-created factory slots and service industries offering better pay and greater security. With sorrow and a sense of loss Malone watched a good number of his fellow shoemakers abandon the craft, grabbing unskilled positions paying top wages. It was a time of introspection and inner conflict for him because he found himself tempted to join the ranks of the upwardly-mobile, especially when old mates would stop by his shop, show off their new riches and question his judgement in sticking with a moribund craft. For a time he wondered if there would be any other shoemakers besides himself left. 'They just began to disap-

pear. One fella would become a milkman and another fella would go off and drive a truck where he might make two or three times as much. The likes such as myself were regarded as idiots by some of them for staying at it. "Why do you stay at it? We're making big money outside." My answer was that I'm my own boss and I earn a living. I like it. . . the love for the work and the pride.'

Without the strategic shift to more orthopaedic work, which has provided a financial cushion, it is likely that the shoemakers would have all disappeared during the sixties and seventies. In this sense, the craft has been granted a temporary reprieve of sorts. Barnwell, of course, had long specialised in orthopaedic shoes so he felt secure. Ryan, however, needed some luck. About fifteen years ago he happened upon a surgical appliance company in Dublin which took orders for orthopaedic shoes but routinely sent off to England to have them made. When he showed that he could produce the same product for about half the cost (£140 in 1983), he earned the new business. By the eighties it accounted for nearly ninety per cent of his output. He now has a reputation in the specialised field and customers arrive at his shop on crutches, in wheelchairs and even in ambulances. It is a matter of economics and social responsibility over aesthetics. 'I prefer to make a nice straightforward shoe. It looks like something. And a surgical one, no matter how well you make it, it's always misshapen. But it's hard to turn anyone away.' The rewards are gratifying as appreciative clients send thank-you cards and mass cards for giving them new mobility and an easier life.

Licken and Malone, too, have found it necessary and fairly natural to move into orthopaedic shoemaking – though to a far lesser degree. Over the past twenty years the health boards and other government and private agencies have become more willing to financially assist with the cost of providing special footwear to the needy. This means not only those with major deformities but the many 'difficult fitting' persons simply plagued by bunions or abnormally curved toes or varying size feet who really need the support and comfort of a specially designed shoe. Both devote about half their labour now to this task – enough to keep them going.

The Last of the Clan

We're down to rock bottom now. . . there are only a few of us left.
John Ryan, 1983

They have straggled into the eighties, still struggling financially, and now face an uncertain future. Compensating for the decline in demand for 'straightforward' shoes by making orthopaedic footwear may allow the last four shoemakers to live out their years but it cannot save the craft from extinction. No-one is being apprenticed to take their place. Because of failing health, it is not likely that Barnwell will work beyond another year or so. Sean Licken, in good conscience, cannot encourage his youngest son to take up the craft though he would dearly like to do so. Only Ryan has a son who could conceivably carry on the craft for which he shows an interest. There is grave concern that the shop may soon be swept away for office space. Indeed, all four shops are decrepit and in real danger of demolition. The future appears bleak.

*'Licken & Son'
shoemakers' shop in
Stillorgan Village*

Licken's predicament typifies that of the others. On one side, he finds himself under increasing economic pressure to mechanise; on the other, he is threatened with the possible loss of his shop. It is an exasperating situation. He abhors the thought of a transition from pure handcraft to partially machine-worked shoes yet he cannot ignore the economic realities glaring at him. 'A machine would stick that sole on in maybe fifteen seconds but it takes me an hour to do it stitching by hand. I don't have to tell you about the economics of that. The hand job will be a better job but if you have a good machine and if you're using the correct threads and wax and everything the machine job will be adequate.' However, he has steadfastly resisted – thus far.

He must also live daily with the fear that the shop, once the cottage in which his grandfather lived, is in imminent danger of being taken away. His worry is warranted because most old premises in the Stillorgan area have been obliterated with impunity for commercial development. This is much on his mind because, if evicted, he could not afford the inflated rent of a new location. 'The owner would love to get us out of the place. We pay virtually non-existent rent. I'll put it this way, it was never increased from 1933. We're sort of sticking out like an eyesore and they'd like to get us out and clear the area. If I were on an expensive premise I would have to start charging £200 [double what he currently charges] for a pair of shoes to make it economical.' There is another reason why he would hate to lose the shop. 'My father now is not really mentally very well – memory failure. There's only a limited amount of work I can ask him to do now. He's still able to do enough to keep him

alive. But if I couldn't bring him down to the shop anymore he'd probably die within six weeks.'

There is a discernible feeling of brotherhood among the four. All view their plight with philosophical resignation. No regrets are expressed about the past – only concern over the future. Is there value in chronicling the last of the shoemakers? 'Ah, yes,' says Licken, 'if people just sort of start forgetting about the old crafts then we'll be in a very poor world altogether, won't we?' Malone sees things in historical perspective. 'We're definitely the last. . . the end of the clan. We'll disappear. Shoemakers will disappear completely. I see myself as a part of history, no doubt about that. I have always felt that pride and satisfaction are the most important. . . love for the work. Somebody said that work is prayer and if work *is* prayer I'll go straight to heaven. Simple as that, because I worked so hard all my life. I've worked every day of my life, I've never been a day idle. I'll work at the craft till I die, I suppose.'

Barnwell has travelled a long road since he was yanked off the streets as a rambunctious lad and placed in the shop beside his father back in 1919. Another age altogether. As the doyen of the little clan, he has seen almost all of the city's shoemakers vanish from view, their simple shops but a memory. After more than sixty-five years at shoemaking he stands arthritically bent over the familiar workbench, saddened that none of his children or grandchildren could have taken up the craft and 'carried it out for another fifty or sixty years. . . but there's not a hope in hell. Soon this little shop will be closed and I'll be up in heaven with my little hammer making shoes for the angels.'

4
Farriers

When I go in for a drink they say, 'Ah, there's yer man Jim, he's the last of the farriers in Dublin. . .' and I say to myself, 'So I am.'
James Harding, 1984

I'm a survivor. I'm aware that there are just the two of us now. It's a nice thing to have a remaining forge in the city of Dublin – which a lot of people aren't aware of.
John Boyne, 1983

The country blacksmith has been lionised in literature and romanticised in poetry. But virtually nothing has been written about the city farrier. Indeed, 'city farrier' seems a contradiction in terms. Not so in old Dublin. It was only a century ago that the 'horse reigned supreme' in the city.[1] Because motorisation came late to Ireland, Dublin literally ran on horse power well into the twentieth century. Heavy draught horses and spunky ponies hauled cargo of every sort through streets and down alleys. It was the urban farrier who made this transportation function smoothly. In 1911 there were 196 farriers in the capital. Today there are but two – 'the last surviving links with that immemorial era which ended not so long ago when man depended on the horse as one of his chief sources of power'.[2]

In Dublin the horse and farrier held out longer than in most cities of the British Isles. The clicking of hooves on cobblestones and pavement was still a familiar sound in the 1940s and early 1950s as horses drew carts, vans and wagons loaded with milk, bread, coal, turf, grain, laundry and much else. In the post-war period change came swiftly however. Motorisation reached the masses. Cars and lorries were prevalent in bustling Dublin, where they usurped the place of lumbering horseflesh. Quietly the horse faded from sight. Dubliners were mostly oblivious. Only years later when a motorist at an intersection observed a horse cart clatter by and regarded it as a novelty did the mind register loss.

As the horses went, so followed the farriers and forges. When the craftsmen were rendered obsolete their old forges, once as ubiquitous as modern petrol stations, were abandoned and left silent – hollow stony shells scattered across the cityscape. Many were promptly demolished. Some were ignominiously converted into repair garages catering for mechanical ailments instead of ministering to horses' weary feet. The ring of the anvil was replaced by coughing carburetors, the hearth smoke by gaseous fumes, and the restful hiss of the bellows by the roar of engines. A few forlorn horseshoes were the only reminder that horses once fidgeted where there are now only tyre tracks.

However, two have survived – both man and forge. One can scarcely imagine more physically dissimilar individuals than John Boyne and James Harding. Surely all they have in common on this earth is that both are farriers – but that is quite enough. Each knows the other's mind because they have passed through the same experience. Boyne is a mountainous man, the prototypical smith of legendary bulk and strength. He is solid and dense, like the anvil he smashes. His rocky physique and crushing handshake mask a gentle tongue and sensitive mien. Harding is of spare frame, puckish manner and sprightly spirit. He is rawboned, jut-jawed and wears thick glasses. When he started his apprenticeship at the age of twelve, 'I weighed about seven stone. I only weigh about nine now. I wanted to be a jockey but there was no opportunity back then.' He was determined to be either atop or below horses.

They are friends, though they seldom see one another. Both are gentlemen – and gentle men. They know their history because they have lived it.

The Shoeing-Smith

Farriers are justifiably proud of their calling, for what other craftsman practises on living creatures and combines the skills of a metal worker and a vet?[3]

The craft of the shoeing-smith, or farrier, extends back in time. There were ironworkers in the British Isles for hundreds of years before the Roman invasion and the Celts cared for horses and were skilled in working with iron. However, not until the Romans arrived do we have documentation of horses actually being shod.[4] It became their practice to equip horses with shoes for the protection of hooves on surfaced roads. Blacksmiths who performed this task were called farriers, from the Latin *faber ferrarius*. Horse-shoeing as we know it today originated around the ninth century AD and the first blacksmith-farrier forges appeared in the thirteenth century.[5] Years ago the terms 'blacksmith' and 'farrier' were synonymous.[6] However, there is a distinction: 'a farrier may reasonably be referred to as "the blacksmith" since a good grounding in smithing techniques is essential to him, but a blacksmith may not necessarily have the training for shoeing horses.'[7] In rural Ireland the blacksmith normally had to do farriering and the farrier some blacksmithing; both needs had to be met in the same forge. In the city one could afford to specialise. In Dublin, where there was a great density of horses and ponies that required shoeing every few weeks, there was a constant stream of animals which kept the farrier busy full time. He might do a little smithing as personal favours. As Boyne explains, 'We were mostly farriers, as against a blacksmith in the country where you would handle all the farm equipment. But in the city we kept at two separate trades. In Dublin the horse, working on the roads, would be shod every three weeks. In the country the horse, working on the land, might be shod only twice a year.' Nonetheless, there were those city craftsmen such as Harding who hung over their forge a sign that read 'Farrier — General Smith' to certify that he could dabble in blacksmithing if need be. Was there ever any

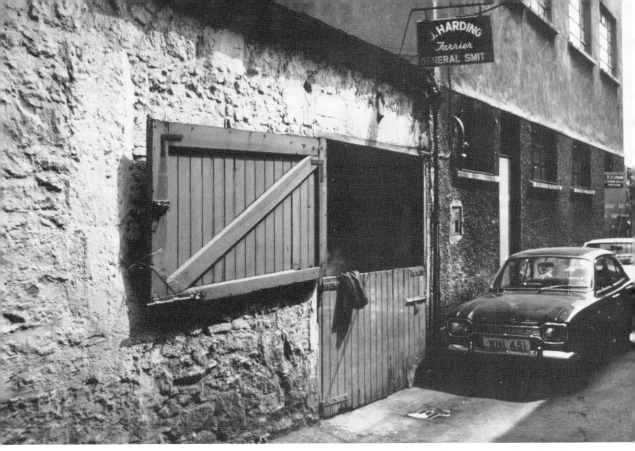

status rivalry? 'I think that the blacksmiths in the country thought that they were more superior than farriers in Dublin,' contends Boyne, 'they would reckon that they could fix a plow or harrow or wheel or whatever while the Dublin man could only shoe a horse. . . but it never caused any friction.'

Whatever his precise title, the smith-farrier was always a prominent figure in the rural or urban community. He was regarded as a metal wizard capable of making or mending almost anything. People had implicit faith that it could always be 'fixed up' at the forge – and usually it was. Apart from his practical skills, he was highly esteemed as a man of integrity, wisdom and commonsense. As Danaher tells us, the master of the forge used to be the 'social equal of the judge and the poet'.[8] In his time, Boyne knew most of the farriers in Dublin and collectively found them 'all characters, to be honest about it. All had very strong personalities and had strong views on things. They were well respected, a very important person at the time.'

Taking up the Hammer

I was striking at the anvil at twelve years of age.

James Harding, 1983

Both Boyne and Harding took up the hammer very young, following in the steps of their father and grandfather. Each was taken to the forge at a tender age by his mother's hand. To an impressionable child the sights

and sounds could be fearsome – metal crashing, fire flying, hooves sizzling and smoke billowing. To Boyne, born in 1932, the picture is still vivid. 'My first recollections go back to the time I was about seven years old. My grandparents had a forge along Pearse Street and actually lived over it. It was marvellous to see him at that time fitting a hot shoe to a horse's foot. It was fascinating. You can imagine if you'd never seen it. . . frightening in one way. Frightening to see him putting a hot shoe to the horse's foot and at that age one wouldn't understand that he was just fitting it. My father and grandfather were big, strong men. I used to think that farriers were giants of men. They seemed like giants of men in my time. They were so powerful and when you were young and seen them standing up over the anvils with big hammers and sweat coming out of them they kind of frightened you more than anything else.'

Harding, born in 1917, entered his father's forge at the age of twelve, toward the beginning of what he invariably calls 'the hungry thirties' when he witnessed barefoot children, impoverished homes and food shortages. When men were scavenging about for any work it was a blessing to be a craftsman's son and move right into the forge which brought in a modest but steady income. 'My father and grandfather were farriers. There were seven of us in the family but only three survived. Two died of diptheria. . . medical science was not advanced then. I'm the only one who took up the affliction [farriering]. In those days you had to sign an indenture with a master and you couldn't break it. I was very keen on it. I was striking at the anvil at twelve years of age. I started at five shillings a week. I seen big men and some were all brawn and no brains. My father wasn't a big man but a stocky fella with a powerful pair of arms, alright, from constant work.'

After the first two years his father, who was basically a farrier, decided to send him over to a blacksmith's forge for wider experience. It proved a tough term. He and another young apprentice worked under a strict boss and another seventy-year-old, impatient and cantankerous farrier named 'mad Joe' for his ferocious temper and disdain for apprentices. Not only would he deliberately withold techniques from the lads out of fear for his own position but he would incessantly criticise and bully them. Finally, the other apprentice, out of frustration and vengeance, retaliated by reversing the old man's tongs over the hearth. The scorching handle gave him a sound lesson. Says Harding, who silently watched in great anticipation, 'It was hot but not red. . . the young lad was fed up.' The apprentices found that they were held in new respect. At the age of sixteen Harding returned to his father's forge much the wiser and knowing a fair amount about blacksmithing.

Boyne's tutelage was under a gentle and unwaveringly patient father, one of Dublin's true master farriers. He has only fond memories of his apprenticeship years. 'I went to the local National School for education and at thirteen years of age I finished and came to work for my father as an apprentice. When I started I got fifty pence a week and when I was twenty-one I was getting a pound. We'd start at half seven and in the summertime work on until about six or seven in the evening for six days a week. There was nothing such as a half day then and I often worked three nights a week until ten. My first job was holding horses – at that

time they were all big strong horses – or making tea or blowing the bellows. It was a hand bellows because we didn't have any electric fires in those days. You pumped the bellows with your left hand and you used your right hand to prepare the irons in the fire. And I learned to handle the sledge hammer. Maybe with my sledge I wasn't very good – at first – but as years went on I became what they called a "striker" and then I worked the floor. My father was very patient with me and in our time you never really finished your apprenticeship. As long as your father was there he was still teaching you. We never knew enough about it but it was seven years before you could go out and work for another man. We had no documentation or certificates to say that you were fit to shoe horses. It was an automatic thing. You would just work away in your father's forge and that was it. You'd just become known in the field of farriers.'

He has incontestably 'become known' in the craft – and throughout the country. After forty years at the anvil he has risen to the stature of premier farrier in all Ireland. He is the RDS's official horse shoer and for the 1984 Olympics shod the only Irish showjumper and three out of the five national horses competing. There is no-one in the whole country who knows more about the craft than he.

Forges and Farriers Around the Town

I have people coming around the present day and they look in amaze-ment. 'What's this place?' they ask. And I say it's a forge and they think they're looking back in the eighteenth century. Some lads, they never seen this.

James Harding, 1984

Horses have long played an important role in Irish life on the farm and in town. Dublin, as the centre of commerce, held the greatest concentration of heavy draught animals and thus had the most farriers and forges. In the latter half of the nineteenth century streets were crammed with horses for haulage and personal conveyance:

> An incredible number of horses was stabled in the city; every large Georgian mansion had three or four horses in its stalls, while less pretentious houses had at least two. There were hundreds of jarveys and large numbers of drays, wagons, milk carts and refuse carts. The main streets, especially in the after-noons, were filled. There were even traffic jams in Grafton Street.[9]

After the turn of the century the bicycle, and gradually the motor car, began to share space but the 'horse was still king of the roads. . . and the smell of horses was still strong up to the thirties.'[10] This was around the time that Boyne and Harding took up the craft. Dairies, bakeries, coal merchants, turf dealers and the like had their own stables, some with a hundred or more horses on the premises. They would retain a few of their own farriers or rely on the local forge. Additionally, there were innumerable small firms and individuals who had one or several horses and ponies in sheds down back lanes and alleys. Animal density was greatest near the docks. Boyne's forge, only a few blocks from Liffeyside, was in the midst of a maelstrom of horse movement.

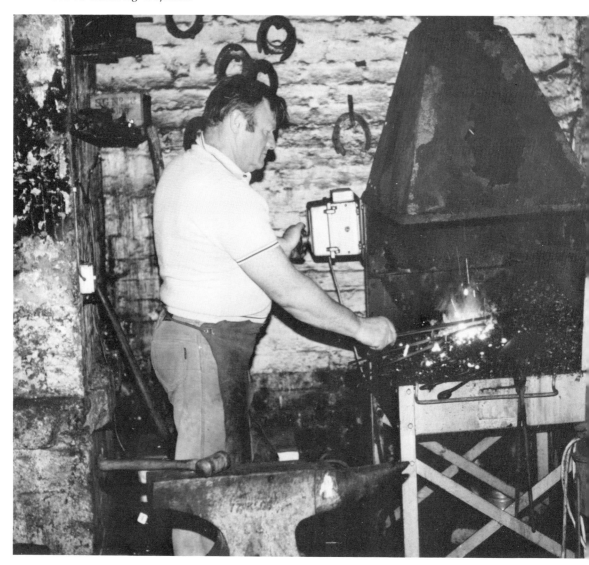

To historically reconstruct the number and location of forges four decades ago, Boyne mentally travels backward through streets and alleys picturing in his mind what once existed. 'There were forges all about. Before my grandfather had his forge along Pearse Street he worked in a forge on St Stephen's Green. It's hard to believe that there was a forge on Stephen's Green seventy years ago. Now even in the forties there were bloody few trucks. . . the horses drew everything. You had your grocery man, your egg man, your turf man, your milkman, your bread man, your coal man, laundry, grain. Ninety-five per cent of your products were delivered by horse. Everything that came in off the docks was delivered by horse, so was everything coming into the country and going out of the country. There were about 3,000 horses just in this general area. The Dublin Gas Company would have had about eighty to ninety horses, Boland's and Johnston-Mooney, the bread people, would have had I'm

Farrier John Boyne still pounds out horse shoes in the city forge inherited from his father. He is the official horse shoer of the Royal Dublin Society and recognised premier farrier in all Ireland

sure a hundred horses each and there were at least three coal merchants by the docks with nearly one hundred horses each. There was no other means of transport therefore every firm had horses.

'Then there were hundreds of individuals with one or two ponies – I mean this area was littered with stables. In the backs of these little houses there were stables for ponies. They all had a job to do, so there would be two's and three's and six's and seven's in back alleyways and sheds. And on O'Connell Street, rather than having taxis you had cabbies, jaunting cars. I would say that there were thirty forges within a radius of two miles of this particular area. Now in the whole city of Dublin back in the 1940s I'm sure that there would have been fifty forges. We farriers naturally knew of one another but we were never very close because we were all in opposition to one another.' Because farriers cared for the horses of delivery men a system of casual barter was common. Boyne, like others, often shoed a horse in exchange for 'milk or turf or coal or fish, a bag of potatoes or a couple of pounds of butter or tea.'

Unlike the country blacksmith's forge, those in the city were not necessarily located at an intersection, though some were. More often they were found in lanes and alleys. They could always be detected by following the scent of acrid smoke. Boyne specifically remembers three forges on Mount Street, two on Stephen's Lane, three around Power's Court, two on Townsend Street and some along Peterson's Lane and Macken, Shaw, Grafton and Mark Streets. To his knowledge, the last working forge – apart from his and Harding's – was on Temple Street, and it closed in the mid-seventies.

Looking back, Harding counts at least forty forges with generally two farriers in each but there were a good number of craftsmen working in the yards of transport companies as well. At this period there were so many farriers in the city that, like the coopers, some had nicknames for the sake of differentiation. He recalls a host of Murrays back in the thirties which included 'Ginger' Murray, 'Long' Murray, 'Cork' Murray, 'Dirty' Murray, 'Red' Murray and 'The Guzzler' Murray. Whether they were related he never knew.

With only two forges now remaining it will not be long before most Dubliners will have lost all memory of them. Historical photographs will have to suffice. It is a pity that Harding's cannot be preserved for it is a classic, undisturbed for nearly a century. If one wished to recreate a forge for a film or museum one could do no better than to duplicate it; everything is authentic right down to the original hand bellows and handmade tongs. The only difference that Harding can see between his forge and those which predated it is the floor. 'In old-fashioned forges all the floors were made of timber because if it was made of those old blackstones or cobblestones and it was a young horse and made a plunge. . . but with wooden floors there was more of a grip in it. So all the forges in the city were made of timber floors but around the hearth you would have stone. Now here in 1934 we decided to get the floor done in concrete.' The forge, inherited from his father, is located on Pleasant's Lane just off Camden Street and only a few hundred yards from St Stephen's Green. It has been a forge since the 1890s. Before that the structure, which is two hundred years old, served as a coach house. Just fifteen feet across

the lane is a flashy disco emitting 'new beat' sounds which share the same air as the 'old beat' sounds of hammer on anvil. It seems somehow sacrilegious.

Boyne's forge came to him in a special way. 'My father when he died, he left me this forge in his will. He always said that it was my forge. In fact, when I was married he wasn't a man with money so he just said, "Look, son, there's the deed to the forge and sure do the best you can," which was very kind of him.' A half century old, it now has an electric bellows. Otherwise it is as authentic as Harding's. At the intersection of Pearse Street and Macken Street, it is completely concealed from view by a fence. Only when the front gate is open can one see the white stone walls, red-framed windows and black wooden door. In the small littered yard are wagon parts, wooden spokes and rusty metal paraphernalia. In one corner is a rock shed large enough to stable a single horse. It is a glimpse of the country.

There is something primeval about the innards of the forge. It is cavernous, craggy, a place of stone, fire, metal and smoke. The stygian interior is accentuated by glaring sunshine outside. The darkness is deliberate, allowing the farrier to correctly guage the red glow of the iron. The hearth is in the gloomiest corner so that seeping light cannot disguise metal colour. Directly beside it is the bellows. About 5 ft in front stand two anvils. Walls are charred and sooty, dotted with rows of pegs on which hang varied shoes. Scattered about are a water trough, ladder, wooden stools, iron rods, heaps of coal, buckets, hammers, tongs and other tools. Wooden half-doors keep the animals in but let the heat and smoke out. In one corner of Boyne's forge is a pyramid of rusty shoes reaching 10 ft to the ceiling. On Harding's wall is a cartoon showing a horse lying complianty on its back so that the farrier can sit on its belly and shoe its outstretched feet. Customers are amused. One is not so sure about the horses.

Surviving forges are enigmas to city officials and insurance agents. Since they are not of the modern world, how does one cope with them on an 'official' basis? Occasionally, Electricity Supply Board (ESB) inspectors and other authoritative types prowl about the stony forge grumbling about wiring, lighting, electrical and other 'practical' matters. Then, shaking their heads, they disappear back into the twentieth century.

Firemen and Floormen

Remember, when you're handling a horse's hoof you're handling nature.
John Boyne, 1983

The country blacksmith might have managed on his own but in Dublin it was customary to have two farriers working the forge as horses steadily flowed in from early in the morning to well into the evening. City forges were a hive of relentless activity. Only tea breaks broke the motion. Farriers were on a piecework system, paid by the number of shoes made and horses shod, and the two-man system, each with his own job and space, was the most efficient. In some forges, such as Boyne's, during hectic periods there could be as many as five farriers including apprentices

and journeymen. When there were no horses in the forge the farrier would still be busy making up shoes for the stock hung on the wall pegs.

In a two-man forge one man was the fireman (or firesman) who worked the bellows, hearth and anvil, hammering out shoes. The other was the floorman, who worked the floor tending horses. All farriers could perform both tasks but normally each man assumed responsibility for the job at which he was most skilled and comfortable. Often the huskier man would handle the horses. The role of floorman varied somewhat from forge to forge. He always had the responsibility of stripping off old shoes and preparing hooves for new ones. However, he could nail on the fresh shoes or this could be done by the man who made them. In many forges men switched roles from time to time, but there could also be a division of labour in which, as Harding puts it, 'a floorman, he only specialised in the floor. He never got a chance to work the fire.' As a man got older he might prefer the security of the fire over the floor. Whatever the arrangement, the two always worked compatibly as a team.

There was no time for wasted motion in a forge. Everything was handled with precision. The fireman would have his left hand on the bellows and his right over the hearth. Mastery of the bellows was vital because it controlled the fire and flow of shoes. Farriers became attached to their bellows and usually regarded it as the most indispensable tool. The handle of Harding's bellows fits his grip like an old friend's handshake. He has retained it, refusing to switch to an electric one, because it responds obediently to his gentle coaxing, producing a steady glow from which he can even tell the weather outside. 'I know the weather. I'll know the winds are changing because when there's an east wind the fire is bright, the fire is beautiful.' After nearly a century of unfailing service the bellows is in need of some repair but he knows of no-one capable of the job. He speaks of it fondly and strokes it as one would a child. 'I was blowing that since I was about eight years old. I was up on my toes working it with both hands. I think that's the only one now still used in any part of Ireland. It could be a hundred years old. . . I'll be gone before it.'

Unlike some other craftsmen, such as coopers, shoemakers and woodcarvers, farriers freely shared anvils, hammers, mandrels and tongs. Tools belonged to the forge rather than to individuals. If a man inherited or made a particular hammer or tongs it might be his exclusive possession but he was seldom fussy about its use. Some of the old implements around Boyne's forge carry initials carved by owners generations ago. Anvils seem indestructible but a craftsman could go through one or two in his lifetime. Most forges had two or three of different size resting atop a block of wood (usually cork or elm) to give 'life'; otherwise it would ring 'dead'. Harding still uses one of his father's, though the 'face has gone a bit hollow'.

With firemen and floormen working in synchronisation the forge ran like a fine clock. This was necessary because, as Boyne recalls, on busy days there could be as many as thirty or forty horses and ponies lined up along Macken Street awaiting their turn. Sometimes it was too much for two men to handle. 'At my father's forge there was my father, his brother, one other man and myself and occasionally journeymen. You see, there would be hundreds and hundreds of horses, so we would start

here at half seven and there'd be one or two firemen and a man stripping and driving on shoes. We might have as many as five animals at a time in the forge depending on who was working the floor at the time. I spent most of my time shoeing, shoeing, shoeing. You'd take off your shirt if it was a warm day. We often worked here three nights a week until ten because people found it uneconomical to get their horses shod during the day and rather than lose a load or two [deliveries] they would get their horses shod when they were finished working. So we had to work at night which was hard.'

During respites farriers would accommodate requests for a bit of blacksmithing. Harding, because of his early training, readily made brackets, chisels, tools, ornamental ironwork and other such items. Boyne's forge was seen as a sort of community fix-it-up shop and he puts the requests into two categories. 'You see, the forge was everyone's little place. Everyone called to the forge. I mean the lady with the pram if there was something wrong with the spring or if the wheel broke down she'd call to the forge. We used to call those "thanks very much" jobs. And the man with the donkey cart, the farrier would repair it. Or he could make up a poker for a lady for her fireplace or make a couple of "S" hooks or maybe someone died and you'd be asked to make a little grave surrounding or make a cross. Those would be a nixer. . . you might get paid for that.'

Handling the Horses

History shows the farrier not only as a shoeing-smith, but as a man who understands the general care of horses.[11]

Farriers are part metal worker, part horse doctor and part animal psychologist. Their work is as much mental as physical. A solid knowledge of the horse's anatomy is fundamental, but above all else the farrier must be an expert on feet. On the wall of Harding's forge is a sign that reads 'No Foot, No Horse.' 'Now lots of people ask me, "What does that mean?" It simply means this – if he has no good feet, if his feet are bad or he's lame, we call it "no foot". That means that his feet are not good. . . no foot, no horse. He can't work and you have to leave him in the stable. He's worth nothing.' The farrier must know all about foot disorders, diseases and cures as well as the fine differences in hooves between draught, riding and race horses. A skilled craftsman, like an orthopaedic surgeon, can correct walking abnormalities. Conversely, a poor one can do irreparable damage to a horse by improper fitting. A farrier tends to pride himself more on his knowledge of horses than his ability to mould a metal shoe.

Farriering begins with the animal's arrival at the forge. This can be a tense moment if the horse is frightened, jittery and therefore capable of sudden erratic action. Sometimes owners are advised to bring young unshod horses to the forge the first time with an older animal companion. In this way, they become accustomed to the smells and sounds. The farrier must be able to pick out the contrary horses from the cooperative ones and deftly handle those which are nervous, excitable or outright

Series of photos showing farrier James Harding hammering out a shoe and in the process of shoeing a horse. He still uses hand-made tongs and antiquated tools. Due to advancing age and failing health he is now wary of large, unpredictable horses. Only about six or eight horses a week are now brought to his city forge, just enough to keep him going

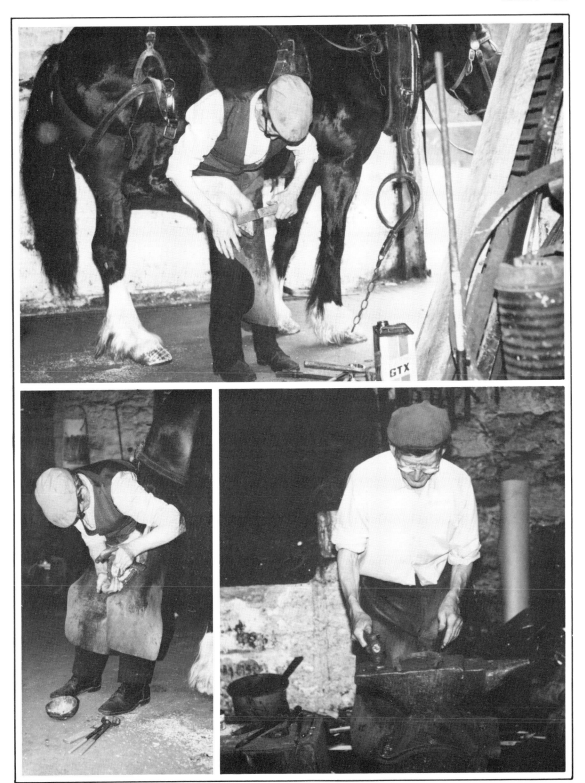

belligerent. Here the city farrier had an advantage over his country counterpart because he usually shoed a horse a dozen or more time each year as compared with only two or three shoeings for farm animals. Therefore, he got to know well a horse's physical and behavioural peculiarities – and he remembered.

Unknown horses pose the greatest risks. As a precaution the wise farrier solicits information at the outset. 'When a man brings in a strange horse,' explains Harding, 'I'll say, "Is he broken in? What age is he? Is he alright? Is he harmless? Is he quiet?" You see, if you have a good man bringing in his horse, if he handles him well, that's half the work. But if a horse is handled roughly, with bad hands. . . it all depends on the owner. If he gets a bad pair of hands on him it's a bad job. I always ask the owner, "What sort is he?" I don't want any rough horses.' Once such matters are resolved the old shoes can be stripped. Next the hooves are examined, cleaned, filed and shaped for re-shoeing. It may take several filings, shoe heatings, and hammerings before the fit is snug. During this commotion the horse may become alarmed. Quivery legs and diluted pupils betray nervousness and fear. The farrier must be ever wary, because working in an awkward position with his back and knees bent he is rendered vulnerable if the horse chooses to assert his independence. Reassuring words and firm stroking of the leg can reduce fright, but the farrier can never be certain.

After nearly six decades, Harding has handled as many horses as any farrier in the country. He has always felt it to be a matter of matching brains and brawn. Sometimes it comes down to a silent war of nerves. Despite his cautious approach (due to his modest frame) he has misjudged some horses and lost a few battles. However, he has never conceded defeat and always likes to have the last word. 'It's a tough, laborious work. You sweat a lot and you get kicked around. See, sometimes horses can take a dislike to you. Sometimes they don't even like your voice. It's – what do you call it – an occupational hazard. I keep my fingers crossed. When you're young you don't mind but then when you get on you get butterflies in the stomach. Ah, I got knocked down many times, all right. I've been knocked out and ribs and toes fractured but you still had to work. There was one horse here and the owner said to me, "I wouldn't trust him." I was just working on the back heels and from the position I was in you'd think it was impossible to kick me. Well, he hit me and put me over there [pointing to the wall 8 ft away]. I knew I couldn't trust him. And when you get a strange horse in you have that sixth sense. The first time I saw this bay horse I had that feeling and he put me up against the wall, but I got into him [laughing]. Now I won't describe it but I had him up agin that corner and I chastised him. But you couldn't talk to this fella, he'd run at you with his mouth open. In the last couple of years I get nervous around these horses.'

Journeymen Farriers

We farriers would all be noted for a particular thing, whether we were
too fond of drink or were extra good to shoe a wicked horse.

John Boyne, 1984

Journeymen farriers were once an integral part of the craft in Ireland.
They would meander about the country visiting different forges for short
spells. The great majority were capable craftsmen who could work the
fire or the floor. Because of the unorthodox, vagrant life they led most
were great story-tellers and characters in their own right. During the
winter months in particular they would converge on Dublin seeking a
haven from inclement weather. Normally, however, they would stay no
longer than two or three weeks. Dublin forge owners would get to know
some of them well over the years and come to anticipate their annual
appearance. During periods of frost and snow when city streets were
slippery and horses had to be fitted with special frost nails, activity at
the forge was frenetic and the arrival of journeymen to help out was
heartily welcomed. The Boynes always ran what he calls an 'open' forge,
or 'free' forge, in which other farriers were welcome to visit, use tools
or stay to assist with work. A journeyman could find some security and
comfort sleeping in the forge. In fact, they were often useful for doing
night work in preparation for the next day. 'These men would travel all
over Ireland,' says Boyne, 'and they would call to our forge and do a
couple of nights here. They were what we called shoemakers and we
would finish at six and they would work until eleven at night making
shoes for the following day.'

Like many other itinerant craftsmen, many of these journeymen far-
riers were habituated to drink. Farriers, being mostly powerful men and
working strenuously in a hot atmosphere, would perspire profusely and
could drink lustily for replenishment. However, it seldom had any discer-
nible effect on them. Unlike tailors and shoemakers, who had the reputa-
tion for over-indulgence, they were mostly men of moderation. Esteemed
in the community and constantly in public view, they knew that excessive
drinking would tarnish their image. The local farrier or smith seen regu-
larly in a sodden state would pay with his reputation. Journeymen, how-
ever, transcended such convention. They were always known as the
heaviest drinkers in the craft. Boyne found one of their concoctions curi-
ous. 'These journeymen would like their pints so they used to have these
cans like the old sweet tin cans and they'd go up and get a couple of pints
of beer in that and they used to take a square bar or round bar of iron,
clean it off with a wire brush, heat it in the fire and put the hot iron into
the beer. They used to make a great thing of this. I think just to fizz it
up. . . something about the taste. They used to call it hot malt or some-
thing.'

Journeymen played a far more important role than merely helping out
at various forges, for they were disseminators of ideas and techniques.
Their range of practical work experience with assorted smiths and farriers
made them walking repositories of craft knowledge and innovation. This
they freely shared along life's way. Harding delighted in their company
and even in the rare instance when he had no work to offer would at

least 'give them the price of a drink.' Over the years he learned much from them about making tools, shaping shoes and understanding horses. 'Oh, I remember the journeymen well. They travelled all over the country. You'd know them by their travels because they'd pick up different ways of craft and things you'd never seen, little jobs that they learned in other parts of the country. Now I'm a long time at this but there's something to learn every day. Journeymen were always paid by piecework. So you worked by the horse, so much a horse. And if he was a fireman he'd be paid so much per dozen shoes. You had all types of journeymen coming into the city. You'd learn something from them every day, little tricks and different ways of tempering and making hammers. The journeyman was more versed because he was travelling from shop to shop. If he was in Dublin now he might get uneasy and walk maybe to Co. Meath and go to a forge. It's a way of life. They just had that urge to go, maybe walk thirty or forty miles. It was easier in the summer.' There was the time he was working on a horse beside a journeyman and complained that the hooves hardened during summer. He was promptly told to 'get the skin of a rasher and rub it around the hoof.' It perfectly softened the hoof. 'Well, that was one little tip I didn't know.' There proved to be many others.

There is an especially soft spot in his heart for the old journeymen because one once came along at a crucial time and played an important part in his life for which he will always be appreciative. A young man at the time, he had just lost his father, inherited the forge and was uncertain of himself and the future. As if by kindly providence, an old craftsman materialised at the forge entrance to become his trusted friend and surrogate father. It got him through the shaky period. As he tells it, 'My father died back in 1939 of tuberculosis. It was known then, I think, as consumption. He was a man of fifty-eight. . . working up to the last day. I knew he wasn't feeling well because he got a bit contrary and had a bad cough. At the time I was a lad of only twenty-one and I had some experience all right, but I found that it was going to be tough for me as a young man to manage the forge. Then there was a man who walked in here by the name of Jack Mooney who had worked for my father, he was an old man, a journeyman. He travelled the country far and might stop a fortnight in a forge. He might stop a month but he'd still always want to go on. So, I said to him, "Jack, is there any chance you could give me a hand?" And he said, "I can't work the floor, but I'll work the fire, fair enough?" Ah, he could make shoes. He was a beautiful craftsman. You see, my father was a farrier, he only knew about farriering but this man, Jack, he knew about making springs. He could make anything. He taught me a lot. If we couldn't get our own knives he could make a knife. We used to make our own tools and tongs. He was a fine cut of a man. . . fond of the drink, you know. He had a sense of humour and the great stories he would tell you about the 1914 war. It was a pleasure. He was like a father. They were the best years of my life.'

After a few years, the inevitable occurred. 'One morning he came into the forge and announced, "I think I'll go packing." And I said, "Fair enough, Jack."' Harding never saw him again. The last journeymen passed through Dublin in the 1940s. Then they came to the forge no more.

The Forge as a Meeting Place

You could settle the affairs of the country in the forge.

James Harding, 1984

The forge was a good meeting place for the chat and the crack and the fun. At the forge you'd always have the people coming in and telling the boys a few stories, even if they were lies.

John Boyne, 1984

Forges have a mystique and lure about them that always attracted both young and old. They served as a communication centre in the community. Here, and at the local public house, ideas were exchanged, news spread, gossip shared and matters settled. Here the 'word' was heard. In the *Ancient Laws of Ireland* there is a passage pertaining to straying or trespassing horses and cattle. It states that they must be impounded and notice posted at the most prominent sites, namely the house of the local lord, the home of the judge, the church – and the forge.[12]

It was natural that men would congregate and converse as they waited to have horses shoed, but the number in attendance always exceeded the number of actual customers. Others were enticed by the setting. To children the sight of a mighty man, exploding sparks and gargantuan horse proved irresistible. It was great drama.[13] Older men found comfort in the forge, continuity with the past, an anchor to their youth. The rest of the world might change and modernise, but a forge was a forge. It was steadying, inviolable and timeless.

The social dynamics of the forge were subtle but observable. There were always the 'regulars' who would mosey in much as cattle follow the path home – more by instinct than deliberation. Men would huddle along one wall sitting on a bench, stools or floor. It was man's domain. Women might take their children for a look or bring an object for repair but they did not dally. When a woman did appear it usually broke the verbal patter of the men, who would graciously smile or nod, then fall silent. Some forges were cliquish, catering almost exclusively to local cronies who fed on each other's tireless chatter. One needed only to open one's mouth, spout a few prefatory words and everyone knew the yarn – but they digested it yet again for lack of more original material. It passed the day.

Boyne's forge was never socially stale. Fresh faces appeared daily. Situated at a busy intersection in the heart of an old established community and only a few streets away from the docks, it crackled with activity. At times it was so thickly peopled that horses took up valuable social space. As an open forge it was egalitarian and spontaneous. Individuals of every ilk were welcome – moneyed race horse owners, rough dock hands, neighbourhood children, tinkers and what Boyne calls 'life's unfortunates'. Everyone was entitled to a kind greeting, some warmth, tea and simple chat. It was a people's forge.

He talks wistfully about the days when the forge was a populist gathering place, a communal artery through which life flowed daily. 'A forge is a great attraction. You see men hammering with a sledge and hot iron sparks flying all over the place and normally the smith or farrier is a big

man with open shirt and he comes along and burns a horse shoe to the horse's foot. It creates a lot of smoke. The hammering and banging and all the smoke, it drew people in. They were always welcome. There was a National School across the road and many children in the mornings would come across to see the horses and then go on to school. The children would be curious about what was going on and naturally they loved to see horses, particularly ponies, and the shoeing, fitting, hammering and anvil. And you would know all the little toddlers who would come with their mothers. It was a community of people working mostly on the docks, just ordinary working people. . . twenty-five years ago. Now the houses are all pulled down.

'But the forge was a meeting place for people, particularly if it were a wet day or if the boats were held up on the docks. They'd gather and congregate in the forge. It was common. They'd just make their way in, the men would all be in here having a chat. You see, at that time in the winter we used to have drums cut out with coals in them and we'd have big roaring fires. And we always had these big tea pots – there was no such thing then as an electric kettle – which were as black as soot from lack of a feminine touch. There was always tea in a forge. And if a man hadn't his lunch someone would give him some of his. So you were kind of brought up to help everybody. There weren't many tinkers in Dublin at that time and they would usually shoe their own horses but they would come in and ask you for a bundle of slippers, these old shoes, which would be given to them, and a few nails. Even the poor unfortunates would come off the road on a wet day and ask if they could dry their clothes. They would always know that they could have a cup of tea in the forge.'

Forge conversation, like that of the pub, could be lofty or limp. It flew from feathery witticism to philosophical musings, from shameless lying to thoughtful debate. Sports, politics and weather were the standard topics of discussion. Gentlemanliness dictated that each man should have his say and be respectfully heard. Normally this prevailed, but if it had been a close match or election and vocal chords had been lubricated at the local pub voices could rise to make a point and a clamourous din might resound. The farrier could choose to work away unruffled or join the fray. Even when tempers flared and feelings were hurt there was seldom any great threat of physical uprising. 'I have never known it to go to blows,' testified Boyne, 'but very close to it. In Dublin there have always been strong arguments whether they were football matches or hurling matches or soccer matches. . . the arguments and discussions would go on in the forge. The forge was a good place for chat and fun but not as far as violence was concerned. Arguments would get warm tempered but they always did respect one another's views and it was settled peacefully.'

Harding's forge, tucked away down a small lane, has been less of a magnet for humanity. This is just as well, because he never likes more than three of four visitors at a time due to the distraction. 'You had to concentrate on what you were doing. Sometimes they would have a few at the local pub and it would loosen their tongues and they would come down to the forge for a chat. But I had to concentrate, especially if it was

a contrary horse. In Ireland there's a saying that a fella is an awful "mouth" but you have to listen to him. And he's always found in the forge or the public house. But everything was settled in the forge – politics, sports, how the country was run. You could settle the affairs of the country in the forge. Most of the people that came to the forge were good chaps but some were contrary. They'd settle anything. . . and a bit of scandal as well. We used to enjoy the fella who could give you a good line, a good laugh.'

Then there were those who came to the forge seeking things which worked wonders. The horse shoe has long been a symbol of good luck and to this day people come to the forge for an old shoe that can be buffed clean and made into a presentable wedding present. It is thought that only a shoe which comes direct from a farrier is the 'real thing'. Another common request is for forge water from the vat in which the shoes are cooled. Applied to the skin, it is believed to cure warts, boils and other surface blemishes. Boyne would let a person dip in and apply some on the spot or take it away in a tin or bottle. 'The only ladies who would come to a forge at that time would be coming for the water. We had a great belief that if people had a wart on their finger or any part of their body a drop of the forge water would cure it and that's still a legend around Ireland. The same way as across the road from me with the Dublin Gas Company. When they made their own gasses the children at that time with whooping cough would be left by their parents standing by these big pits of gas tar and they would inhale the fumes and they found that this was a cure. It was not uncommon to see twenty children outside there.' Harding had a bus driver who used to visit the forge religiously for the water but was not content with a few drops – he used to wash his hands in the forge water. 'It took away the warts.'

Farriers would collect manure for neighbourhood city folk to put on their gardens. Filings from the horses' hooves were also saved and used as fertiliser. Harding recalls a retired policeman with bronchitis and asthma who found a medicinal use for the filings. He came to the forge one day and asked, 'Do you have a bit of the hoof?' He began taking a scoopful home each day, igniting it with his cigarette lighter and inhaling the smoke. He swore that it cleared his chest better than anything the doctor prescribed. Boyne had requests no less bizarre. A number of people asked for the blue scale that comes off the hot iron when it is pounded. They would mix it into the soil around their roses, claiming that it changed the colour to blue. Even more innovative was the man who used to tramp the city streets pushing a rickety pram filled with small sods of grass which he sold to bird owners to place in the bottom of the cage. Always he would stop at the forge to collect old shoe nails. 'He used to convince these bird people that to give the bird an iron tonic you'd heat the nail and cool it in the bird trough' – a few pounds ingeniously earned.

Frost Nailing

It was a kind of harvest time for farriers.

John Boyne, 1983

Frost could paralyse Dublin. Horses could not negotiate the slippery cobblestones and pavement without risk of falling. It created a serious danger for animal and man. Paddy Crosbie, writing about his childhood days, describes the scene:

> Falling horses, particularly on frosty mornings, was another hazard. Everybody in those days seemed to have some knowledge of horses. As soon as the horse slipped or fell, a dozen or more helpers gathered around to prevent the beast from rising again while under the shafts. Some held the horse's head flat, others loosened and opened the straps; then the shafts were pulled back leaving the frightened animal free to scramble to its feet.[14]

During frosty periods it was the farrier who literally kept the city moving. Draught horses had to have their shoes fitted with special frost nails for grip. Farriers had mixed emotions when awaking to find the city glazed with ice or snow. It meant a financial boon but physical ordeal. Thousands of horses had to be shod with the greatest speed. Surely the country farrier never knew such chaos. If freezing conditions persisted for days the problems were seriously exacerbated. Boyne remembers well having to rise at three in the morning, working frantically until midnight, falling from fatigue into a few hours' sleep, then being roused to begin again.

'It was our best time to earn money in the snow and frost because we used to put frost nails on the horses to get them out to work. Otherwise there would be no milk delivered, there would be nothing delivered – coal, fuel, nothing. So if the frost struck in the middle of the night we would all be out of our beds and would go to the stables right away. The mail would be delivered to the railway at four in the morning to send all around the country. So, the mailmen would be the first out. The milkman would be the next, about half past four. Now the horses couldn't go out in this and slide and slip. So the farriers would have to jump in and put in nails like spikes with a point. It was a very panicky time for us. A man could do eight or ten horses to the hour. You'd arrive at the stables and you would knock out three nails and put in three nails but you would be using the same holes so you wouldn't have to be driving for new holes. The men would divide up and five men might hit one yard with seventy or eighty horses and we'd be out of there in an hour and a half or two hours. There would be no time for dilly-dallying. . . every man was working. It was a kind of harvest time for farriers because we were going to get the money. It was continual work. If we got frost for a week we'd work for a week night and day. You'd get sleep the best way you can. That was a very, very busy time for us. I remember when I was an apprentice fit to frost and I got about three pence a horse, a lot of money at that time. I think that the last time I frosted a number of horses we were on one and sixpence per horse. But that was a lot of money to us.' After making the rounds of delivery stables he would drag himself back to the

forge only to find as many as forty independent horse and pony owners waiting for their frost nails. They were never turned away.

Bad years are etched indelibly in the mind. 'The toughest year was 1947,' recounts Harding, 'snow for six weeks solid and we've no fuel and people are burning furniture in their homes to get warm. I was working here at half five in the morning for six weeks. The frost nails came from Sweden but during the war years we couldn't get those and we used to have to sharpen them [ordinary nails]. You'd go down to the stables and we'd put nails on maybe thirteen horses before our breakfast. Some horses were very heavy and you might have to do it twice in one day.'

Disappearance of Horses

The place that was once filled with the noise of horses, hammering of metal and the acrid smell of burning hooves has fallen victim to the motor age.[15]

'In the fifties it come sudden. . . deteriorating every day. It was sad. Men started to get out of it,' Harding remembers. Motorisation swept Ireland in the post-war period. Between 1947 and 1957 the number of motorised vehicles on the country rose three-fold, from 52,000 to 135,000; by 1967 there were 314,000.[16] The greatest concentration was in the capital. The era of the city workhorses was nearing its end. Recalling the horse-jammed streets, Crosbie was prompted to write, 'Many Dublin people of the present day find it hard to believe that there was such a Dublin forty, fifty years ago.'[17]

Original horse power could not compete with the internal combustion engine. Horses were quaint and dependable but not economically efficient. The horse-drawn cabs which lined O'Connell Street were replaced by motor cars and the lorry displaced the horse cart. Being located so close to the docks, Boyne witnessed first-hand the containerisation revolution and the disappearance of horses. 'Overnight. . . it's hard to believe, really, how quickly. There used to be horses by the hundreds taking everything from the docks and delivering it. . . your grain, fruit, coal, sand. Then ships were converted, all converted for container traffic. Containerisation eliminated the whole port, really. I mean it was a "roll on and roll off" thing. Big 40 ft lorries with a big container on top and a crane puts them on and takes them off and a forklift truck comes along and takes everything. . . .' Forges began closing up all around the city. Those that remained open were reduced to mostly one-man operations. The shoemaker, tailor or saddler might survive solitary status but for the farrier working both the fire and the floor it was a burden. He coped only because the flow of horses fell to a trickle.

Many of the older farriers failed to fully comprehend the impending consequences of motorisation. Some engaged in self-delusion. They rationalised that many of Dublin's narrow streets and lanes could never accommodate lorries and therefore there would always be a need for the old horse system. To the younger, more realistic farriers, this was clearly wishful thinking. Boyne observed with great sadness the effects of change

upon his father. 'The late fifties was a bad time for farriers. Horses went completely off the road, just overnight you could say. . . although we should have seen these things happening. The cars came in and it was a terrible big bang to men. My father and all the men of his age, they'd just be working and banging here and they were just working away making shoes. They were making shoes and nowhere to go. . . it was sad, really, for them. It was sad for them mentally and physically. They just couldn't see. . . no, they thought that there were a lot of little narrow streets in Dublin and they'd be saying, "Sure there's trucks that'll never get down there. They won't be able to deliver the coal or milk" – they could *never* see it. Mentally more than physically it was very sad. Men of my age, they went to welding or panel beating, they moved with the times.'

As if by reflex action, old farriers continued to hammer out shoes for horses which were never to come. The pyramidal heap of rusted shoes in the corner of the forge is testimony to Boyne's father's wilful ways. Says Boyne, 'He eventually just got that bit old and really mentally disturbed by the whole thing. He couldn't understand it. He didn't know anything else, just working.' Even when his father could no longer strike at the anvil he brought him regularly to the forge. 'I looked after him.'

Adaptation and Survival

Regarding history. . . it was nice to be part of it.

John Boyne, 1983

'One must change with the times. I'm a survivor. I'm aware that there are just two of us now.' Boyne has survived by adapting. In the mid-sixties, when the city draught horse was virtually extinct, there was a new surge of interest in pleasure horses and country riding. Well-to-do and middle-class Dubliners began stabling horses in the environs. If horses were no longer brought to the forge, he could go to them. He became mobile, acquiring a small van, packing up his anvil and tools and doing 'cold' shoeing around the country and as far as Wicklow. 'Today I have a thirty-mile radius shoeing mostly showjumpers, race horses, yearlings, polo ponies.' He covers private stables, stud farms and riding schools and performs farriering for the Irish army and the RDS.

It has been a dramatic shift for labouring men from shoeing heavy work horses in a hot forge to pampering polo ponies in the airy suburbs for the leisure and pleasure set. Physical adaptation has been easier than the mental and emotional change. Boyne's heart is clearly back in the forge where he still spends several hours each week making shoes. On occasion, a horse or pony is still brought to him. He enjoys the new social contacts and finds countryside rambling invigorating but misses the old ways and intimate contacts. 'I miss the horses coming into the forge and the chat because a man driving his horse, he was driving it for his *living*. That was getting him a living every day and therefore the communication between the horse, the man and the farrier was very, very close. A man used to come in and tell me how his horse worked today or who he had met or what he'd done, some little bit of history about the day's work,

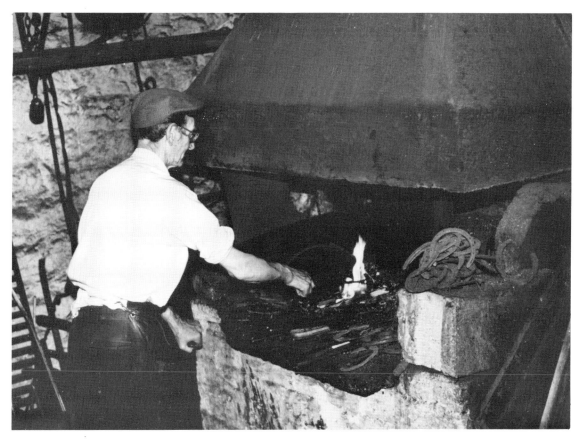

Farrier James Harding pumps his century-old original bellows, the oldest still in use in Ireland

which was interesting.' He had a strong kinship with his fellow working men. In the forge he felt the very pulse of the city.

In the seventies, due to the incipient popularity of horse riding, there occurred a shortage of farriers in Ireland. In response, Bord na gCapall established a training school. Boyne's son enrolled in the programme to gain certification, though he has learned most of what he knows from being with his father in the forge. Boyne wants to keep the forge for him but the Corporation is menacing. 'How long this forge is going to last is a very hard thing to know because of these new developments in the city. There's a great danger. It makes me sad to think that it might be eliminated. You've spent the best years of your life here in the forge. It would be lovely to think that it might be kept here. As long as I'm alive and no matter what it costs to work to keep it, I'll keep it. . . no way I'm going to let it go, barring everything coming down like a new roadway or something.'

It would seem that his son is carrying on family tradition. However, things are not the same. In truth, he is one of the new breed of mobilised, mechanised shoers of horses. There is no flailing at the forge before a fiery hearth. No men clustered around the anvil in animated conversation. No heavy draught horses to nail before the light of morning so that the city can stir. It is not the old craft. The old craft lives on in his father – and it will die with him.

Harding did not adapt. He had neither the financial means, the will, nor the energy to abandon the forge for the countryside and a new way of life. After nearly sixty years of pumping bellows, pounding metal and wrestling with giants he is visibly weary and worn. His strength sapped, he no longer has the confidence to handle large horses. There is a tentativeness in his manner that a clever horse sometimes detects and exploits. It is not easy for him to admit to uncertainty and fright. A few loyal and caring customers still bring their horses from the city outskirts to his forge. In a good week he might get seven or eight, just enough to keep going. He has shelter and food and wants no more. For the past fifteen years he has worked alone. A friend, sensing his loneliness, suggested that he get 'one of them transistor radios. . . ah, no way. . . with the hammering you couldn't hear it anyway.' Sometimes boys will wander over from the disco and peer into the darkness but, 'They can't understand.'

The forge has been his life but he has no-one to leave it to. 'I'm a bachelor. The two things I haven't done in my life is committed murder or got married.' He frets openly about its fate. 'Many farriers have come in here and said, "This is a fine forge". About thirty years ago this was grand. The ballroom and the factories wasn't there. It was more open and bright. Now, when you get the fire going the smoke can't get out. . . can't keep the forge clean now. I had an old man, seventy-eight, an old smith, come in the other day. He has to come in. . . can't get it out of his head. . . just can't resist coming into a forge.' Harding understands.

His health is failing and he has at best another year or two of work. He accepts that the forge will then probably fall to redevelopment. What would he do if they came to demolish it? 'Well, I'd have to go for a long walk. . . to think. . . going back years. Some were tough, some were good. Good memories and bad here. I can still see my father here and see this old fella, Jack Mooney, coming in and taking up the tongs. I can remember things forty years ago but if you asked me about ten years ago I couldn't.' Soon his hammer will fall upon the anvil for the last time and the ring will dissolve in the Dublin air – never to be heard in the city again. 'When I go there'll be no more.'

5
Saddle-Harness Makers

When one considers how for thousands of years the horse was a critical factor in transport and communication, the saddler's part should not be underrated.[1]

It's amazing the number of people that you hear speaking, going by the door, saying, 'I didn't think that there were any saddlers left in the city.'

Sam Greer, 1983

The craft of outfitting animals with leather harness and riding gear can be traced back to ancient Egypt but it did not develop fully until the time of the Romans.[2] In the British Isles by the Middle Ages, when men journeyed afar on horseback and by coach, the saddler's role was indispensable. In self-supporting rural communities he was nearly as important as the blacksmith and carpenter, producing farm tackle, belts, straps and most other leatherwork not done by the cobbler.[3] In the city, saddlers equipped draught horses and outfitted fine steeds that drew carriages. City dwellers always demanded more refined, ornate leatherwork than country folk. Saddlers thrived in Dublin, where they had their own guild. The craft flourished during the opulent Georgian period when the Anglo-Irish adorned their riding and carriage horses with leather finery. Around the turn of the century leather accoutrements were still much in vogue and view:

> In those days (1900) it was the hobby, or the fad, of various wealthy people to drive coaches for their own amusement, or possibly to indulge their love of horses and driving. These coaches were usually expensive affairs and were drawn by four matched horses. The harness was always very shiny and well-kept and the trappings and buckles.[4]

Harnesses even produced a sort of street music to which Dubliners became attuned. As Keatinge writes, 'Is it my imagination, or was the Dublin of half a century ago a more colourful place than it is today. . . did the buckles on the harness of Mr Malcolmson's coach-and-four jingle more musically than their present day prototype?'[5] Leather rubbing and brass jangling was a natural sound of the city. Catering to both work and pleasure horses kept urban craftsmen busy. The 1911 Census lists 254 saddle-harness makers in Dublin. However, like his cousin, the farrier, the city saddler lived by the work horse and faded with the motor age. Today only two remain.

Last of the Saddlers

It must be the most photographed shop in Ireland.

Sam Greer, 1983

In Smithfield Market next to Red Cow Lane and across from Thundercut Alley is a humble little shop whose face reads 'Patterson's Saddlery, Established 1890'. Its bricks are crumbling and the wood in want of

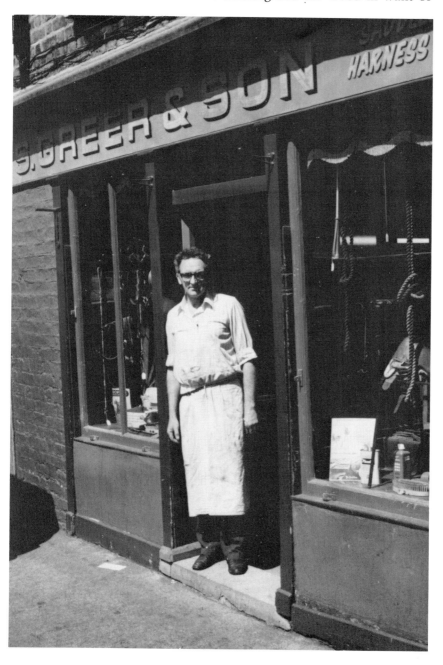

Saddler and harness maker Sam Greer in the doorway of his shop on Poolbeg Street, central Dublin. The sight of this old saddlery in the heart of the city draws many curious visitors

paint. At the workbench, which faces out into the cobblestoned street just five feet away, sits sixty-five-year-old John Cruite, saddler and harness maker. He has a slight frame, fair complexion and silvery-white hair. Soft-spoken and reflective, he is inordinately fond of the phrase 'honest-to-goodness'. His light, lyrical voice is that of a choir boy. Beneath the white cloth apron is a tie. It is a touch of formality he likes. Exactly why, he can't explain. More than a surviving craftsman, he is one of the last real journeymen. Twelve years of tramping country roads and nameless boreens gave him a special perspective of the craft. Even on the road he wore his tie.

Across town on Poolbeg Street, a stone's throw from Trinity College and a hundred yards' distance from O'Connell Bridge, saddler Sam Greer stitches away at his bench. Born in 1926, he followed his father and grandfather into the craft. Dark-haired, blue-eyed, there is an intensity in his speech, his gaze, even his stitching. He works away uninterruptedly as the tape recorder listens to his words. His answers are often concise, economical, snappy. No need to waste words or leather. His father worked beside him until the age of eighty, when he was forced to retire due to failing eyesight. 'He's still not happy about it.' The shop, of which he is openly proud, has become something of a city-centre curio. It bears a striking fascia board handwritten by signwriter Kevin Freeney. One old craftsman appreciates another. Scarcely an hour passes without a pedestrian halting, interpreting the façade, and peering curiously within. When they find it inhabited many feel compelled to enter. Visitors are welcome but work won't cease for the sake of chat. 'They want to come in and take photographs. I'm sure that it must be the most photographed shop in Ireland.' One photograph was made into a postcard and displayed on racks around the city. It delighted him. Struck by its aged authenticity, a cigarette company filmed a commercial in the shop – presumably in the hope that the rich, old-fashioned flavour of the setting would be conveyed to their product in the minds of viewers.

Old Saddlers and Shops

Old harness makers. . . they were a set all to themselves. They had their own peculiar ways.

John Cruite, 1983

Greer was apprenticed under his father while Cruite learned the craft from an older brother. Greer's early experience, beginning at the age of fifteen, was typical of the times. 'You'd get there in the morning, sweep the floor and build the kettle for tea. You might be told to go and clean the windows or wash down the paint work. Or you might be sent out to a stable yard to pick up material. The working day was nine to six. We had tea breaks back then around half ten. . . it was religion, you had to get your tea. My first week's wages were two and sixpence in old money out of which I had to give my mother one and sixpence. But you could buy ten cigarettes for fourpence and get into a cinema for fourpence as well, but you were broke by Monday.' Over seven years he was taught about tools, leather, stitching, making waxed threads and fitting horses

snugly. The knowledge handed down was little changed from the days of the guilds; implements and techniques are much the same.

Around the early forties, when he was taking up the craft, Cruite remembers about twenty saddle-harness makers' shops in Dublin, with an average of two or three men in each. In Greer's there were five. Thus approximately sixty craftsmen served the urban horse population. Owing to the scarcity of materials during the war years and a gradual decline in horses, competition was stiff. 'They'd undercut one another,' recalls Greer, 'there was a lot of poaching [stealing customers] went on.' Old saddlers could also be secretive about their techniques, hiding knowledge from the younger generation gaining on them. As a young man Cruite would visit different saddlers' shops for a friendly chat, only to be viewed with suspicion. 'The majority of old harness makers, they were a set all to themselves. They did have their peculiar ways. If you went in to see them working and they'd think you're looking at them, they'd nearly cover up their work. They didn't want you to see what they were doing. . . very secretive some of them.'

One reason for such guarded behaviour was that specialisation still existed. Prior to the twentieth century the craft was ordinarily divided into saddlers, harness makers and collar makers. Around 1900, when horses declined and craftsmen dwindled, many survivors had to expand and make all three products. Due to the importance of the draught horse, most city craftsmen concentrated on harnesses but in some Dublin shops which catered to a wider clientiele there was still great enough demand for all gear to allow specialisation to persist. As Greer recounts, 'During the war years my father had five men here. There was plenty of work at that time. In those days when I came into the trade and more so in my father's time, you had men who specialised in one aspect. You could be working five or six harness sets at one time. One man would spend all his time doing bridles and reins, another fella would be making saddles and other fellas were experts on repairs but they were no good at making stuff.' Expertise could be established. 'I always tried to specialise in harness making,' says Cruite. Others would make nothing but collars. However, as the craft began to shrink in the fifties, a man could no longer survive financially by making only one product. As Greer puts it, 'Nowadays you have to be an all-rounder as we say.'

Both piecework and the straight wage system prevailed, and, as usual, there was disagreement over which better served the craft. Some shop owners insisted that their men work on a flat weekly rate, reserving piecework only for journeymen; others gave employees a choice. The saddler's piecework system was more detailed than most because work could be broken down into separate tasks such as lining and trim. As Greer explains it, 'There were two systems of payment used. Some men would work only piecework, paid for each individual job such as a bridle or collar. Others preferred a flat wage, a set price. In the old days you had to do what was called "make up a book", which was so much for lining a collar, so much for lining a saddle, so much for making a reins and so on. My father was never a lover of piecework because he said that it led to inferior work and slipshod methods to get work out quick. He preferred a man to do his best for a week's wages. It left him in a

better position because he'd know exactly what his outgoings were for the week. If you wanted really quality work you wouldn't do it on piecework. Your regular men employed over the years were on a weekly wage. It was only the drifters [journeymen] who would do piecework.' (At least in his shop.)

Saddlers' shops used to be among the most intriguing and colourful in all Dublin, primarily because assorted wares were displayed in front. Hung on pegs or arranged on the pavement were saddles, harnesses, reins, collars, brass fittings and sometimes bright blankets to set them off. This visual cornucopia could be spotted a hundred yards away. A heavy scent of leather added to the appeal, and the scene was always enlivened by a horse or two awaiting a fitting. Neighbourhood children delighted in just hanging around. They might mount a saddle and plunge into the world of make-believe, or, playing the clown, insert their nubbly head through a pony collar. Adults were content to just rub and grip the leather because it felt good. No thought was given to someone snatching an article. Greer did not have to keep watch from his workbench as people fondled the merchandise. 'There were hooks outside the door there and when you'd open the shop in the morning you'd hang out collars. . . advertising or for sale. You know, people would spot them. But you couldn't do that today. You couldn't turn your back. They wouldn't be there for five minutes.'

Inside, walls were lined with hanging leather gear and gleaming brass fittings. On the floor were stacked a few saddles and a heap of collars. A full stock was kept because demand was great. Saddlers made up products knowing that they would be sold. 'It was completely different years ago,' says Cruite, 'because people were bringing in their stuff and taking out stuff all the time. . . every other day. Firms like dairies had sixty or seventy horses. You'd see more stuff hanging up for sale because there was more demand. You always had a certain amount of harnesses made and hanging up and if a man wanted a collar or such you had it there. You could afford to make them up ahead of time and you would know that you'd surely sell them. When I was young I seen at least forty collars hanging in a shop this size.' Those were the days when big orders could arrive at any time – like the day the man from Johnston, Mooney and O'Brien casually approached the counter and placed an order for twenty-five full sets of heavy van harnesses. 'It was fantastic.'

Outfitting the Horses

If the horse's health depends to a great extent upon the skills of the vet and the farrier, its efficiency as a working animal owes much to the saddler.[6]

Greer's shop, smack in the middle of cinemas, elegant restaurants and office buildings, obtrudes as a glaring anachronism far removed from any world of horses. Visitors with obviously little sense of history naively inquire why it is so misplaced in the city centre. 'People today don't understand why this shop is so central,' he says, 'but the reason was that it was central to the *docks*. Seventy-five per cent of all cargoes and goods

coming into the country were handled by horses at that time.' It was ideally situated in the midst of horse circulation. O'Connell Bridge and the quays were the hub for north-south and east-west traffic. At some time during the day most horse-drawn vehicles passed within close proximity to the shop. The fact that five men were fully employed is testimony to the brisk business.

Apart from making gear, the saddler played a vital daily role by being on constant duty to repair it during working hours. As Cruite likes to put it, 'They were depending on us to keep the wheels turning.' With legions of horses hauling sundry products through the urban maze there were constantly problems which demanded the saddler's attention. Harnesses, reins and straps would become loose or break. Often the saddler had to improvise to get the delivery animal through the rest of the day. Equipment could be removed and brought in for repair or, as Greer attests, 'They used to bring the horses right up here to the shop. I came near to getting killed one day. I tried to hold onto a runaway horse from inside the door and he was in chain harness and the harness came undone and hit me across the crown of the head. . . knocked me out. But you'd get the man working down at the coal yard and he might have a breakdown and he'd rush up and get a rein repaired or something that could be done in an hour or so and you'd generally help them out because otherwise it meant that they might have to go back two or three miles to a home yard to get replacements. We knew most of the men in different yards on a first-name basis. Some you'd be more willing to oblige than others. And at that time you had foremen going around. They used to drive in a trap and they'd be checking on their own men, their own firm's men, who were working with the horses and if they broke down they'd tell him and he'd go back to the stable yard and pick up whatever they needed in the line of a spare or they might say, "Go up to Greer, you're only around the corner."'

City saddlers generally turned out a different product than their country counterparts. Harness, reins and straps were heavier, double-stitched and stronger. Saddles and collars were usually more refined, ornamented and costlier. For ponderous draught horses leather gear had to be extra durable and safe. Leather took a beating. 'There was no comparison between the city harness and the country harness,' contends Cruite, 'the city harness was all double harness, double stitching and much bigger and all brass. They didn't use them in the country on the farm. They never bothered about brass. And the van harness used for the bread and milk [horses], very few firms in the country used van harness. They had to be stronger because you had a horse on the streets all day long and it had to be one hundred per cent. If the horse ran away in the country in a field, well, nobody would be killed. But in the city if you had a van harness and it didn't do as good as it should and they'd break away it could kill many people. And the Dublin harness would have a better finish on it.'

Greer found prosperous dairy and bread companies eager to invest in fancy leatherwork to enhance their image. It was good promotion and public relations. In his estimation, only the experienced city saddler could produce heavy leather gear which was also highly refined and finished.

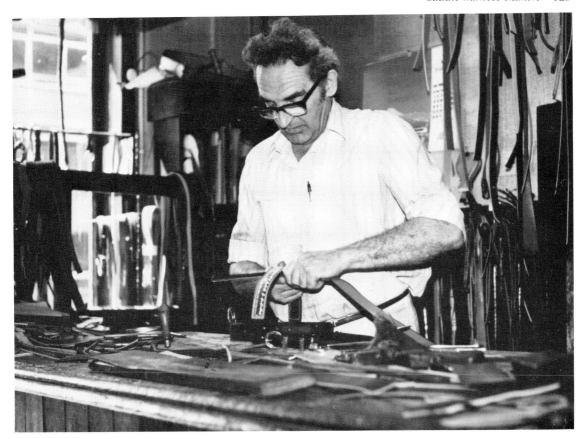

Saddler Sam Greer learned the craft and inherited the shop from his father, a master craftsman. In the old days Sam made mostly sturdy gear for heavy city working horses. Today his products are lighter and more refined for pleasure horses

'I'm not ridiculing the man in the country but they don't do as high a quality as we do. . . and they can get away with it. You don't need the refined stuff in the country and you won't get paid for it. The horses in the city were heavier horses pulling heavier loads and therefore that required heavier harnesses. There would be wide strapping and heavier collars. . . city working collars we called them and they were better finished and more ornamented. Years back the bakeries, dairies, coal yards and the like, people with a big number of horses, firms with an average of thirty-five to fifty horses, they liked a bit of show. . . you know, it was good advertising as well.'

Greer's View of Journeymen

Some you'd employ and others you wouldn't let inside the door.

Sam Greer, 1984

Over the years Greer and his father had innumerable journeymen traipse into the shop seeking temporary work. Experience showed that each had to be treated individually. Some proved feckless, others reliable and useful. He kept an open mind, making it a practice to always put them to a test before promising work. If he hired them he expected a fair job for a fair wage; they were treated kindly but not coddled. He remembers

them in this way: 'In the country most of the harness makers would more or less have their own shop and live in an accommodation combined and the journeymen would live with them. The harness maker's wife would feed them and wash their clothes and deduct for board and lodging. It was hard to get them to come to the city in summer time. They'd only come in winter. They'd sort of dig in at that time and they might do a month or two months here and drift off to somebody else in the city.

'If they were hard up you might, for the sake of charity, give them the price of a meal or a night's lodging. You wouldn't let them down. You'd give them the price of a meal so at least they wouldn't go hungry. Some would come with all their possessions in a bag or case. . . they'd just walk up. The men who came here were mostly journeymen collar makers. Some you knew by reputation. Some you'd employ and others you wouldn't let inside the door. Some of them could be a bloody nuisance and a lot of them were alcoholics and they'd work for a drink. Well, you'd test them out. Like a fella would come in here and say, "I'm a collar maker, do you want any collars made?" So you'd give him one collar and let him make it and you'd know immediately whether he knew what he was doing or not. Sometimes they wouldn't be to your satisfaction and you'd have to get them to adapt to what you wanted. Some of them could and some of them couldn't but you'd always pick out the chancer. They were principally what we called rough collar makers. You'd supply all the materials and they'd make up a stock of "roughs" – that's collars before they're finished. They wouldn't put the side pieces on or line them, that wasn't their job.

'Most were decent enough and they wouldn't forget if you got them out of a hole. Their failure was that most of them were fond of drink, but they wouldn't be the fighting type. They weren't abusive or anything like that. They were fools for themselves, really. . . they worked their guts out and the publicans benefited from their labours more than they did.'

On the Road: A Journeyman's Perspective

You'd go to a shop and get a couple of weeks' work. Then it would be a lovely sunny day and you'd move off.

John Cruite, 1984

Cruite was one of the last roving journeymen in Ireland, the tail end of a vagabond breed. In his twenties he felt footloose and fancy free. With no intentions of early marriage, he set out on a bicycle to explore the country and perhaps discover something of himself in the process. The forties was a good time to be on the road. Traffic was sparse, people were friendly and saddler shops were plentiful. It was still a relatively innocent, uncomplicated time for Ireland. Itinerant life was safe. People were honest and trusting and crime little known. It was an especially rewarding time to be a journeyman because this was the last real decade of travelling craftsmen; very few straggled into the fifties. Cruite mingled with countless blacksmiths, farriers, shoemakers, saddlers, coopers, tailors and others. He met them on the road and in shops, and lived with

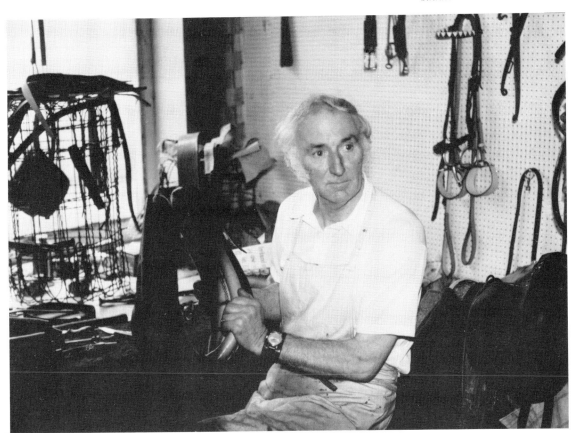

Saddler and harness maker John Cruite, owner of Patterson's Saddlery Shop in the old Smithfield Market. In his early years he tramped the country roads as a journeyman. Today, at sixty-five, he still makes handcraft horse and pony gear for a discriminating clientiele. Sadly, his little shop is now regularly vandalised

them in boarding houses, some of which catered specially to journeymen. He encountered all types – gentlemen craftsmen, crisply attired, who could quote Yeats and spout philosophy, as well as raggedy lost souls who lived from drink to drink and slept in haystacks and graveyards. All were equal friends. There was something to learn from each. It was an unorthodox education for a young man, but one he wouldn't swap. In retrospect, they were the most exhilarating and joyous years of his life. He tells his own tale of life on the road:

'After I finished as apprentice with my brother I travelled the country as a journeyman to go to different shops to work. I was a journeyman for twelve years. I seen a lot of the country. I travelled to Wexford, Tipperary, Limerick, Clare, Cork, all over. I slept in boarding houses. Never thought of sleeping out, doing the hard life, cause I knew the old men who did. . . met a lot of them in my time. You'd go to a shop and get a couple of weeks' work, maybe stay a month and then it would be a lovely sunny day and you'd move off. If I wasn't satisfied I'd move off because there was no problem getting work and I was young and carefree because "when your cap is on, your house is thatched" – that's an old saying. It means that you're free, you can do as you like and if it rains, well, you have your cap. You'd only have to carry about a half dozen tools and that would be sufficient to keep you moving. Wherever you'd go the leather would be there. You'd carry very little clothes with you packed in just an ordinary little case. Maybe I stayed in a job for a couple

or three weeks and would move on again in fine weather. . . it's lovely to be out. I had a bicycle so I cycled. But the best pleasure in the country is walking down a boreen. That's real nature as you're walking along. You see all the little rivers and streams. I do miss it.

'It was great experience travelling all around and meeting all the different tradesmen, all the journeymen. I remember in Limerick an old man came in, Riordan was his name, and it was a real hot summer and he had nothing on him, only a pair of white shoes and a big long black coat. He'd no shirt. He kept moving and never had any money. He drank the few pence he had but he was the perfect gentleman. He was wasted really because he wouldn't stay in a job. He was like the travelling people. . . he wanted to keep moving. And one time I worked in Offaly and I was staying in digs and there was about twelve different tradesmen there – blacksmiths, tailors, the whole lot and we had a great time. An old fella once told me, and he travelled the twenty-six counties and England as well, that once there was up to fifty craftsmen on the bridge of Athlone on a summer's day. They all happened to meet. There were blacksmiths, harness makers, tailors, old craftsmen. . . and he says it was a sight to see.'

Settling down in Smithfield

On Monday evening that square out there, you couldn't move in it because of all the horses and loads of hay.

John Cruite, 1983

After a dozen eventful years on the tramp Cruite 'wanted a change'. Returning to Dublin, he took a job with Donoghue's on the quays. After about a year the elderly owner of Patterson's Saddlery asked if he would like to take over the little shop in Smithfield. It struck him as the perfect location because the market area retained a strong rural atmosphere and was filled with horses and country people. For an ex-journeyman it was an ideal way to keep in contact with the outside world. From his bench window he could visually feast on all the raucus activity of the historic market place. 'Back then it was cobblestones. And every Monday evening you would see loads of hay with horses. Horses would come from Co. Meath, Kildare, Louth, all over and there was always a sale of hay on Tuesday morning. On Monday evening that square out there, you couldn't move in it because of all the horses and loads of hay. They'd have come on a long journey before dark and they used to park their loads of hay, stable their horses and have a couple of drinks. And they would come out and sleep on the hay which was very warm, you know, until morning. And there used to be a horse fair on Wednesday and you'd see the horses running up and down. There would be a hundred horses anyway. I have seen horses running away and they do a lot of damage. They were honest-to-goodness people. They'd come into the shop with their stuff and if they wanted anything. They all knew one another and enjoyed themselves. The majority of people have gone now. It's all changed. It's not the same anymore. All the old people are gone. . . and the old people you could trust.'

There was no more lively spot in Dublin than Smithfield. It boasted a

hotch-potch of colourful characters – market traders, horse dealers, hay sellers, cattlemen, tinkers, vagrants and 'observers'. There were four other saddle-harness makers in the market at the time and this drew journeymen. Having been a man of the road himself, Cruite was unfailingly sympathetic. Many were eccentric but one in particular stands out in his mind as a man whose happy-go-lucky nature exemplified all the journeymen he had known over the years. His speech and expression become more animated when talking of this old fellow who had so amused him:

'I remember one old man who came here and said, "Will you give me a few week's work?" And I said, "I certainly will," because you always liked to help out a journeyman coming in. He said, "I'll make a few collars for you" and I said, "By all means." So I got the stuff out and he started to make them and he was *fantastic*. He was one of the oldest that I'd ever met over the years and he had a white beard, snow white, that came down to his stomach. And he had fantastic hands. He had fingers like piano fingers. . . you know, long fingers. You'd never think he was a harness maker. And he was trim and proper. He was a Wexford man. He had been broke a lot of times and slept in graveyards. He stayed with me for about a month because he said he wanted to get a bit of money to buy a few clothes cause he was moving off and said, "I won't draw any wages." And he said, "I think I'll go to England for a holiday". . . he wasn't going to England. He always used to sing "The Doggy in the Window". Anyway, he got the money off me on the Saturday and he was a terrible man after the dogs and horses. So he went on the beer that Saturday and he hired a taxi to go down to the dogs, to Shelbourne Park, and every penny he had he lost in a couple of hours. And he come in to me on Monday morning and says, "I'm broke, will you lend me a couple of pounds for to get a few drinks?" And that man, you know, he had *nothing*. And he came back into work the next day and I never heard one curse out of that man. You see, other men would have been cursing and swearing. And, honest to God, I said to myself, "That is a *man*." It was *his* decision and it was *his* money he was spending. And he was quite happy when it was all over. He wasn't giving out to anybody. He might have been giving out to himself inwardly. Oh, I'll never forget him as long as I live.'

Smithfield suited him perfectly. He regularly saw old friends, journeymen visited, horses could be led directly to the shop, and life in the market was always interesting. The four neighbouring saddlers were all elderly and without sons entering the craft, so it seemed that he would eventually inherit their business. Since he was already working long days he decided to take on a partner who became his closest friend and confidant. They were, he felt, like brothers. Mutual trust and dependence developed. During troubled times the other was always there for support. For twenty years they stitched side by side without so much as a tiff or cross word. 'Tommy Slattery was his name. He always done the light work and I done the heavy work. He was true-blue. You could trust him. . . trust him maybe more than your wife. He always worried about me. If I was sick, when I was in hospital for a few months, he was very worried. He took control and there was no problem. When he died off I was very sad. Dear, dear, I'll never forget it. It was like my left hand,

you know what I mean? It's true, it was like part of you gone.' After Tommy's death, he could barely bring himself to return to the shop. To this day he still feels his presence. It was *their* shop. He has worked alone ever since.

Decline and Change

The old men died off and sons never took it on.

John Cruite, 1984

That is the way it was. 'Just like me,' says Cruite, 'my sons won't take it on. When I came here there were four harness makers in Smithfield and they were all old and they died off.' During the fifties, when draught horses were being replaced by lorries, most saddlers' shops were reduced from two or three man operations to one-man businesses. Sons saw no future in the craft so when the father died it died. As business withered away financial circumstances forced other craftsmen to retire. Saddlers' shops vanished. Those few which remained became conspicuous for their survival. It was a period of struggle and uncertainty. 'We had a lot of bad times over the years,' confides Greer, 'when the heavy working horse was starting to go off the road and being replaced by motor transport in the late fifties and early sixties. You'd be tempted to get out of it at that time. A lot of people did get out of it. A lot disappeared at that time. Like a lot of men that had families and sons wouldn't dream of putting them into it because the future didn't look good at that time.' Due to economic need, the dwindling craftsmen had to take on such tasks as making belts, brief-cases and other leather products. Greer made some 'human harnesses', strong leather bindings to restrain drug addicts, 'to stop them from injuring themselves' – a sad sign of the changing times.

Like the farriers, saddlers who hung on through the lean years found that by the seventies the pleasure horse craze produced new business, but it meant adapting. With heavy work harnesses no longer in demand, Cruite and Greer had to begin turning out fancy saddles and light, refined reins, show harnesses and decorative collars. Greer enjoyed a distinct advantage, due to his father's shared experience. 'We adapted. We had to more or less rebuild. We changed over into saddlery and light harnesses. We were maybe more adept at getting into the lighter stuff than others. And the fact that my father in his younger days in the first World War did a lot of light harness and he never forgot how to do it. And his father before him did all the stuff. My father was able to tell me the way the old things were done. . . I was lucky that he lived so long. Other fellas weren't so lucky because their fathers died out and weren't able to pass along the information.'

He works in the old shop but now makes new products for a different clientele. Horses are no longer brought to his door. If so, they would have to be tethered to a parking meter. He seldom sees horses anymore. In fact, he often fails to see even their owners. 'Owners. . . an awful lot of them we don't even see other than to speak with them on the phone because they send a groom in.' Drivers of dairy, coal and laundry carts had no grooms; but this is the eighties, and if the new system is socially

stagnant at least it is financially profitable. 'You're getting better rewards for your labour compared to years ago. Men used to do some very high-class work for very poor wages.' Today a saddle that once sold for £20 now fetches £250. Business is so steady that Greer agreed to take on an apprentice sponsored by Bord na gCapall. He is being trained to produce light leatherwork for pleasure horses. However, even after his four-year term, says Greer, 'he won't be what I would call fully qualified because I wasn't after seven years.'

Finishing out the Years

It's my life. I look forward to coming into the shop each day. I'll never retire.

John Cruite, 1983

The craft of saddle-harness making seems destined to survive in Ireland, owing to the resurgence of interest in pleasure horses and ponies, but the city craftsman who played a special historical role and produced a different product from the country saddler will disappear with the passing of Greer and Cruite. No sons will follow. Tradition will cease. As Greer declares, 'Our family had a good reputation over the years. People still come in here and tell me that they remember my grandfather. You've got to have love for it and a desire to produce something well finished. I have no sons. I'm the last of the family.' If allowed to do so, he believes that he can work well into his eighties. But the shop is precariously placed, hiding in a high-value property zone ripe for development. To sweep it aside in the name of progress would be all too easy for the Corporation, which is good with the broom. He has heard unsettling rumours. The future is beyond his control.

Cruite's shop, like Smithfield itself, is haggard, crumbling and under threat of demolition. He hangs on. It is a quiet existence. In the old days he could get thirty customers in a day. Now he is lucky to see that many in two weeks. Some days there are none. Now, more than ever, he welcomes visitors of any sort. 'I like people coming in to talk to me. Little children love to come in and see the old harnesses and the old collars and old saddles. . . the old things that their grandfathers used to have. People who come in love the smell of leather. When a customer comes into the shop I usually have a chat with him but it's not like years ago, they're all in a hurry now. I miss the old men, the old harness makers who would tell me about the past. Some old men still come around, men in their eighties most of them. They'll have a chat about the old times and the horses. It's sad, you know, to see everything gone.' As he speaks, a bellicose lorry rumbles past, causing the already arthritic shop to quake and crack further. 'I do miss the horses trotting by.'

The neighbourhood, once so comforting, has now become menacing. Old securities are shattered. Over the past eighteen months alone his shop has been vandalised three times. He walked in to find the interior brutalised, his private world torn asunder. Besides saddles and harnesses, century-old tools were stolen. 'Irreplaceable tools. They'll probably dump them — that's the age we're living in. You could leave the door

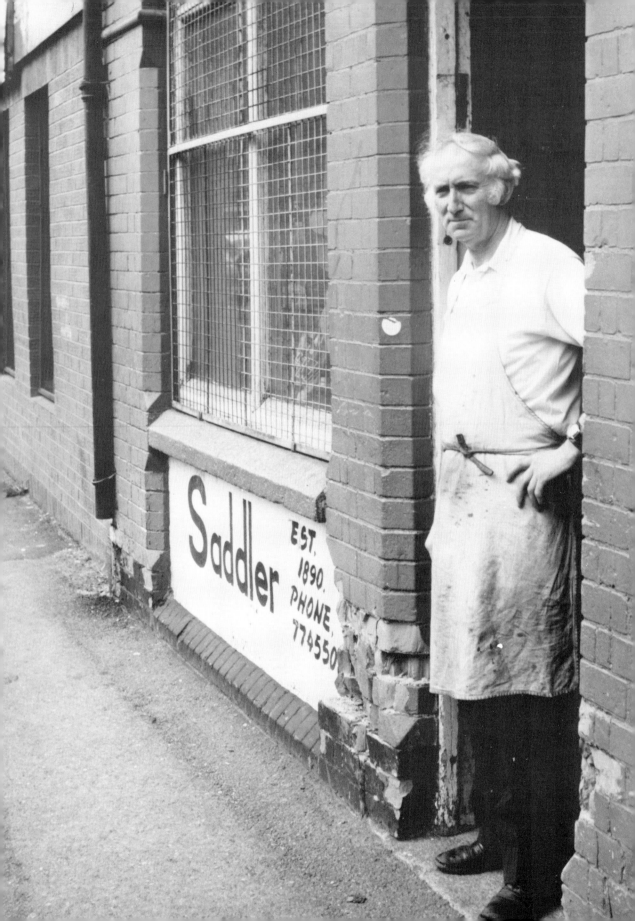

Saddler

EST.
1890.
PHONE
774550

open years ago and nobody would interfere with you. For a small man to walk into his little place and find it vandalised, it affects you inwardly.' Allegedly, the culprits were youths. As he describes the crimes a band of bored, tough-looking teenagers sit just across from his shop along a concrete wall adjoining a boxy tenement complex. They toss rocks, taunt passers-by, pass the muggy summer day in simmering discontent. Violating innocent shops provides diversion. When Smithfield was a living community thuggery was non-existent. A good pub row was the greatest local upheaval. Cruite cannot comprehend the present-day hostility. It frightens him. Now he is not only fearful of leaving the shop but also of returning to it.

Patterson's saddlery and the owner John Cruite

However, he refuses to abandon the place. However vulnerable, it is his niche. 'I have a great love for my work and I'll never retire. I'll keep working until I'm not able to do it. I look forward to coming into the shop each day. . . it's my *life.*' About his own imminent passing he says, 'You trust in the Man above. That's all we have in the end, no matter what you do in this life. We have something to look forward to. . . to me, that's something I always think of. You trust in the Man above and he will lead you on the straight road.' And when in heaven? 'Ah, I would like to meet the whole lot of them [old craftsmen]. . . God, I'd love to meet the whole lot of them that I met as a journeyman.'

6
Stonecarvers

The craft of stone-carving is rapidly disappearing.[1]

We're a dying breed. It's inevitable. In stoneworking when a man dies a link is broken. . . there is nobody else. We'd hear of a man dying and we'd say, 'Oh, you can't ask him about that because he's gone, dead now.' So the whole line of information is dried up.

Eamonn Crowe, 1983

Evidence of early stoneworking in Ireland may be found in 3,000-year-old tombs.[2] Stone fortresses such as Dun Aengus (2,000 years old) on the island of Inishmore exhibit impressive masonry. During the medieval period there was a proliferation of fine stone churches, castles and abbeys, many of them finely carved. Scattered ancient reminders are still visible – beehive huts, round towers, Celtic crosses and graveyard headstones. Because much of Ireland is stony, stone has always been a ubiquitous building material. Even country folk break Connemara rock for building cottages. Stone is symbolic of a hardy land and people.

Carving, the elitist branch of the stoneworker's craft, advanced in sophistication with the influx of English craftsmen introducing new techniques. Following Catholic Emancipation in 1829, church-building received a powerful impetus, a boon to carvers and masons. Many splendid churches and imposing public edifices were built between the first quarter of the nineteenth century and the 1940s. In Dublin, stoneworking firms – mostly concentrated along Brunswick (now Pearse) Street – flourished. C. W. Harrison's, one of the largest, was typical, identifying itself as a 'Monumental and Ecclesiastical Sculptors'. In 1900 they advertised that they made 'Monuments, Headstones, Tombs, Pulpits, Altars, Baptismal fonts, Tablets'. The craft was healthy. In 1911 there were 218 stoneworkers in Dublin. How many were specifically carvers is not known but much carving was done at the time. Stone seemed a basic, irreplaceable material.

Of all craftsmen, stoneworkers have perhaps been the most clannish. Even other artisans found them unusually 'obsessive' in their devotion to craft. In many ways they were like one large extended family. Stone was their *raison d'être*. They worked it, talked incessantly about it, dreamed of it, lived it. They knew and cared about little else in life. Their English counterparts found them a curious breed. Over a century ago it was claimed that Irish stoneworkers had 'peculiar properties and idiosyncracies little understood' by English craftsmen and architects.[3] It was even alleged that Irish stone masons used *poitín* for tempering their mortar. Seamus Murphy, in his classic work *Stone Mad*, lovingly immortalised

the 'stonies' around Cork, describing their idiosyncratic traits and indomitable spirit. He wrote out of a sense of duty to record a vanishing way of life. Twenty years ago Murphy wrote:

> I'm afraid the future holds little in store for us, especially in the cities and big centres. Like many more of the crafts, we will be squeezed out into the small towns and villages where tradition dies hard, and people still insist on a tombstone in stone. . . but it will be a precarious existence at best and cannot survive long.[4]

Dublin stoneworkers proved especially vulnerable because in the post-war period concrete and steel construction assaulted the city. Labour-intensive stone building methods became economically impractical. The era of grand churches, buildings and monuments passed away. Coincidently, machinery crept into the stone yards, usurping the old mallet and chisel. Finally, imported stonework and changes in church ornamentation sealed the craftsmen's fate. To be sure, stonies railed against imports, mechanisation, and those 'damned concrete churches', even entertaining the quixotic notion that somehow they might persuade the government to pass a law requiring that such structures be made of permanent stone. However, it proved futile. As Tomit, one of Murphy's more cynical and realistic cronies complained, 'You can't stop progress, it's a mechanical age and we're in for the same fate as the coach-builders and the harness-makers and all the rest of them.'

Yet a stubborn, proud few remain, men who, in quiet defiance of mechanisation, still wield the hammer and chisel as did their fathers before them. Working mostly now on headstones, they chip away at stone memorials which will stand for ages after they have faded from the scene. However, even headstone carving is now imperilled by mechanical lettering devices, changing public tastes, hard economics and cremation. Unmistakably, the craft is nearing its end.

In all Dublin I found only four men who still carve stone in the old-fashioned handcraft manner of their forbears. One of these, Arthur Breen, a stone sculptor in his seventies, has a small yard in which he still creates a few carved figures, but he is not very active anymore. Information obtained from him during taping sessions was sometimes too redundant and obtuse to be constructively incorporated into the text. However, he should be recognised as a surviving master craftsman. Another carver, John O'Donoghue, recently retired, was extensively interviewed because, indisputably one of the finest craftsmen of this century, his historical perspective was invaluable. Born in 1908, he was forced a few years ago to put his tools down when there was no longer sufficient handcarving at Mount Jerome Cemetery to warrant his retention. A modest man, he hesitatingly confesses, 'Now I'm going to stick my chin out. . . but I've been described as the best letter cutter in Dublin.' Indeed he has; his reputation as a peerless carver was heartily confirmed by the other craftsmen. He can trace stoneworking back to his great, great grand-father. A gifted conversationalist and mental recorder of facts, he is methodically precise and has a talent for historical recounting.

Eamonn Crowe, aged sixty, and his brother Brendan, younger by eight years, can be found in their stone yard along Thomas Street behind a

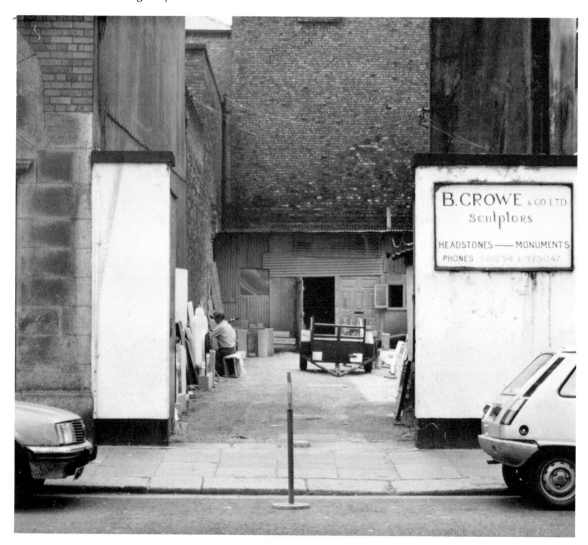

The small, largely hidden stonecarving yard of the Crowe brothers on Thomas Street

sign which reads 'Sculptors: Headstones — Monuments'. It is a narrow yard with a tiny shed barely large enough for four. A layer of white dust looking like a sprinkling of snow spills out into the street. Since the craft goes back several generations in the family it was preordained that they become carvers. Their father's workshop was behind the house. 'Stone was there from the time you could remember,' says Brendan, 'it was always a part of the background. You sort of drifted into it naturally.'

About a mile away, on Harold's Cross Road, Dermot Broe, aged fifty-two, works alone in his cluttered stone yard. He is a member of one of the most renowned families in the craft. His father, brother and several uncles are all cited with distinction in the appendix of Murphy's book. Though it may sound trite to describe his features as coarsely chiseled like the stone he works, it is perfectly true. In fact, the yard is littered with old figures and carved faces which bear an uncanny resemblance to him and the explanation for this is quite simple. When he, his father,

brother and uncles worked side by side, one would conveniently glance up at the other to use his sharp features as a model. Thus the distinctive 'Broe nose and profile' haunt the yard. Creative by nature and trained as a sculptor and carver, Broe has now been reduced by modern technology and economics to making mostly headstones. He is disenchanted by this mean turn of events, and – perhaps due to frustration and stifled genius – is uncommonly outspoken, candid, somewhat cynical and unpretentiously irreverent.

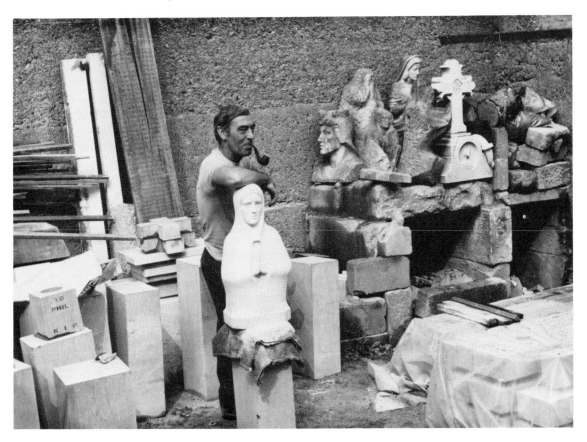

Stonecarver Dermot Broe standing amid relics of carved figures in his yard, a reminder of a past time when hand-sculpted figures were sought and valued

Becoming a Stonie

Carvers were a motley collection. They had a different attitude. They were a freer breed.

Brendan Crowe, 1983

Traditionally the stonie 'family' was divided into cutters, carvers, letterers and polishers. Stone cutting has always been a closed trade, an inherited privilege. Other facets of the craft were open to those fortunate enough to acquire an apprenticeship, but these were at a premium because craftsmen were insecure and protective of their positions. Within the craft there was a recognised hierarchy. As Broe explains, 'The carver was the supreme man. The letter cutter always classed himself above the

mason and the mason certainly classified himself above the polisher. The carver had the most prestige and the polisher was at the bottom of the pile.' Stone cutters sometimes did carving but carvers were never allowed to engage in cutting stone. Carving and lettering were often done by one man. There was no stereotypical stonie. They came in all shapes and sizes. Nor were they necessarily men of powerful physique. 'No, in fact some were the weediest little men you could imagine,' retorts O'Donoghue, 'but they were great for work and terribly strong. You didn't have to be large but you had to have a certain strength. And you had to have good eyes and a steady hand, particularly when it comes to ecclesiastical work or engraving or carving. Some of the finest stoneworkers I knew weren't impressive men, they weren't educated men but they had an intuition, a feeling for the thing.'

Back in O'Donoghue's day, becoming a stonie meant following family tradition and being indentured. So, at the age of thirteen, he was indentured to his master, Simon Maddock of Mount Jerome Monumental Works, for a period of seven years. The conditions under which he was bound today seem oppressive, if not archaic. His original indenture form, treasured as a family historical document, is dated 7 November 1921 and, in part, reads:

> During which Term the said Apprentice his said Master faithfully shall serve, his Secrets keep, his lawful commands everywhere gladly do. He shall do no damage to his said Master nor see it be done of others, but that he to his Power shall let or forthwith give warning to his said Master of the same. He shall not waste the goods of his said Master nor give or lend them unlawfully to any. He shall not commit fornication, nor contract Matrimony within the said term. Hurt to his Master he shall not do, or cause to procure it to be done by others. He shall not play at Cards, Dice Tables, or any other unlawful game whereby his said Master may have loss with his own or other's goods during said term. He shall not haunt or use Taverns, Ale-houses, or play-houses, or absent himself from his said Master's Service Day or Night unlawfully.

There was little left to do but cut stone.

Apprentices began by simply being around the stone, learning its character and complexities and getting a rudimentary feel for the tools. Stoneworkers were a rough but soft-hearted bunch who could understand a young lad's experience yet demanded dedication and respect at all times. When O'Donoghue entered Mount Jerome there were ten craftsmen and two apprentices. 'The men were a very agreeable lot. They had a certain sympathy for the apprentice serving his time. When I was serving my apprenticeship everyone was "Mr" to me. You didn't refer to any man as "Joe" or anything like that, or your own father'd come along and give you a clip on the ear and say, "Behave yourself." You had to have respect for them. In my period you simply had to toe the line. You did what you were told.'

Eventually, he was allowed to pick up mallet and chisel and began hacking away at large rough stones, reducing them to a workable form for the men. This allowed him to get the feel of stone and begin to learn its properties. Keen eyesight was the measuring instrument and this had to be developed to a high degree. 'We would get stone in that was com-

pletely rough and the first thing you had to do was to work to the lowest point along the rough face. Then you had to put a straight edge on it and sight it through your eye. . . normal optical sighting. You'd no technical instruments or anything for it. Your eyesight was very important because it was necessary that the face was true. That's the way it was done in the quarries, marble yards, monumental yards and all. There is a going-way in stone just as there is a grain in timber. Mind you, stone has its own sensitivity.'

Unlike many other craftsmen, stoneworkers did not have a uniform set of tools. Hammers, mallets, picks and chisels came in every imaginable form to suit the holder. Because of constant abrasive use, they were rapidly eroded and had to be replaced regularly. The objective was to spend as little as possible when buying them and fashion your own if you were capable. If a man could make his own it represented a fair savings over a lifetime. Furthermore, there were no manufactured tools to suit certain jobs. Even the local blacksmith or farrier could not produce the perfect implement. This resulted in great improvisation and innovation. Men routinely scavenged about for discarded automobile engines, railway parts and scrap metal from which they learned to forge their own tools. Many of the tools which Broe inherited from his father were made from car engine parts and old batteries. 'At that time there were four steel battery pins and they made a marvellous tool, good for making chisels.' They were more durable than anything he can purchase today. One chisel, superbly tempered, has worn down from an original eight inches to only two, but is still usable after more than half a century.

O'Donoghue learned as a novice the value of making one's own tools, and became more skilled at it than most. 'Now almost every stone cutter had to be a blacksmith because we made and sharpened our own tools. We didn't make them all but we made a lot of them. You bought a steel bar and you made tools out of it, such as chisels and punches. There was a blacksmith adjacent to us but generally speaking blacksmiths were farriers and they didn't understand the nature or the type of stone and the steel you'd be using on it. And when a tool is sharpened you have to temper it to suit the particular stone you're going to work. The blacksmiths generally didn't understand the tempering of steel for stone work and the result was that during your apprenticeship you learned to be a blacksmith, or toolsmith. When I got proficient at it I used to have Fridays for sharpening tools and I took each man's tools up separately and sharpened them and tempered them. Now out in the quarries where they worked granite, which is very severe on tools, the men sharpened them every day. Each man spent about one hour out of his eight hours sharpening and tempering his tools.'

In his third year he was introduced to carving and lettering. Mastering the three scripts – Old English, Gothic and Roman – became his forte. Like the signwriter, the letter carver must contend with the nuances of alignment, spacing and balance to achieve visual perfection. 'I always felt that Gothic letters were not bad. Now I'll tell you, some people say that an "S" must be very hard to do. I didn't find it hard but "H" was my bogey letter for the simple reason that you've two parallel lines and unless they're perfect they're going to show up. And a single "I" as a

capital letter must be perfect. Unless it's perfect it looks bad.' After the inscription was chiselled into the face, the stone was handed over to the polishers – then known as 'rubbers' at Mount Jerome – for smoothing.

Carvers were the aristocrats among stoneworkers but statistically they were absorbed into the general craft population. In the early 1920s, O'Donoghue estimates, there were about 200 stoneworkers in Dublin. How many were specifically carvers is not known but Broe contends that by the forties there were no more than 'ten or fifteen' carvers left. They were found either at the larger monument and stone sculptor firms along Pearse Street, such as Harrison's, Sloane's and Smith's, or were hidden away in small family-run stone yards. Carvers were an independent and sometimes renegade lot. They were set apart from other stoneworkers by their nomadic tendencies, piecework pay, temperamental character and dedication to detail. They tended to be individualistic and separatist, consistent with their creative nature. Many clearly saw themselves as pure artists. 'Carvers were always alone with themselves,' divulges Brendan, 'the masons were more rushing in their work and they had a foundation in a certain place. The carvers were slightly itinerant people. They could move to where the work was.' Many regularly trekked from Dublin to Cork and beyond in search of piecework jobs.

By the forties, when Broe and the Crowes were getting their start, craftsmen were disappearing and quality declining. The era of stone churches and buildings was ending, men were unemployed, and survivors were understandably protective of their fragile position. Brendan relates, 'There were very few men in the city at carving. Many men were half-retired and new apprentices were not being taken on because the older men were very jealous of their positions. You see, a lot of figure work was being imported and there wasn't enough at home to keep all the figure carvers employed.' As a consequence, at the larger yards where some apprentices were already entrenched they were often purposely deprived of knowledge. 'The masters kept their secrets from the apprentice,' says Broe, 'that's why many apprentices never learned anything.' As the craft shrivelled up each man was forced to look out for his own welfare, and the old fraternal spirit faded.

As the larger firms saw their ecclesiastical business disappear, they depended increasingly on monumental work. Commercialism superseded quality. Work was just 'churned out. . . it was rush, rush, rush,' says Brendan. Long gone were the days when his father worked at Harrison's, where perfection was so important that Mr Harrison himself would go around with a magnifying glass inspecting carving and lettering. Some men were intimidated into becoming perfectionists. However, while pride and tradition were dissipated in larger firms, they persisted in the little family yards like the Broe's and Crowe's. Broe marvelled at his father's gift for spontaneous creativity. 'He was what you called a natural carver. He'd mark it all out in his head and he'd make a rough sketch on the block and work directly into that. He never made a model in his life. I'd say that there were only a couple of men who could do that. Seamus Murphy could do both.'

Similarly, the Crowes regard the knowledge gained in their father's yard as vastly superior to that obtainable elsewhere in the city at the

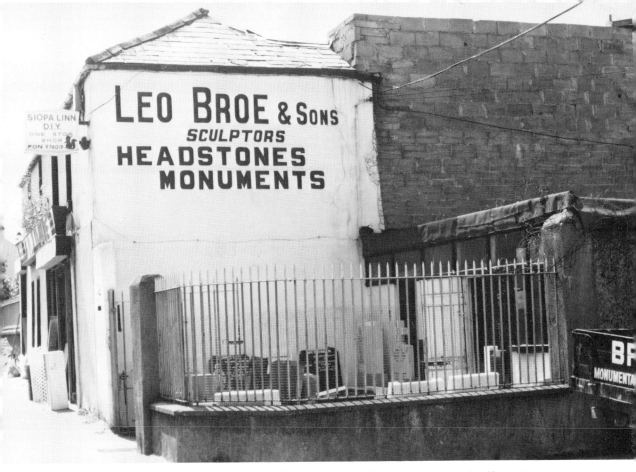

The yard at Broe's – one of Ireland most renowned stonecarving families – on Harold's Cross Road

time. 'It was really the best type of apprenticeship,' affirms Eamonn, 'because you were given the opportunity to do everything and he was critical of what you were doing. You couldn't get the attention to detail that he required in any ordinary commercial establishment.' Brendan concurs, 'My father gave us everything to do so we were both carvers and stone cutters. You saw both sides of the thing. . . lettering, carving interlacing crosses, figure work and foliage. Everything had to be just one hundred per cent. He'd have us go over it and over it. If you were working in a commercial establishment filling in a time sheet they'd be saying that you were too long on a certain job and you wouldn't be allowed to go back over it. You weren't allowed to perfect your work. Our father had a great appreciation for the old carvers he had worked with. He had great admiration for them and he just wanted to see it carried on.'

A Proud and Clannish Bunch

They're all slightly mad. For example, the money you get. My dad lived on a pittance and my mother had to go to work to support him. But it's in the blood. It must be true.

Dermot Broe, 1983

The two most salient traits of stonies were their fierce pride and clannish nature. Their abundant self-esteem stemmed from two factors. First, their

creations were grandiose testimonials to their hands – splendid churches, stately buildings, dignified memorials, artistic crosses and elaborate headstones. Second, these works are not only visually impressive but imminently enduring. What other craftsman could boast that his hand-work would still be on public display centuries later? With this reality constantly in mind, pride was inherent in the craft. Perhaps the indestructibility of the stone imparted in craftsmen a sense of their own continuity and invulnerability.

In such an inbred, familial craft reputations were highly important. A man could be known around the country for his particular skill or 'touch' with the chisel. 'You could recognise a certain man's hand in the lettering from a hundred yards,' claims Broe, 'you could say, "That's so and so's work".' Carvers took exceptional pride in their work, knowing that it would be closely scrutinised. A real master would never sacrifice quality for the sake of speed or economy. O'Donoghue recalls 'having a row with my manager once. Now we were great friends but he wanted me to get the thing done in a hurry and I said, "Look, I mightn't always be working here and my reputation is worth more to me than a week's wages in this place. If I get sacked for doing a bad job my name is mud all over the country but if I get sacked for being too long on a job, for doing it right, then discriminating people will want me to do their jobs." Our reputation was very important. Oh yes, a good name, a reputation was very important and some men had better reputations than others, very much so. You'd be aware of others' reputations.'

Carvers were used to criticising their own work severely because they knew that their peers would do so; whether it was a majestic church sculpture or modest headstone they had a tendency to re-visit and reassess the job. Transported back in time, minute details would be called vividly to mind. Brendan says, 'You'd remember the problems you had with it. It would bring back a whole series of memories about the thing. It might have been a tricky job. It might have been a happy job. But you'd immediately go back to that time. And you would look at it and might be very pleased or might not be pleased with it. But it's there and you can't do anything about it now' – which is precisely the point, and explains why carvers are such perfectionists.

Pride was communal as well as individual. Whether they were cutters, carvers or polishers, all were members of the same clan. As Murphy attests, stoneworkers were 'like a big family so that they could go into any yard or quarry in the country and feel that they were coming home.' They shared special origins, traditions, language, satisfactions and problems that were often incomprehensible to others. They were exceedingly clannish, mixing mostly among themselves. They never tired of 'talking stone' with mates. At the end of the day they would fraternise in the local pub, chatting about little other than their craft. Like other craftsmen who worked strenuously, they would often drink heartily to replenish bodily liquid and vitality. As Broe puts it, stoneworkers had 'as good an excuse as any' for liberal imbibing – 'it's the dust'. Inhaling stone dust coated the lungs and innards with a dry grittiness that was best salved with something more smooth and substantial than water. Men left tell-tale tracks to the pub. Brendan claims that stoneworkers were 'big drin-

kers. . . it was a dusty trade. There was this terrific drought you'd have from inhaling dust, especially in summer, and all you'd want to do was get out and sit at a bar and have a pint. I often noticed at Harrison's on Pearse Street that the men would be coated in white and you'd see a trail of footsteps leading across to the local. I would often laugh to myself over it.'

Obsession with Work

The pride men had in their work, the way they talked about the stone. . . it was obsessive.

Eamonn Crowe, 1983

The work came first – even before family.

Dermot Broe, 1984

Stoneworkers were more than dedicated to their craft, they were emotionally and psychologically immersed in it almost to the exclusion of the outside world. The world of stone was their private universe. They could even become so entranced with their work as to be utterly oblivious to all external reality, including family life. For many, it became a bonafide obsession. Carvers, in particular, experienced personal 'confrontations' with stone; it presented them with infinite possibilities – and problems. To them stone seemed a magical substance awaiting transformation. In the imagination of the craftsman a dead chunk of grey matter became a lifelike figure, interlaced cross or foliage-framed headstone. He could gaze at the stone and fall into marvellous fantasy at the possibilities it presented.

To stonies, work was not just a livelihood. It was also their play, leisure and relaxation. 'There was no nine-to-five thing and then the whistle would blow,' explains Eamonn, 'they would talk about it continuously and when they went into the local afterwards they took the thing along with them. They were always trying to work out some problems with a building or church and they'd spend all their evenings trying to work out a scheme. It was pride in what they were doing. They lived for their work. It was obsessive. They could be quite boring for their families and others because they talked about their work so much.' With the Broes, craft came before family. It was that way with Dermot's father, brother, uncles and himself. There was no escaping it. He found that carvers were the most reclusive, commonly neglecting family life when they became mentally caught up in a complex project. Being often the victim himself of this mesmerising experience, he feels that there must be something metaphysical, or at least genetic, about the inherent obsession.

'It must be something in the genes, because you'd be mad to work at it. . . you're just existing, really. Conditions were always bad. Pay was bad. But I love stone. I love working with my hands. I love to get in the yard. My dad was the same way. He was happy when he was working but it screwed up his family life. The yard is the only place that I'm happy in. . . never bored here. If I had a bar here now I'd be in heaven. I used to spend evenings here in the old days. You'd just get stuck into a job

and forget everything. You couldn't wait to get back to it in the morning, especially if you were working on a figure or something. Everything has to go out of your mind. You go to bed with it and you get up with it. You just stay with it. Everything else is forgotten. Sometimes you get a mental thing, you'd just bring it home with you. You'd be working on a figure and you just don't know how to put the hands and you would be working on it for a couple of weeks. It just became a white blur and you have to move on to another part. And then you'd be having a meal at home or even watching the television and something would click. . . that those hands should be so forth. When you were doing a decent piece of stuff that you liked you'd stand back and admire it and criticise it no end. You never really produced something that you were satisfied with.'

Grey World of Stone

We're just misfits outside of the yard.

Dermot Broe, 1983

Conditions in some yards were dreadful, terrible, disgraceful. You didn't complain because your place could be taken by three people.

Brendan Crowe, 1983

One must wonder how stonies so loved their work, for their habitat was grim. By contrast to the outside world it was a colourless environment. Everything seemed grey and pallid, from the coarse rock to the men's complexions. Dust lay everywhere, creating an ashen, funereal ambience. Summer skies and crisp air could freshen yards and quarries but dismal wintry weather tended to breed gloom and melancholia. The weight of the greyness occasionally got men down. The cold and damp seemed to seep right into them making some as mute as the rock, and there was always the incessant, deathly, monotonous thudding sound of steel on stone.

Conditions were primitive and men had little protection against the elements. Ordinarily, they worked outside or in an open-sided shed. The wind would whistle through and swirl about, allowing rain and snow to assault them and the cold could be severe enough to induce numbness. Men engaged in heavy, steady activity in the quarries had the advantage of generating their own body heat, but the plight of the sedentry carvers was pathetic. Sitting in one spot, in one position, the chill petrified them except for arm movement. A man's hand could nearly freeze solid around a chisel and have to be dislodged by its mate. 'To give you an idea how cold it would be,' volunteers O'Donoghue, 'we were working with stone and steel and we used a piece of Yorkshire flag as a rubstone for sharpening the tools and you had to put water on this stone and you'd pour water on it and rub the tools on it. Now you'd go there in the morning and rub up a tool and come back ten minutes afterwards to give it another rub and that water was just ice, an absolute thick piece of ice on the stone. You'd have to scrape off the ice and put water on it again.'

Brendan is more explicit in his condemnation of the working environment. 'Conditions were terrible. You'd have these lean-to sheds open to

the weather because you had to have open access for rolling stones, and maybe a corrugated iron roof over your head. No fires were allowed, you just went straight to the bench, picked up ice-cold tools and that would be your way of getting heat into you. You'd be standing on a soil foundation, just ground clay which would be damp and wet. That was hard and there was no way around it. When the big firms were operating with maybe twenty or twenty-five men, they just tolerated dreadful conditions. The fact was that there was a surplus of men so you didn't complain because your place could be taken by three people. The unions weren't very strong. There was fear all the time. Men were a bit fatalistic about it.' Around the yard, men kept their feelings of discomfort and discontent to themselves. Overt grumblings might be interpreted as criticism of the management, and in a craft where workers exceeded work a man could be replaced in an instant. Men found consolation in the knowledge that their mates were enduring the same miseries. It somehow seemed unnecessary to express it verbally when it could be so clearly seen in their faces.

Danger accompanied discomfort; physical hazards were part of the craft. Almost everything was manipulated by hand; shifting large, jagged stones endangered limbs, and cutting into rock put the eyes at risk. There were no real safety devices other than a man's own alertness. Huge stones weighing well over a ton would be delivered by horse cart and had to be lowered and hauled into the yard by a team of men. On cold and wet days when the stone was icy, ropes wet and hands numbed, the danger was increased. 'You can't take chances with big stones,' exclaims O'Donoghue, 'if one skipped or started to shift or roll it can take the legs off three or four men. You can't get away quick enough.' Says Brendan, 'Crushed fingers and toes were a fairly normal occurence.' Men were cautious, and serious accidents infrequent. 'But the possibility was always there. Very primitive conditions that were always hazardous. Manhandling those blocks through the yard, lumbering them up on rollers, these round pieces of timber. . . always a hazard of something slipping.'

A man had to protect his health to hold on to his job. There was no such thing as disability pay. Most never knew financial security, living frugally from week to week. Stashing away money for hard times was generally unknown. As Tomit, one of Murphy's mates, put it, 'Whoever heard of a stonie leaving a few hundred pounds after him?' Even back in 1862 people deplored the fact that stoneworkers received such 'miserable wages' for their arduous labour.[5] No stonie ever felt that he earned his real worth. They were usually kept on a weekly wage, and piecework was openly discouraged. Employers apparently used the standard wage system deliberately as a levelling device to keep salaries low and men non-competitive. As O'Donoghus explains, 'Piecework was objected to in our trade. They objected to piecework because you'd have some fellas that would be able to do twice as much as someone else.' Carvers, however, got piecework because their jobs were erratic and employers could not usually afford to retain them full time. Furthermore, bosses knew that most carvers were perfectionists who took their own good time on a project; it would be too costly to pay them by the hour.

Despite the harsh conditions and paltry rewards, stoneworkers loved

their craft and relished the company of their mates. Their shared daily experience fostered strong kinship and camaraderie. Moods could rise and fall dramatically; on Fridays (payday), spirits were high, whereas on Monday mornings men were often grouchy and impatient. Lunchtime, however, always meant liberation and levity. Men stomped in from the cold sheds and huddled like bandits around the fire. Animated by the warmth and the companionship, their voices would rise and good-natured slagging fly about with wild abandon. Many stonies were inveterate chatterers and gamblers – a lively combination.

Brendan recalls with zest the socialising typical of stone yards and the shared joviality as men congregated at midday. 'The majority of people were fairly gregarious. I always found a lot of talk going on up and down the benches, talk about horses. A lot of them were gamblers, and the apprentice – the "nipper" – would be sent running back and forth to the bookies. The boss might turn a blind eye. There was very little he could do about it. It was pre-transistor radio. You didn't have a radio. So the apprentice would be dispatched out to get the result of the race and then he'd come back in and there might be gloom or celebration. And then they'd send another bet out to try and cover that one. Some of the real gamblers would bet on every race at the big ones so it could be quite hectic.

'Now the nipper was always running back and forth. He did all the messages, boiled the cans for the tea, generally was a "run-around" the place. That was during the first year. He did general work. He wouldn't be at the bench working. And you'd have lunch-hour when you'd have all these people gathered around the stove, the only time you could get together, and there would be a terrific amount of chat going. Criticism and baiting people and, you know, the sort of thing that would go on among men. It was a time when they could all collect together and then they'd be dispersed back to their benches. And preparing lunches was a very primitive affair. In Harrison's they had like a blacksmith's forge, a hand forge [bellows]. . . you pump it with coke and cinders. And this young kid, the nipper, trying to boil maybe eight or twelve cans of varying sizes on this stove and keep them all boiling and at the last moment he'd be sent running off for a message and he'd come back and the fire would be nearly gone and it would be two minutes to one and he'd poke the thing and the flames and sparks would go up in the air and back into the cans and it would be just like porter they'd be drinking but it was tea. And they all had their own brew. One would take sugar and one wouldn't take sugar and if he mixed them up he was gone. I can see that vividly. Most of the people had their lunch there and there was a scene of pandemonium at five to one. You wouldn't believe it. Nobody would tolerate it today. The stove would be like a volcano and then there would be curses and swearing and clouting him on the head. The bell would ring and the men would all come along and grab the cans and look at it and give him a punch or something and then go off to try and drink this awful thing. Some tins were improvised with a wire through them. They're good memories but I think they probably hastened the demise of a lot of fellas.'

Graveyard Duty

Graveyards are all right in the summer but they are the most miserable places a man ever worked in the winter.[6]

The bitter cold, bleakness and wind of the winter months made graveyard duty abysmal. The solitary figure of the carver hunched in front of a tombstone silhouetted against thick greyness could be an eerie sight. The repeated 'click, click' of hammer on chisel was the only sound, the motion of a single hand the only movement. Working in the 'land of the dead', as some called it, was a necessity because headstones, once permanently set, required inscriptions which could only be done by hand on the spot. Contorting the body into the right position to carve demanded dexterity and discipline. Ground level carving was particularly challenging.

O'Donoghue put in his fair share of duty in graveyards and regards it as the most abominable of jobs. 'After I learned how to do lettering I was sent out to cemeteries to do additional inscriptions for people who had died. It was hard physical labour. You'd sit down cutting the letters with the headstone upright. Out in the cemetery we done the inscriptions on the stones *in situ*. The stones weren't taken down. Now sometimes there'd be just one name on a headstone and you'd have to sit up high at it. Other times you'd be down near the bottom of the stone and you would have to dig a hole in the grave and sit down in the grave while you were carving. That's the way it's still done up to the present. Now in the winter time from the waist down to your toes you'd be absolutely frozen. When you were sitting down in the grave everything was cold around you. The tools were steel, the stone was cold and from the waist down you were practically dead. The ground was all damp and cold and miserable. And if you were working up high on a job and there was an east wind blowing on you it would freeze you inside. You were practically immobile. Just the movement of the hands was the only activity you had. You couldn't wear gloves because it's freehand work and there's a certain sensitivity in your hands. How we survived it I don't know, because we should be full of rheumatism or arthritis.'

Living with Insecurity

There was no security at all in the stone trade. The fear was there all the time. They were fatalistic about it.

Eamonn Crowe, 1983

Stone working has always been one of the most erratic, insecure crafts. Rarely was employment steady and reliable. Everything depended on getting contracts. There could be a flurry of work for months or even a year or two followed by a plunge into the doldrums. It always seemed a 'boom or bust' business. News of a new church or large government building in the plans swept through the stoneworkers' ranks. When such a job was bid there was great anxiety. During the waiting period rumours and speculation spread like wildfire; it often proved completely unreliable. When it was finally learned that a job had been won there was great

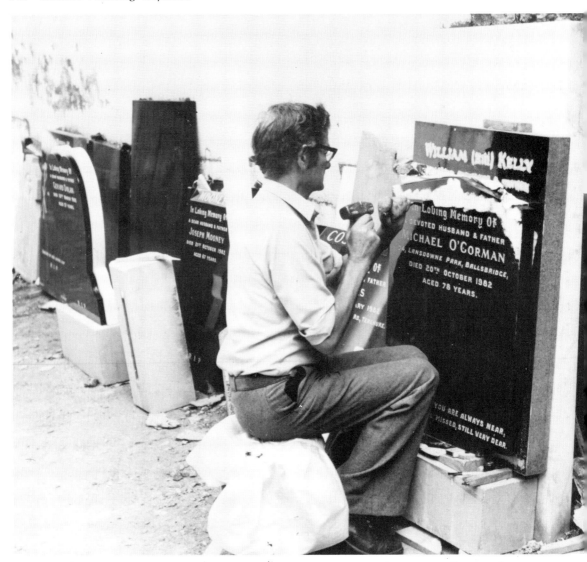

*Eamonn Crowe carving
a headstone by hand in
the old tradition*

rejoicing, but a lost bid triggered disappointment and depression. When a large project was underway it kept everyone busy, from the men in the quarry cutting stone to carvers ornamenting the building; but they always knew that every job had to come to an end and beyond that the future was uncertain. The strain of living with such insecurity took a toll on the men and their families.

O'Donoghue learned at an early age about the fickle nature of his craft. 'I finished my apprenticeship in 1928 and in 1930 there was a terrible slump. There was extensive idleness everywhere. One day in 1930, January, the manager come out and says, "Boys, we're down to bed-rock. . . have to let all hands go." And the whole lot of us went except the two apprentices who were indentured and bound. So I was a couple of months idle and then I got a job at Harrison's on Pearse Street. They had got a contract for headstones. Now this was in 1931 and there had

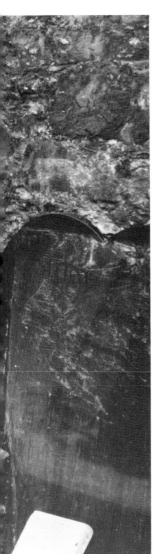

been a lot of war headstones done for Flanders, thousands and thousands of war headstones done for members of the British army and this was a British War Office contract. Then they dealt with all the victims of the war who had been buried in England, men who came home and died. It took all those years since the First World War to get around to providing headstones for them, and Harrison's got a contract for 565 headstones. On each headstone a cross had to be cut on it, the inscription had to be on it and the cap badge put on it. I worked there for about a year and then the headstones got spent and then I did some odd jobs around other places.'

When work was slack dismissals became inevitable. Layoffs were an inescapable fact of life and men lived in fear of hearing the deadly words. Friday afternoons were especially anxious times because if a man was to be sacked he was usually given the required hour's notice around four o'clock. However, dismissal could come at any time and for assorted reasons. 'There was fear all the time,' says Eamonn, 'the boss could more or less say, "I'm not happy with your work – out! Bring in somebody else." It was a very Victorian sort of thing and I have a feeling that the other crafts were stronger. They might have had more security.' It was an intimidating system in which the boss and foreman were lord and master. Layoffs could be handled democratically or through blatant favouritism. Men were always aware of their fragile status and vulnerability. This, again, is why they seldom dared grumble openly about poor conditions or pay. They could not really plan their lives or even be certain that three months hence they would be employed. Men were the pawns of vacillating economics and architectural trends over which they had no control. Due to the sporadic nature of the craft, many men took to travelling around the country or to Britain in search of work. Broe's father typified the carver who had to become itinerant to survive, heading for Northern Ireland and Liverpool. It was always hard on the family. He likes to cite the irony of his father, an avowed 'IRA man' doing carving on Stormont. Economics before politics!

Brendan witnessed on too many occasions the callous, insensitive manner in which stoneworkers were treated by their bosses. He attributes this to the simple law of supply and demand – too many workers and not enough work. It was painful for a man to have to face his family with the bad news that he had been laid off. It was enough to drive good men to drink and ruin their family life. The schizophrenic character of the craft gave men a cruel emotional buffeting between the euphoria of a new job and the depression of unemployment. They accepted this but never really got used to it. 'During the hard times there was a surfeit of good men, very good quality men, and there were always too many of them for the work available so a lot would be unemployed. But then you'd have a sudden burst of work and they'd be literally called in from the corners. They might get two months' work and then they'd be gone. There was this one fellow who was a foreman at Harrison's, a very rough sort of guy. They used to call him "Baron You're Off". The reason he was called that is because when a job would end you had a stone yard of maybe fifteen men working side by side at big benches – "bankers" they were called, big stone or wood benches – well, when the work would

be slack he'd walk down the line and he'd say, "All from here – you're off!" And that was his way of dismissing them. The men would just pick up their tools, wrap them up, walk out. There was no going down and getting supplementary benefits and all that sort of thing. . . it was a rough thing.

'You'd hear rumours that a job was coming along or that a job was being priced for a certain church or bank and there would be hopes and then you'd hear that it was gone to some other firm. But if the job was confirmed they'd take on ten or fifteen men for the duration. But immediately when it was finished you'd be gone. Now when Stormont, the parliament building in the north, was started there was a great exit of most of the carvers who went north. A huge Corinthian thing and lots of capitals carved. It was a very difficult lifestyle, leaving their families and then they'd just live up there fairly rough at the cheapest digs they could get because the money couldn't have been very good. So everything was a sort of impromptu existence. You couldn't say, "In six months time I'm going to do this", because you mightn't be working in six months. They just worked from day to day. Stormont gave a little breathing space to a lot of Dublin carvers. They got a last little thing working there but that was the last of the big contracts.'

The Coming of Concrete and Machinery

Concrete. You'll see it all around the town. . . ghastly buildings.
Dermot Broe, 1983

Machinery made a terrible difference. In most yards the letters are now cut by machine and they're terrible looking things to be quite honest.
John O'Donoghue, 1983

The stonie's world disintegrated with brutal swiftness. During the forties and fifties several pernicious developments conspired against the craft: mass utilisation of concrete and steel for construction, acceptance of machines over handcraft, changes in church regulations, and the importation of stonework. Craftsmen could scarcely comprehend these changes, much less combat them. The post-war building boom centred on Dublin. The demand for higher buildings, faster construction and less labour-intensive methods made concrete and steel economically preferable to traditional building materials. Buildings were no longer erected to last for centuries or please the eye aesthetically – functionalism ruled. (The Galway Cathedral, built in the 1960s, was a notable exception). Concurrently, the pneumatic hammer, carborundum saw and diamond-tipped cutting tools gradually replaced hand techniques in remaining yards.

Stoneworkers were vexed and distraught over the collapse of their craft. In the 1940s they began protesting against the incursion of concrete and speculating pessimistically about their future. As one of Murphy's compatriots gloomily prophesised, 'Concrete. . . you can't fight it, it's creeping in everywhere. People aren't building for the future anymore. The trade's wiped out.' Men recoiled at the very mention of concrete.

They fretted about it, cursed it, and even discussed trying to get the government to pass legislation outlawing it for the use of churches and other major buildings. However, reason prevailed and they grudgingly accepted that it would be like trying to legislate against the swelling of the tides. As work withered away men were laid off and yards closed. Survivors, bewildered and bitter, put their sons into viable occupations. Apprentices disappeared. Some men took to disparaging their own craft and all mankind.

Headstone, altars, religious statues, pulpits, small monuments and figure work kept the craft alive but these, too, were eventually undermined by changes in church rules and imports from Italy. In the 1950s the Vatican decreed that churches should be less elaborate. Simplicity became a virtue. Slabs of straight stone could serve just as appropriately as an altar. To exacerbate matters, stone figures were being imported. The importation of foreign stonework especially invited the wrath of Irish craftsmen because it was one element over which some protective control could be exerted. However, there were ways to circumvent the law. 'I blame the clergy here more so than anybody,' says Broe, 'because in the early fifties and sixties when a lot of stone and finished stonework, figures and the like, were coming in cheaply from Italy the government gave the stoneworkers some protection by imposing heavy duty on it and placing certain limitations on imports but then they came in the back door. The clergy brought them in as gifts. Money was going out and the Italians were getting paid but it was brought in as a gift.' If there is rancour in his tone it is because he witnessed these illicit imports deprive friends of their livelihood.

Brendan is no less vehement in his denunciation. 'A lot of figure work was imported and there wasn't enough at home to keep all the carvers employed. That was really when the rot set in. The whole trend in church styles changed with the new Vatican rules. That really put the finishing blow on the thing. During the 1950s a new church rule came in about the ornamentation on churches and altars. Lots of churches where you'd expect to see an old Gothic-type altar instead you'd find a solid granite block. They would just chuck the old stuff out and brought in the granite block which was just a simple feature, nothing ornamental.'

Monument yards making mostly headstones proved to be the last bastion of the craft in Dublin but this, too, suffered from imported Italian marble. Irish stoneworkers resented the importation of foreign marble for tombstones instead of the use of native limestone. They thought it both unpatriotic and impractical. Limestone, they argued, weathered better in the moist Irish climate. With marble, dampness eats into the inscriptions and the lettering loses clarity. Customers nonetheless found it 'fancier' and were even willing to pay more for it. This exasperated craftsmen and left them with the degradation of having to carve foreign stone. Then, with the spread of machinery for cutting and lettering, even this was jeopardised. Letter-etching machines allowed any unskilled neophyte to go into the business of monuments and headstones. It struck hard at the craftsman's ego. The public generally made no distinction between hand-carved lettering and machinework. Insult was added to injury. Their disdain for this development was hardly hidden. 'Machinery made a

terrible difference,' complains O'Donoghue, 'where there used to be elaborate monuments done on practically every grounds now everything is plain, straight lines. The reason is that you get a saw to cut it in a straight line and that's it, where there used to be a lot of hand work and moulding and things like that on headstones and crosses. That has all been eliminated now. Everything is made to suit the saw. In most yards the letters are now cut by machine and they're terrible looking things to be quite honest.'

Mechanical stone cutting is devoid of originality. Inscriptions are flat, one-dimensional and sterile looking. Brendan explains the differences: 'The style of work has changed dramatically with the advent of this black polished [imported] stone and machinery has taken over. So many areas have been wiped out. Where stone would have been cut very laboriously with a wire saw and sand, just grinding through, now it's done with a diamond saw which slices the stuff to an eighth of an inch. So everything is mechanised. Now the machines are computerised. They just feed the things into it and it churns out the work. Everything is being processed today, not crafted. Now the stonecutter is just a machinist.

'And they have the lettering machine and they are all stereotyped letters like little blocks, like a printer setting up type. It's very limited what you can do because you're working with the letter blocks and you can't control your spacings. For example, you might have an "I" on one block and an "O" or "N" on another one. So, if you have the "I" too far away from the other connecting letters. . . well, if you were handcarving them you would compensate for the fact that "I" was a single straight letter but you can't do that with a block and machine. Look around the cemeteries today and you'll see this new work all around. They're flat-bottomed letters whereas with hand carving you have a V-cut letter that gives you a third line running down the centre and one side will throw a shadow on the other but if you use sandblasting or other mechanised techniques you don't have that. There is great variety in a man's own style and he does his own style of Roman, Gothic, Old English and he could introduce two or three of them in an inscription. . . whereas now they are always stereotyped.'

Down to Headstones

I have to do headstones for the bread and butter now.

Dermot Broe, 1984

The age of great stone churches, monuments and buildings is gone. Stonecarvers work mostly on headstones now – a humbling decline. Yet Irish headstones have their own tradition. In 1903, in a letter to the editor of *The Irish Builder and Engineer,* an exuberant reader wrote that 'death is the lot of mankind and an Irish tombstone may be a beautiful recognition of the fact.'[7] He even suggested that Dublin's headstone firms might use the catchy advertisement 'Go with a vengeance'. Regrettably, public tastes today are more mundane. A simple marker, properly priced, is normally sufficient. 'There's very little appreciation for the hand part of it,' says Brendan, 'the majority just don't care. If they can read something,

if it's legible, it's grand. It's disappointing. You could just turn it out by machine and they wouldn't mind. For most people it's just a marker. You often look at the stuff [machined headstones] and say, "Lord, how was it ever allowed out of the yard in the first place? How could people accept it as a lifetime memorial?"'

There are still the discriminating few who specifically request a hand-carved headstone. Other jobs trickle in sporadically too, such as a Celtic cross, mantle piece or garden ornament. In Crowe's yard rests a large smooth-faced Celtic cross awaiting carving. Back in the forties such crosses were a major part of their business. The charge was £40. Today the cost is between £700 and £800, prohibitive for most. When they do get a cross it rekindles the old spirit and they savour the creativity. Headstones, however, now pay the bills. The men are clearly frustrated over having to compete with the new breed of headstone 'machinists' turning out undistinguished work so readily devoured by an indifferent public. Pride and tradition compel them to retain hand carving. It would be sacrilegious to bring a machine into the yard. Yet the economics of time and profit are against them; it takes about a day and a half to inscribe a headstone that could be lettered in a few hours by machine. Eamonn confesses, 'I start to think is it worth my while to go to the bother when other people are getting away with it and people don't even know the difference? Our carving is all done by hand. A lot of them are using machines because they can't use their hands. People don't know how to use a mallet now. Young lads, the only thing they know is the compressor. They wouldn't know how to break into a stone or know anything about texture. When you're actually working the stuff, engraving, you're intimately concerned in every little fleck of the stone and you can see if it's going to be good or bad, hard or soft. Today they might know that this is granite or that's limestone but they don't know the composition and possibilities of each stone. To understand it as we do you'd have to be stuck at a bad block of stone so that you'd curse sometimes and it'd make you really work. Then you might get a nice soft piece from a different quarry. But all that sort of thing is lost today if you're only a machinist. He's not a craftsman.'

There is no mistaking Broe's discontent. For a craftsman who once carved life-size figures of Christ and Mary, ornate religious grotto scenes, handsome memorials and etched labyrinthine crosses it is, in his words, 'ghastly' to be reduced to merely lettering headstones. His resentment is directed toward the impersonal economic forces which have deprived him of his creative opportunities and his words are tinged with pessimism: 'In my early days there was nothing but limestone work, mostly Celtic crosses and they were beautiful because the whole face would be carved. The last Celtic cross I did was seven years ago. . . so that's gone.' Today he carves mostly black imported marble because those are the headstones people find attractive. They sell for about £480, but his heart is not in it. Not only is his creativity stifled but the work is insufferably monotonous. Inscriptions almost invariably read 'IN LOVING MEMORY OF. . .'. He appreciates the occasional customer who departs from dreary custom and shows some imagination. One woman wrote a poem about her husband which she wanted inscribed. 'It was something about picking

Overleaf:
A Celtic cross in the Crowe's yard awaiting elaborate handcarving and interlacing. Such challenging carving tasks come seldom these days as the craft is dying

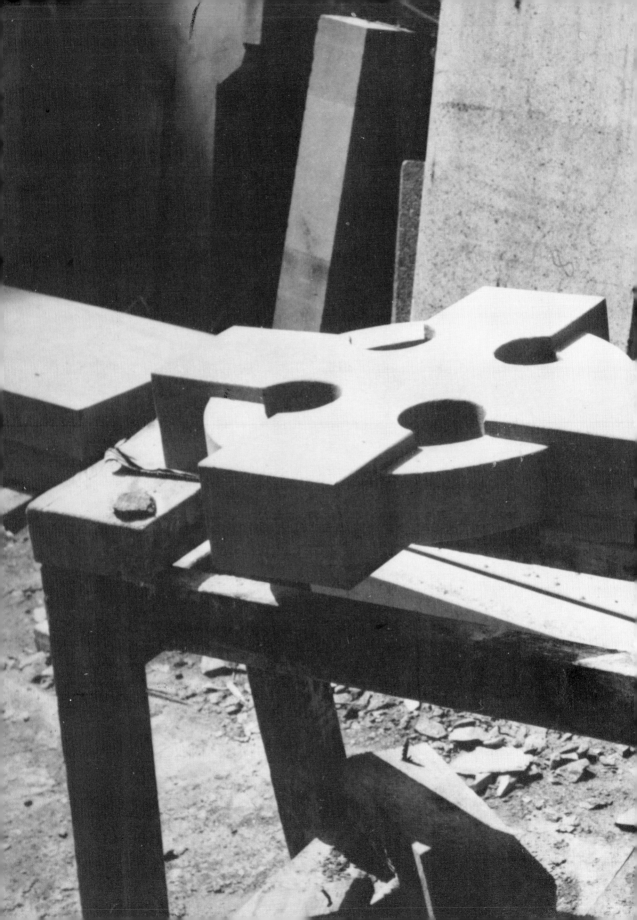

crocuses because he was picking crocuses in the garden when he dropped dead.' Another requested a carved tree. 'Just branches with no leaves on it. The tree was dead like the person who was gone.' He finds such variety refreshing.

His cynical façade belies a sense of humour. People are funny about funeral markers, he says. Normally, relatives do not worry about the headstone until two or three years after the death, and rarely will they buy one within a few weeks. 'There is a myth here in Ireland that people think they have to wait a year before they can put up a headstone because of the grave settling. They don't realise that the stone doesn't touch the grave. How could it? Because if you put it on the grave it would sink.' Sure enough, during our taping session a woman entered the yard and asked if she had to wait a year for the soil to settle before she could erect a headstone. Broe smiled.

At the opposite extreme, some individuals are possessed of great foresight and personally arrange for their own headstone before the big event. 'I remember one. He was a well-known butcher in town. And I'll never forget his name, Valentine Brown, and he was a friend of my dad's and he retired from his work and went into property for a hobby and made a lot of money. And one day he came in here and wanted to pick his headstone because he didn't trust his wife and couldn't trust his kids. So he picked out his own grave in Glasnevin and we put up the headstone. We carved in everything except the date of death. He'd go out once a month and look at it. Then when he died we went out and carved it.'

He has a decidedly irreverent, pragmatic attitude toward the whole funeral-headstone business. 'The cost of funerals here is ridiculous. A Dublin funeral costs anything up to £1,500. . . just to get someone into a hole in the ground. It's a rip-off. The last thing people in this country want is a damn headstone. To me, they're ridiculous anyway. Headstones are very unnecessary and costly. I'm certainly not going to have a headstone. . . no way. I'm going to be cremated. I don't mind putting stones over people but I'm not going down in a hole. It's my life's work but it stops at the grave. Now the old ones I kind of went with. Years ago when you did a headstone you actually carved the craft of the person on the stone. In other words, if he was a miller you'd put some decorative thing with wheat. If he was a cobbler you'd put a boot. Now *that* I agree with. It gives a sense of identity for who he was and what he did. Now you just have a name and age. What else was he?'

Stonecarver Dermot Broe at work carving a statue of the Madonna for a special exhibition

Lasting Memorials

The hammer and chisel days is nearly finished.

Dermot Broe, 1983

It's strange because there was always a feeling, a pessimistic thing, for the past forty years. People would be saying, 'It's finished, the stone trade is finished.' And it's come true.

Brendan Crowe, 1983

Broe is a realist. He knows that machine-lettered headstones and 'creeping' cremation bode ill for his moribund craft. There is also the spectre

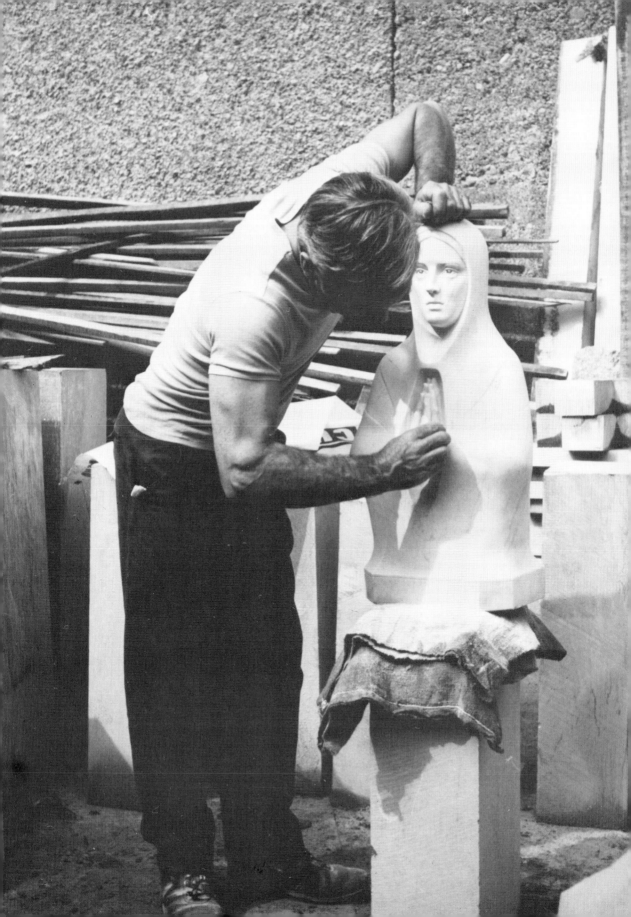

of cement headstones. He has even heard of a company in Scotland manufacturing plastic ones. At present there is a law that in Irish cemeteries markers must be of real stone. He is, however, wary and distrustful, having seen too many insidious changes in his time to dismiss any possibility. Cremations pose an immediate threat. They are on the rise. In 1963 Pope Paul VI approved cremation for Roman Catholics. The younger generation in Ireland, less bound by tradition, increasingly see it as a viable economic alternative to standard, costly burial. (Cremation costs far less than the average burial. A grave site can cost several hundred pounds, a headstone between £400 and £500 and burial fees another £100. The basic cost of cremation is about £80, and another £80 can be paid for a mini-vault if desired.) At Glasnevin Cemetery, for example, there were about 2,000 ordinary burials in 1984 and 377 cremations. The latter figure was expected to rise to 500 in 1985.[8] The British experience, where over seventy per cent of the deceased are now cremated, is an ominous harbinger.

To preserve his skills and sanity Broe indulges in an occasional project for his own gratification. In the centre of his yard is a lovely Madonna carved for an exhibition. None of the master's touch has been lost. After the display, though, it will be stacked beside other relics. No-one, he claims, would pay for such sculpture work today. He fantasises about retreating to the Dingle Peninsula surrounded by a world of stone and carving to his heart's content. Financial struggle could be averted by simply giving it all up and seeking alternative employment. 'If I were at something else I might be able to double my wage, but I'd rather be at my craft and be happy.'

The 'very tail end' of the craft in Dublin – that is how the Crowes see themselves. There are no sons to follow in their footsteps. They have had to witness not only the numerical decline of fellow craftsmen and the closure of stone yards but also the disappearance of age-old skills. This has been subtle but observable. It saddens them, for they realise better than anyone that a certain technique once lost is irretrievable. 'Some of the skills have already been lost,' laments Brendan, 'there are certain little things that you mightn't have a call for now and suddenly you're confronted with a problem and you say, "How was that done?" Maybe it's been ten years since you've done it. For example, doing raised lead on a granite surface. The whole process of drilling the stone, beating the lead into it and then actually cutting the letters out of the raised little panel of lead was done quite a lot, but you wouldn't get two or three people now who would know how to do it.' The same is true of interlaced carving on Celtic crosses. 'When you're not called on much anymore to do it you realise that it's slipping away from you and you'll say to yourself, "Now how did I used to mark that?" Something will quietly vanish through lack of being required and it will go without you realising it.'

They have a strong sense of history about their craft and find comfort in the knowledge that their work is lasting; that the innumerable crosses, headstones, monuments and sculptures they have carved over a lifetime will endure for ages gives them a sense of continuity and immortality – a link with the past and future. As Brendan puts it, 'It's nice to know that the stones will hopefully still be standing when there are not many

of us left around. That's the idea of it. . . it's a testimonial. Your hand is in them somewhere. Your effort is in them and it's an individual sort of thing. The names won't be remembered but even today if you see some early nineteenth-century headstones around an old churchyard with beautiful panels on them, overgrown possibly and buried in the ground, you'd stand and look at them and say, "That's a nice letter on that." You'd have no idea who might have carved it but there is a link there. The man has said something and it's still there. We're part of that tradition.'

7
Tailors

*There are only three or four of us now doing what you call 'bespoke'
work.*

Michael Hawkins, 1984

*The craft has been dying since I was a boy. The old tailors are gone. I'd
love the craft to be known as it was in this city.*

Gerald Devereux, 1983

Tailors like to tell the tale of St Patrick's curse on their craft. As the story
goes, St Patrick was traipsing about the country when he happened to
tear his cloak. He asked a tailor to mend it for him but he was told that
he would have to pay. St Patrick explained that he had no money.
Nonetheless, the tailor refused to do the job. Angered, Patrick proclaimed
that 'pride and poverty may follow your trade till the end of time.' It
proved prophetic, for over the ages Irish tailors experienced greater strug-
gle and deprivation than most of their fellow craftsmen. Yet they retained
an indomitable pride.

Long ago, tailors were among the most ubiquitous of craftsmen. Irish
country folk had their clothes 'made-to-measure' by travelling jour-
neymen who might stay at their farmhouse or sleep in the barn. Towns
and cities had resident tailors. Dublin had the greatest concentration,
including those boasting the most refined skills for catering to the urban
gentry. The Guild of Tailors was formed in 1417 and their hall was in
Winetavern Street. In 1706 it was moved to Back Lane where today it
stands as the last physical relic of the guild age. The tailors' fraternity
(artis scissorum) was one of the most visible and spirited on the Dublin
scene. They seemed inordinately fond of drinking, parading and public
festivities of every sort. Because mechanisation and factories came late
to Ireland, tailors fulfilled a vital role in society. In 1911 there were still
nearly 1,500 craftsmen in the capital doing mostly handwork.

*Entrance to the Tailors'
Guild Hall, last of the
physical guild relics in
Dublin*

A Downtrodden Past

More than the other craftsmen in this book, the tailors perceive them-
selves historically as an exploited and often oppressed working group.
Their downtrodden self-image has irrefutable roots in history. By com-
parison with other urban craftsmen they received lower wages, worked
in worse conditions, put in longer hours and suffered more abuse by
employers. Bosses always endeavoured to keep them in an insecure and
vulnerable position. Rumblings of discontent or rebellion were quickly
quashed. In 1778 there was a reward offered by the masters for the
identification of journeymen tailors who were joining ranks for improved

wages and resorting to breaking windows to publicise their plight. Such efforts at organisation were readily put down.[1]

Conditions in Dublin were never more appalling than during the Victorian period, when tailoring was a major component in the labour force. What came to be known as the 'sweat shop' system proved the scourge of Dublin. Men were clustered like cockroaches in dingy workshops poorly lit and ventilated and infested with disease. Others, known as 'outworkers', lived in squalid tenements, sewing in rooms 'unfit for pigs.'[2] These infested settings spawned contaminated clothing throughout the city. An article from the year 1875 vividly portrays the seriousness of the situation:

> It appears that not only are the hovels in which the miserable working tailors carry on their toil of the worst imaginable description but the commonest precautions to prevent the spread of loathesome contagious diseases are neglected. It is not sufficient that the clothes are put together in stinking dens not rarely fever-stricken but the work goes on uninterrupted by the presence of the most fatal forms of smallpox. The master tailors of Dublin must be recklessly disregardful of the facts of infection to permit clothes from such places to pass through their hands.[3]

In rebuttal, representatives of the tailoring trade contended that 'the sweating system is no worse than in London, Edinburgh and Glasgow.'[4] Despite denunciation of such deplorable conditions and sporadic efforts to eradicate them, little progress was made. Actually, mechanisation and the spread of the sewing machine did more to rid the city of its large tailoring population. Between 1841 and 1901 the number of craftsmen in both tailoring and shoemaking – closely related crafts – was more than halved.[5] Many surviving tailors were conservative to the point of myopia, believing that the handcraft system could never truly be replaced by machines. Nor could they accept the influx of women into the workshops as 'finishers'. In 1861 Dublin tailors declared the sewing machine a failure, condemning its use 'vicious and immoral' and proclaiming the hand-sewn method the 'best, cheapest and most deserving of support.'[6] Not until the 1920s did some old-fashioned bespoke tailors concede that the 'machine can do better work on some parts of the job and a woman can do the other part of the work better than men can.'[7] Acceptance of the sewing machine and women finishers gradually led to a division of labour in which one man no longer produced an entire article of clothing himself. He would make only part of the whole. Over time it was natural that many craftsmen forgot how to perform those tasks no longer used. This made them dependent on employers to integrate their work into the larger scheme of production. Concurrently, British clothing factories were booming and Irish ones were on the rise. In the twenties, manufactured clothing could be purchased more cheaply and in greater variety than ever before. The new economic realities compelled many craftsmen to shift to factory work. Still, there were enough discriminating dressers in Dublin to support a number of top-quality tailoring shops. However, by the 1940s the master craftsmen were growing old and the apprentices dwindling.

The Bespoke Four

Today there are four 'bespoke' master tailors left in Dublin (a few others may label themselves 'custom' or 'handcraft' tailors but in actuality they rely heavily on machinery). All were nurtured through the traditional apprenticeship system, retain the purity of handcraft methods and abide by the highest standards of the craft. Each still has his shop in the inner-city.

Richard Pender

An eighth-generation tailor, his 'people came to Ireland with the Norse invasion.' His grandfather was a journeyman tailor. His father, born in the Liberties, was a master craftsman, 'roared more than he hit' and once told him as a youth 'if you can put a man's arse in trousers you'll never go hungry.' So he did. Today he is Ireland's leading maker of military uniforms. At the age of sixty he still works long hours in his shop in Stoneybatter, Dublin's oldest neighbourhood. On a dusty shelf rest vintage 1930s copies of *The Tailor and Cutter* magazine, once the London-based bible of the craft before its readership declined.

Joseph Monaghan

Born in Galway in 1925, his mother died when he was two and his father emigrated to America, leaving him under the care of a schoolteacher aunt. At the age of fourteen he was stricken with rheumatic fever and confined to a hospital for three years where caring nuns 'showed me how to do a bit of sewing.' A doctor encouraged him to pursue tailoring since it would keep a lad with illness out of the open elements. When he was seventeen he began an apprenticeship under a tailor in Loughrea, living with him in his home attached to the shop. Here he learned the craft well. In 1959, after a stint in Belfast, he decided to enter the prestigious Tailor and Cutter competition in London and won the supreme award for dressware, receiving the gold medal. The ensuing publicity propelled him to the top of the craft in Ireland and never since has he been in want of customers. His fashionable shop occupies an elegant Georgian building on St Stephen's Green. The gentleman's waiting room is embellished with award photos, framed certificates, a marble fireplace, cushy chairs, an antique phone and a sketch of Tailor's Hall. Despite his exalted status he is modest in manner and speech.

Michael Hawkins

At the age of seventy-one, he is the premier 'britches maker' in Ireland, specialising in tailoring for the 'horsey set'. His cubicle shop, a minor landmark, is at the bottom of Parnell Square, in the shadow of the monument. He learned the craft and inherited the shop from his father, one of the city's most respected tailors of his time. He has no peer when it comes to fashioning riding wear. Through his doorway come the grandsons and great grandsons of old customers – a heritage of friendship. His finest suits command £350, costly by Dublin standards but a bargain for

his British patrons. The annual Dublin Horse Show is like a grand personal display of his riding finery.

Gerald Devereux

Pedestrians ambling along Lower Abbey Street may glance up and discern the lettering 'G. Devereux & Son, Handcraft Tailors' on the fourth floor window. The son has long since sought more lucrative grounds, but silhouetted against the light late into the night can still be seen sixty-five-year-old Gerald Devereux. Of the four, he has had the greatest struggle and still works the longest hours in the most modest setting.

As an orphan he was knocked around in his early years. At the age of fifteen he was 'smashed up in football and in poor health.' Owing to his limited physical capacity he turned to tailoring as a viable livelihood. His early apprenticeship was 'under a man named D'Arcy down in Ballaghdereen.' It was a Dickensian experience. He was forced to live above the shop, work for less than a shilling a week, and was regularly mistreated. 'I was neglected, abused, hardly fed at all.' Sympathetic townspeople helped him out. After two gruelling years he fled to Arklow and continued his apprenticeship under a 'magnificent tailor' but one who also drank excessively and made him work until four in the mornings. A year later he settled in Wicklow and worked for a deaf and dumb tailor who treated

Handcraft tailor Michael Hawkins in his shop at the bottom of Parnell Square. He is the premier 'britches maker' in Ireland and he specialises in making fine riding clothing for Dublin's 'horsey set'

him with welcome kindness, but after a while he realised that to learn
the finest craftmanship he would have to go to Dublin, where the premier
tailors were to be found.

After ten years of city experience he finally got his own shop. It is
reached by ascending a rickety flight of wooden stairs right at the top of
the building. He shuffles about amid mountains of cloth, clippings, pat-
terns and thread spools which spill onto the floor from makeshift tables.
On the wall above his antiquated iron is a photograph of the Pope. The
slow, deliberate manner in which he caresses a swatch of tweed is almost
sensual. He has struggled to raise seven children, still works six days a
week until ten at night and candidly confesses, 'My wife would love me
to have a car.' His work is as expert as that of his three colleagues but
he has never sought recognition or awards. Though he has made suits
for government leaders and the likes of Brendan Behan, he sells his work
for less than he knows he could command so that a wider range of
Dubliners can afford it. 'Money means nothing to me at all.' He remains
the quintessential craftsman, true to the ethic that pride and satisfaction
far outweigh monetary gain.

Images and Traits

*The tailor in the majority of people's eyes is a little, happy fella with a
short leg and a gunner's eye and he works in the cellar.*
Richard Pender, 1984

The stereotypical image of the tailor is that of a diminutive, weak, often
unhealthy individual. In truth, many were. This is because a boy with
frail physique, physical disability or illness was precluded from entering
most crafts which demanded strength and stamina. The indoor, sedentary
nature of tailoring suited their limitations. 'If a fella had any disability
that prevented him from being, say, a carpenter or plasterer or something
like that,' explains Hawkins, 'they put him to tailoring. So, therefore,
tailors had a reputation of being a bunch of cripples because their legs
were damaged and very often they were very slight.' Indeed, Monaghan's
rheumatic fever and Devereux's damaged legs channelled them into
tailoring. Strong arms, back and legs were not vital; delicacy of hand
movement and keen eyesight were the requisite human tools.

And Danaher writes, tailors, because of their physical fragility, were
often viewed as almost 'womanish'.[8] The contrasting images of the
'scrawny' tailor and 'brawny' craftsman created in the former a sensitivity
and an inferiority complex. This was exacerbated by the fact that tailors
were not highly esteemed in society. The negative imagery of weak men
and low pay was sometimes felt personally. Devereux confirms that
women would sometimes refuse to go out with a man when they disco-
vered that he was a 'lowly' tailor. The craft's image was also blemished
by a small unruly element comprised of those either socially deprived or
depraved. Pender knew them as 'people out of Borstal schools taught the
trade as part of their training. Their attitude toward life was "get away
with it if you can."' He feels that their often shoddy workmanship and
rowdy behaviour damaged the craft's reputation.

Apprentices and Journeymen

Apprenticeship in tailoring was generally less formal, regulated and enduring that in other crafts. It required the standard seven-year term and began with typically menial jobs like sweeping floors, sorting cloth, gathering up scraps, heating heavy irons, tending the fire, fixing tea and running errands. The degree of subservience was especially great. Master tailors were absolute rulers who set their own terms free of external intervention, and while most craft apprentices worked in a corner of the saddler's or shoemaker's shop within public view, the tailor was always hidden away in the back room. If he were abused it went unseen. Too many bosses exploited this opportunity to overwork, underpay and maltreat their wards, knowing that they could easily get away with it. Consequently, many apprentices ended up working under multiple masters, fleeing one for another better. Devereux's experience of dividing his early years between a dictator, a drunkard and a deaf and dumb master was all too typical. For some unknown reason, it was accepted in tailoring that apprentices could be worked well into the night, a practice seldom tolerated in more open crafts. Even when working under his own father an apprentice could feel, as did Pender, 'like a slave. As a slave, right or wrong, you took orders. There was no good saying that you had a date with a blonde or your mother was going into the hospital. . . it didn't matter.'

Tailoring was characterised by extremes in craftsmanship. Men ranged from wizards with cloth and thread to rough stitchers with no finesse. A bright apprentice might realize that after a short time he had gained all the experience possible under a mediocre master, in which case he would move on. This was especially prevalent in the country, where tailors had less refinement and expertise than their city counterparts. Nonetheless, many top-notch tailors began their training in the country, and extol its benefits. Since most tailoring shops were one-man operations, an apprentice had the opportunity to learn how to make everything from children's trousers to wedding dresses. If the boss was not the most skilled he was at least highly versatile. An apprentice would not be likely to gain such wide experience in a more specialised city workshop, but, like Devereux, an ambitious youth would eventually have to head for the city. 'I came to the city and really started into the upper end of the craft. I went in with LeHane and McGuirk on Dame Street. They were one of *the* tailors in Dublin then. I worked for nearly ten years for a very small wage, for food and digs, just to learn the craft.' Such a combination of country and city experience allowed a man to go out on his own.

Country tailoring had its diversions because journeymen were still roving about. The 'footloose and fancy free' journeymen, as Hawkins knew them, were independent souls possessing unquenchable wanderlust and an intolerance of being rooted too long in a single spot. The journeyman tailor seems to have been even more romanticised than other travelling craftsmen. Perhaps, in part, this was due to the fact that, unencumbered even by tools, he seemed especially carefree and vagabond in nature. Surely one of the most mythologised accounts is Joseph Reilly's 1920 article entitled 'The Journeyman Tailor'.[9]

He's a singular individual, but withal a convivial and enjoying companion to converse with. Unfortunately, he is becoming, I fear, a *rara avis* in this island of ours. His collective numerical strength is on the wane and on the road to extinction. Nevertheless, he is still a ubiquitist of these islands. You'll meet him on the quiet country road (he's on the 'tramp' then), drinking to the full Nature's beauties as he wends his way; or again in our village and towns, at work or seeking it. . . he revels in pedestrianism. To him it is the elixir, the balm of life.

Naturally he gains much knowledge from his travelling which has the effect of making him broad-minded in his views and free of prejudice. You'll find him fluent and accordingly interesting. His love for an argument is supreme. He's quite at home in an argument, be it on theology, sociology, politics or otherwise.

What a simple natural life he leads. Free and independent, he spends his life a strict follower of nature and her laws. No material troubles weigh upon his mind, but indifferent and unheeding of the selfish struggle which goes on around him, he wends his way along the road of Time, as he lives he dies, unwept, unhonoured and unsung.

Devereux remembers the old journeymen in a more realistic light. 'I've worked with them. They'd think nothing of walking forty or fifty miles and come into a shop, sleep under the bench or in a barn and work until maybe four in the morning. They'd do piecework and get bed and breakfast. The journeyman tailor was mostly a drinker, always on the move. He might last a week but he very seldom stayed more than two weeks and very few of them were really good workers.' He also witnessed how journeymen were exploited by the small town 'gombeen' – often the local publican who arranged all the local deals. He would arrange for the tailor to do jobs for people but pay him only in beer and liquor. Consequently, many were habitually under the influence of drink and down and out. Fortunately, as Monaghan notes, there existed an ethic of craftsmen taking care of their own. If a straggling journeyman appeared at a tailor's shop but there was no work, it was customary for the master to give him a handout. The last of the journeymen tailors were seen in the 1950s.

Cross-Legged Tailors in Old Shops

The like of my shop is gone.

Gerald Devereux, 1984

In the forties, when Devereux was learning tailoring, the craft in Dublin was dying in the sense that fresh apprentices were few. Nonetheless, the city was still 'reeking with tailors. Not all top class. . . a few top class. There were a lot of small little tailor shops. The factory was only getting in at that time. There were the "fifty shilling" tailors and the premier tailors. And the Jews were starting to take control. There were very few Jews, by the way, in tailoring itself. They were in the factory but not doing the tailoring itself. The only Jews who did tailoring that I ever met were Russian Jews and you could count them on your hand. They were Russians who were run out of the country after the Revolution. They were good.' Shops varied enormously in size, quality and conditions. Hawkins speaks of the 'first-class shops like Callaghan's, Scott's and

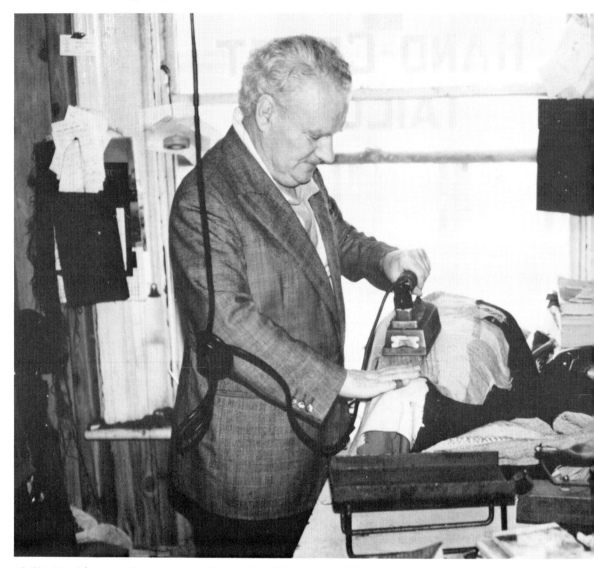

Phillip's' almost with reverence. Such prestigious establishments were mostly along Dawson, Grafton, Dame and O'Connell Streets. 'In the top class tailor shops,' says Devereux, 'there would be roughly seven men, while in the cheaper sweat shops there would be about thirty. Some larger shops could have fifty of sixty tailors on the premises. I can remember along Dame Street around half five you could see hundreds of coat makers coming down. But some of the tailors were outworkers who did their work at home.'

He deplored the vestiges of the Victorian period he knew in his early years. They were the shops characterised by human congestion, close bodily contact, poor ventilation and lighting and poor health among workers. Men sat hunched and cross-legged, with their heads hung low while labouring long hours. 'Conditions were terrible. It was slave labour in a sense. They were the sweat shops at the cheaper end of the trade. It

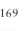

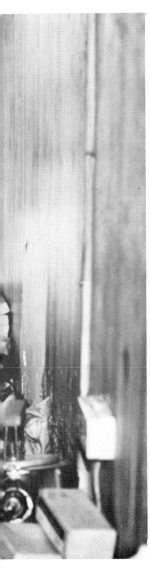

Handcraft tailor Gerald Devereux working in his small top-floor shop along Lower Abbey Street. He still puts in ten to twelve hours a day stitching jobs completely by hand and using antique irons for pressing

wasn't the gentry. The sweat shops existed up to the forties. They were crammed, with poor lighting and there were only two places that you would find a tailor's shop. Either in the cellar or at the top of the house because that was the cheapest space. At the sweat shop level it was just unbelievable. You always had a stove for to heat the irons. Coal was mostly used. That stove was on all day, winter and summer. Large shops could have fifty or sixty tailors sitting cross-legged on a bench. The reason for that is that tailors took up less space. In fact you had them working

under tables. You would sew on your knee and the old tailors pressed on their knees with a lap board. Men at the lower side didn't get a lot of satisfaction from their job.' It was the ambition of every tailor to rise above the 'sweating' level and secure a position with a 'civilised' establishment, but most never achieved this.

'Working on Dead' and 'Taking the Boot'

The tailor was very badly paid. . . always. Old tailors worked all their life without a week's wages and never getting a holiday.
 Gerald Devereux, 1983

Most other craftsmen worked either for a straight week's wages or on piecework but tailors had what was known as the 'log' system. Since many could not complete an entire coat or suit they worked only on sections. Each week they kept a log of how many collars, lapels or sleeves they had made and were paid accordingly. A specified log rate was assigned to each task, though it might take one tailor twice as long as another. Devereux detested the system. 'Tailors never worked for a week's wages. The coat was logged through. The tailor got paid individually for making the canvas or the pockets and it worked for him because he'd do only part of the coat and want his money. The log rate for a certain job would be half an hour or an hour and one tailor could take two hours doing it and I could take ten minutes but still got the half-hour's money for it. The wage was one shilling per log hour in the 1940s. So the tailor was very badly paid. It took an old tailor who was working on the log a whole week to earn two pounds.' Some shops did pay their better, more permanent tailors a weekly wage, but the log system was generally applied and men could take their work home with them.

The piecemeal manner of payment meant that tailors survived financially on a day to day basis and were often flat broke or even in debt. They could bail themselves out of poverty by collecting the 'boot', a cash advance for a job. Such a man, says Devereux, would 'come in, do part of the coat, want his money and go off drinking somewhere. So by the time the coat was finished the money was gone, already spent. He was flogging a dead horse.' Hawkins elaborates, 'You see, once a job is paid for it's called "dead". If a man came in and got the boot, was paid for the job, he calls that "working on dead" because there's no money to come to him.' To be constantly behind in wages was psychologically debilitating for many. Accepting the boot depended on one's financial need, philosophy and temperament. Hawkins knew 'one particular man who would never take an advance. He hated working on dead so much that he wouldn't do it. If he came in on Monday morning and had to work for the next three days for nothing it annoyed him so much that he just wouldn't let himself do it. But others would take all the dead they could get.'

Indeed, most tailors became bogged down in the boot system, habitually behind and working on jobs for which they had already been paid. Though there may have been a strong temptation to abandon the job once the pay was in the pocket, this was rarely done for fear of getting

a bad reputation. As Hawkins describes it, 'There was always a tradition in the trade that once a job was paid for it was paid for only once. The tradition was that if that fella left without finishing the job the rest of the tailors in the workshop would finish it for him. Therefore, the employer was quite safe in giving the boot. If a fella got the reputation for leaving too many jobs "dead" behind that would stick with him. You see, if the tailors didn't finish the job then *they* wouldn't get their boot because they wanted it too. So it was to everyone's advantage to play the game.'

Impoverished tailors also relied on the local pawnshop to get them through hard times, leaving behind a pair of scissors or an iron. Some were more innovative. They would take in just one section of a garment such as a sleeve and the pawnbroker, confident that they would have to retrieve it to complete their job, gave them the full price of the coat. Some enterprising tailors made up single sleeves, collars and lapels just for this purpose.

'Collecting Cabbage'

Most tailors Devereux knew were 'very badly dressed. They didn't have the money. Most of them couldn't make the complete job and were dependent on someone else to finish it for them.' As a consequence, ragged-clothed tailors would sit sewing fine outfits for others – a sad paradox. Were it not for the tradition of 'collecting cabbage' many might not have been able to clothe themselves and their families. 'Cabbage' is the material left over from jobs. Tailors had the right to collect such scraps for their own purposes. It was a sort of entitlement. Colour and material made little difference. There was, however, a strict code of ethics governing this practice. As Pender describes it, 'If a man was able to, he would save pieces of cloth from his work to make items for his family. This cabbage would be accepted as his property. It wasn't considered pilfering. Whatever a man had left over was legally his. But if you skimped on garments to get this cabbage, that's *robbery*. It's always been accepted within the craft that you're entitled to cabbage but you are not entitled to skimp to get it.'

Even with cabbage, some tailors could never quite make it. Devereux knew an old trouser maker who always wore a raincoat and what appeared to be new trousers every few months. He never removed the raincoat and the trouser legs were always immaculately creased. Only when he died did friends discover that he had but one pair of tattered trousers which he 'chopped off at the legs' and to which he sewed creased bottoms made from cabbage scraps. 'He was in rags elsewhere.'

Drinking and Socialising

In a tailor's workshop if you had half a dozen men, and there were no machines going then, they were talking. Religion and politics and everything was discussed in full. They were generally looked upon as very learned fellas.

Michael Hawkins, 1984

Tailors enlivened the monotony of their work and the dreariness of their setting by animated chatter. They fancied themselves philosophers, political pundits and connoisseurs of literature. Most were surprisingly well read and informed and many were versed in classical literature and philosophy. All seemed to have strong opinions. The close communal setting, the quietness of the shop and the boredom of stitching were conducive to conversation. 'You see, in our craft, and saddlery was the same, you could talk and work,' says Pender, 'in weaving there was the noise and they mouthed it across the looms to each other. Now with us, we could talk to each other and in the old workshops the young lad had to be in early in the morning and he would get the boiler going, put in the goose iron, the smoothing iron, and the other job he had was to read the newspaper to the staff. They weren't so interested in yarns, facts were more important.' Conversation could slip into debate and end up in heated argument but there existed a gentlemanly code of conduct which precluded personal attacks, foul language and off-colour jokes. 'The easiest thing in those days to create an argument was to mention De Valera. Straight away you had an argument. But we were instilled with this respect for each other. We had this code of decency among us. Respectablility at all costs. Bad language would not be tolerated. You wouldn't speak ill of anybody and nobody would criticise the boss. You knew well that you should, but nobody did.' Doubtless this was due in part to fear that it might get back to the boss himself.

Devereux always appreciated the joviality with which individuals displayed their own personality and originality. Many had colourful nicknames like 'The Horse's Head' and 'The Horse's "A"', 'The Student Prince', 'Dicky Bird' and 'Toucher Doyle', who was forever borrowing money. Each was amusing in his own way. 'The old tailors were like little old Barry Fitzgeralds, exactly the type, and they had their own philosophy of life. Some of them would be philosophising more than sewing. They could quote Shakespeare, Wordsworth, Longfellow. Very learned and yet they never got anywhere in life. They were marvellous characters with their own language and their own way altogether.' Some of the terms peculiar to the craft are as follows:

TERM	MEANING
cabbage	Material left over from a job
on the cod	On the booze
codge	To do bad, clumsy work
crushed beetles	Badly made button holes
easy stitch	A pleasant job
iron tailor	Early name for sewing machine
making your coffin	Overcharging for a coat

pig or *pork*	A garment so badly made that it cannot be put right and has to be 'killed'
trotter	A tailor's assistant who takes work out, or a messenger
cutting his own flap	A tailor who looks after himself

Humour and mischief had a place in the workshop. Men were given to good-natured slagging, pranks and practical jokes. It broke the boredom. There was a system known as 'barring' in which, if a 'smart ass' made some cracks, a fellow tailor needed only to whistle in order to have the remarks fall back upon the originator. Some days 'all you would hear was this chirp all the time,' says Pender. Pranks were particularly relished. 'If a tailor didn't like somebody,' divulges Devereux, 'he'd put what you call haircloth in the fork of the trousers. You were permanently going around scratching. Like having a thistle in your underpants.' More ingenious were stunts perpetrated against friends. 'I remember old Bill, a big fat trouser maker. As a young fella he had a date with a girl and he needed a special suit. So the boys agreed to make the trousers for him and they sewed a live mouse into the fork. Poor Bill was standing there, didn't know what was wrong with him that night, didn't suspect anything, didn't know what the hell was going on.'

Socialising in the workshop was often fuelled by drink. Despite their typically slight physique, tailors had a reputation as heavy drinkers given to rambunctious, sometimes riotous, behaviour; as evidenced from this account in the 1906 *Evening Mail:*

> Tailors give us more trouble than all other classes of men in Dublin. Most of them spend their money on drink. The system of drinking in the tailor's workshops is scandalous.

Devereux recalls with amusement such 'scandalous' drinking in one old tailor's workshop along Dame Street and the futile effort of the boss to sober up his staff. 'One of the boss fellas was getting a bit worried that the boys were drinking too much during working hours and the reason that they were drinking is that there was a pub just across the alley from them. One day he said, "You'll have to stop drinking. I'm locking the bloody door and you can't get out." He thought he was alright. But the next thing he knew he came back and the boys were fluted with no work done. He didn't know what happened. And this happened for a couple of days and he could *not* figure it out. There was no way they could have got the drink unless they got it down the chimney or something. It wasn't until he went to take his afternoon stroll that he realised how they were doing it. The pub had a window across the alley on the second floor, same as the tailor's shop, and the boys had fitted a line across and rigged up a pulley and the bucket they used for their water. The bottles were transferred across from one side of the alley to the other and their money would be put in the bucket.'

The tailors' heavy imbibing stemmed from a combination of their insecurity, nagging inferiority complex, stifling work conditions, monotonous labour, low pay and domination by bosses. Drinking and carousing were a means of expression and emancipation. 'The reason that they were hellraisers,' Devereux believes, 'is that their life and livelihood were very poor. They would drink and were always in debt and

their employers revelled in it.' Many were alcoholics whose family life, work capabilities and longevity were adversely affected.

Masters and Underlings

Tailors were never their own master. They were at the mercy of their bosses.

Gerald Devereux, 1983

There existed in tailoring a level of domination, exploitation and abuse by bosses seldom seen in other crafts. As Pender puts it, 'The masters hated the men and the men hated the masters. The master was the boss. Workers were exploited.' Devereux is more explicit: 'The old tailors would be crucified by the master tailors.' Tailors constituted one of the most powerless working groups in Dublin. Several factors account for this impotent status. First, there was an abundance of craftsmen; each knew he could be summarily replaced. Second, since many could only complete parts of coats and suits they were dependent on the boss to integrate them into the shop process. Third, many were physically frail or disabled or came from socially deprived backgrounds such as reform schools or industrial schools and deaf and dumb institutions. Collectively, they were insecure, passive and non-aggressive. Bosses exploited this vulnerability, forcing them to toil long hours for paltry wages, verbally brow-beating them and deliberately intimidating them. 'Bosses always played tailors against one another,' notes Devereux, 'praising the work of one man to another while demeaning the quality of *his* work in order to get him to accept a lower rate.' They did not rise up against their antagonist because 'tailors would need independence to do that. Employers didn't want troublemakers around and if a tailor were poorly dressed or asked for the boot it showed that he hadn't got it and so right away that man is not going to give you any trouble and there's ten others outside the door waiting for the same job. So if you were in the position of needing the job badly you had to crawl and once you start crawling you start drinking, you see, because you're selling your soul and your pride is gone.'

Insecurity led most craftsmen to be jealous and secretive of their techniques, unwilling to share their knowledge with peers or apprentices. As Devereux found, 'Old tailors were very jealous of one another and they wouldn't teach you anything. They weren't inclined to teach a youngster because they were afraid that they'd take their job away. They were very secretive. Competition was keen and if you saw a man doing a nice button-hole you might say, "Would you mind showing me how that was done?" And they'd tell you to mind your own business. You couldn't really blame them. They were subjected to a very hard living. They were frightened type of people these tailors, very insecure all their lives.'

To appreciate the plight of the underling tailor one must understand the hierarchy of the shop. Shops were owned by a master tailor or simply a businessman who hired craftsmen to do the work for him. He would employ a master tailor or foreman cutter to handle the front office duties

of greeting customers, measuring, making patterns, selecting fabric and cutting cloth. In some cases the businessman-owner would have the audacity to masquerade as a master tailor before customers who did not know the difference. This galled working tailors in the backroom. 'That's what was wrong with the trade,' Devereux protests, 'many of the employers weren't tailors at all, they were businessmen. They controlled the prices, made a lot of money, exploited the tailor.' They could sell a suit for three or four times the amount it actually cost them to have their tailors make it.

Tailors resented such owner-bosses but they dared not confront them. However, they did regularly tangle with the master tailors and cutters. The two were not always the same. Paradoxically, a man could become a master tailor without perfecting cutting. Conversely, an individual could be trained to measure, make patterns and cut cloth with precision without mastering tailoring. It was the latter who was most detested by tailors. According to Devereux, 'There was always ill feelings between the cutters and the tailors.' Each saw himself as the more skilled and indispensable. In truth, tailors were far more dispensable because they greatly outnumbered cutters. Pender expresses the tailor's position: 'In those days it was never accepted that the cutter was of any use. The tailor was *the* man. He cut it but I *made* it.' Devereux adds, 'The cutter was only a bit of dirt as far as the tailor was concerned.' A master tailor could, as in the case of Hawkin's father, pay another craftsman to teach him the art of cutting. This allowed him to set up his own shop and pass the knowledge down to his son. In prestigious shops like Callaghan's and Scott's there could be two or three cutters parading about in morning suit and striped trousers. It was the foreman cutter who ruled the roost. 'The foreman cutter was the master of the shop,' states Hawkins, 'He was the kingpin of the whole place. A working tailor didn't go out drinking with the foreman cutter. They were of a different class. A lot of good tailors saved the jobs of poor cutters.' The two seemed locked in constant battle. In part this was due to the fact that cutters liked to march about like a 'bloody surgeon', bossing and bullying the tailors in the backroom.

Tailors had to suffer a double standard by which cutters could criticise their work and order them around but they were not allowed a peep of protest for fear of losing their job. Says Pender, 'A tailor could never tell a cutter that his work was wrong but a cutter could tell a tailor. He couldn't accept criticism from a tailor.'

Thus the atmosphere in the front office which customers saw was always civil and tranquil while in the workroom frustration simmered and tempers flared. Here blatant favouritism was practised, with the cutter giving the easiest jobs to those he liked best. On the other hand, Hawkins testifies that they could be 'vicious' in their treatment of tailors they disliked. He recalls the case of a cutter who had the job of making up a dress suit for a particular customer and 'they had a terrible lot of trouble with it but eventually they got it right and he (the cutter) called the tailor down and said, "Rip that up so I can get a pattern off it." And so the fella had to go upstairs, rip the thing out, press it so that the cutter could get a pattern off it, and then sew it up again. That was the sort of thing they could do because there were so many tailors available at that

time that if he refused he was out. Ah, it was soul-destroying.' One spirited old tailor, having endured a lifetime of abuse from various cutters and masters, venomously declared that 'hell would never be full until every master tailor in Dublin was in it.'

Old Tailors Fading Away

I was just coming in as tailoring was going out.

Gerald Devereux, 1983

When Hawkins was born, handcraft tailoring was still flourishing in Dublin due in part to the world situation. 'With the 1914 war there was great demand for uniforms and a lot were made in this country. A large portion of young men in Ireland went off to the war and the Anglo-Irish families, their sons all went off as officers. When the war started off an officer was turned out with three of four uniforms and the whole blooming lot. But as time went on more and more officers were needed and there wasn't time to make uniforms because some of them would hardly have their uniforms before they were shot. Then after the war the fellas were coming home with their discharge money and army suit and the first thing they wanted was to get a suit of their own.'

Devereux verifies that in the 1930s when factories were expanding very few of the small tailoring shops were using machinery. 'The machines came in when the Jews came in. When the Singer sewing machines came in it began to put men out of business bit by bit. And the thirties was the big boom for factories starting.' World War II brought new hardship to the craft. Materials were scarce and tailors had to resort to repair work. Like Devereux, they 'couldn't get cloth so you would have to "turn" jobs. You would rip the material completely out, turn it and remake it.' Others, like Hawkins, also 'went in for the ladies' trade because the ladies could always get a bit of cloth somewhere.' After the war, clothing factories went into full gear, imported British apparel was readily available and Irish department stores stocked a wide range of clothing at reasonable prices. Affordable ready-made suits straight off the rack threatened the business of the handcraft tailors. Many prudently shifted from the little workshop to the factory where the advantages were many. As Pender explains, 'In the 1940s when the factories started to take over, the working tailor discovered he could earn more in a factory than he could at handcraft. He could get a better wage in the factory putting in collars and sleeves all day with the volume of trade. And the factories started with trade unionism, and holidays with pay. Others wanted nothing more to do with tailoring.' Higher wages, shorter working hours and the collective benefits found in the factory siphoned off mediocre tailors, leaving a small number of top-class craftsmen to cater to a loyal clientele of Dubliners still demanding the elegance of a hand-crafted suit. Out of pride and conservatism they clung to the craft but their children were not so inclined. They saw their fathers still struggling through long hours for minimal profit. Other occupations offered more promise. 'Very few of the sons took over,' says Devereux, 'you can imagine an old tailor flogging himself. His family suffered for it. How

could you, as his son, go into that craft? Seeing him work so hard for so little, how could you even think about it?'

With the fifties, Ireland began modernising. Factory-made clothes were available in a greater range of cost, colour and style. By then, Pender relates, 'the tailoring trade was on its knees. We started to lose the tailoring premises in Dublin along Dame Street, O'Connell and Westmoreland. It was all but dead. It was inevitable.' Then, during the sixties, some of the city's technical schools began turning out what Devereux calls 'a lot of little mushroom tailors' who had minimal training and made poor-quality clothing using sewing machines, 'They weren't top class. They were in between a handmade job and a factory job. My contention is that there are only two types of jobs, a good handcraft job and a good factory job. It never worked out.'

With the seventies there appeared an even wider selection of factory-made clothing, but more important was the notable improvement in quality. Loyal customers who always attired themselves in tailor-made suits now felt comfortable wearing the finest manufactured ones. Often they could have two of these for the price of one handmade suit. Monaghan interprets this development: 'The ready-made suits you used to get in Ireland, ones made in this country, were very badly constructed. And there were all sorts of restrictions and licences on imported ones. But with the EEC there is free entry and practically every country in Europe is sending suits in here. There's a very big selection now in styles and cloths and quality. So the vast majority of people are buying ready-made suits.'

The Tailor-Customer Relationship

Few craftsmen have such a close relationship with their customers as the tailor.[10]

If ever an art deserved the term 'creative', surely it is the tailor's.[11]

Typically, the relationship between tailor and customer begins as a business transaction but develops into a lifelong friendship. It used to be a more formal affair. In the old days, top tailoring shops had an ambience of exclusivity. Not only was the reputation of the establishment important, but that of the customer was too. A man could not strut unknown into a shop and expect to have a suit made. Nor was cash offered as a deposit. As Hawkins tells it, 'If you wanted to go to a prestigious firm in Dublin like Scott's or Phillip's you didn't just walk in and say "I want two suits." They would reply, "Who are *you?* Have you references?" This was done to establish your identity and credit worthiness. They didn't take deposits. It wasn't done. They'd ask you for references. The system was that when you went in to get a new suit you always paid for the last one. And it wasn't a question of coming in and getting your suit and putting it under your arm. It was sent out or a chauffeur or coachman was sent for it.' It was an abiding relationship based on trust, loyalty and longevity. This is illustrated by the case of the ninety-year-old man who, realising that he would no longer need any clothes made, went to his

tailor to formally close his account after seventy-five years. The tailor dejectedly responded, 'What have we done to disappoint you?' 'He was heartbroken,' says Hawkins, 'it was a *relationship*.'

Yet, despite the gentlemanly demeanour and congeniality, it has never been an equal relationship. Pender affirms that the difference in socio-economic status between the two was understood. 'You never drank with your tailor. Oh, tut, tut, no. A tailor was not good enough to drink with customers. The attitude of the customers is that he's my employee. He makes my clothes.' Though most customers are respectful, some pomp-ous individuals haughtily 'look down their bloody noses' at the tailor. Over the past five decades customer types have changed little. Back in the forties when Devereux was charging £20 for a suit – considered 'a lot of money' then – his customers were largely the 'racing crowd', ban-kers, doctors and solicitors. Today there are more government officials and businessmen or what Pender labels 'upcoming people, the whizz kid in town', who must impress people while climbing the social ladder.

All four craftsmen have outfitted the high and mighty in Ireland, from famous surgeons and government potentates to personalities from the world of entertainment. Devereux has made suits for 'a few TD's' but best remembers Brendan Behan who, about twenty-five years ago, was making a trip to the United States and wanted to be properly attired. 'I made him three suits for that trip. . . and he went to America and got drunk.' Confidentiality between the tailor and such prominemt custom-ers has always been a tradition. Secrets learned in the fitting room are inviolate. This is a prudent policy because, for some inexplicable reason, patrons can become as chummy and vociferous with their tailor as with their local publican, spilling upon him all manner of personal problems and embarrassing minutiae. An ethical tailor remains deadly silent. Indeed:

> One is led to reflect on what would happen if tailors preached about those who pass through their portals. No man is an Apollo to his tailor and the great shrink visibly during the process of disrobing. There is no end to the physical, moral and mental defects that a tailor could publish about the ele-vated and eminent whom he makes passable for public display.[12]

The perceptive tailor begins practising his craft the moment the cus-tomer enters his shop. He shrewdly but gently appraises personality and general deportment. 'A tailor is ninety per cent psychologist,' declares Pender, 'he sees a fella with a hump on his back and he has to convince that man that he hasn't got it or he gets a flat-chested woman and tells her that she's Marilyn Monroe.' Final judgement as to what looks best is a mutual decision, but the canny tailor can coax a customer into the most appropriate style and material. He seeks not merely to fit, but to adorn the customer. His role, as expressed in a 1932 issue of *The Tailor and Cutter* is to improve upon nature:

> The tailor's mission is beneficent. The moulds of nature are not perfect. Many are mis-shaped by accident, labour or foolish living – others by legacy. Modern conditions are against keeping the body straight, shapely and supple. Thereby, the tailor's task is more difficult and more honourable.[13]

Historically, the Irish have been more concerned with function than fashion. 'Back in the 1930s and 1940s,' observes Pender, 'most Irish men had only one suit – the one that they were married in and buried in. It didn't wear out because they only wore it to Mass. And they let it out if they got fat.' Fitting the fat is perceived as the tailor's greatest challenge. In truth, it is just the oppostie. As Monaghan explains, 'A tall, skinny man with bones sticking out is the most difficult to fit. Fat people are not as difficult. It's very hard to fit bones. To make it properly you want to cut a hole and let the bones out.' Devereux agrees: 'These big pot-bellied, well-to-do businessmen, I can make them look as thin as can be. It's only when he takes off his coat that he realises that he has a big pot belly. From experience you can learn the logic of the thing.'

Handcraft tailoring means transforming limp material into a garment with 'life'. This is done in the backroom, or 'inner sanctum' as Devereux calls it, the part of the shop never seen by customers. A tailor is judged by the quality of his sewing, and Devereux is a perfectionist. Working at a steady rate of 1,000 sitches per half hour his motion is fluid and rhythmic. Some tasks demand special precision. 'I once had a girl apprentice in here. It took me a year to teach her how to do a button hole. That's a fact.' The aim is to create a coat that looks absolutely natural and 'alive' as opposed to factory-made ones, which craftsmen term 'dead'. Devereux defines the difference like this: 'Ready-made suits are stereotyped. There's no personality in them, no expression. It's just dead, flat. A suit has to look as if it's actually alive. A lapel can have life in it. Factory-made suits are just fused together. There's no tailoring in them.' Hawkins is more blunt. 'Factory-made suits are now engineered. The head of the factory is not a tailor anymore, he's an engineer because they look upon tailoring the same as making motor cars or refrigerators. You just assemble the parts.'

The Irish today are discernibly more clothes conscious. Some confront their tailor with premeditated ideas and precise details. After all, 'bespoke' means that the customer has spoken his request, even if it assaults the tailor's sensibilities. More difficult is the individual who has no notion of what he wants. 'The easiest person to work with,' Hawkins feels, 'is the most meticulous person. I remember one fella came in and I often told him, "I think you're bringing specifications for a battleship." He had everything written down, where the buttons go and everything.' Another customer cared only that the inside coat pocket was exactly sized to fit his packet of Lucky Strikes. Even when the fit is flawless there are always the fussy few who insist on alterations. Tailors commiserate with each other over such malcontents. Devereux recalls one such finicky patron who, over the years, had nearly driven his tailors to madness by his insistent alterations. 'Now this old man was being buried and they were putting the coffin in the ground and it wouldn't fit, just a small corner of the thing. So your man had to get the shovel and spade to get the coffin down and his tailor turns to his other tailor friend and says, "See, even to the *end* he has to have an alteration!"' Such psychological quirks frustrate tailors; once, one of Hawkin's old colleagues was prompted to retort acerbically to a dissatisfied , grumbling matron, 'Madame, I can fit your body but can I fit your mind?'

No More Michelangelos

When I die these skills will die with me. It can't be passed on. It's like there are no more Michelangelos. It's gone. The craft goes with you.
 Gerald Devereux, 1984

Bespoke tailoring is dying in Dublin because no-one is coming along to take up the craft. 'I haven't had an apprentice for years and there's nobody looking to be an apprentice,' laments Monaghan, 'it's down to the last two or three of us now. We've seen the last of the tailors.' He takes great pride in having faithfully retained handcraftmanship in a technological age. 'I have a great friend who is the Duke of Edinburgh's tailor and Prince Charles' tailor and even he does the lapel and button holes by machine.' In five years the lease on his Georgian quarters will be renegotiated and he fears that the inflated rent may force him to retire.

Pender owns his shop and can hold out until old age but sees 'no future in being a tailor. There are no apprentices coming into the craft. I'm sad to see it happen but it was inevitable.' Hawkins, now in his seventies, has been at the craft for more than half a century. It has been hard on his eyes and hands. Business remains brisk thanks to the flourishing 'horsey set' in Dublin but eventually the annual horse show will have to go on without him. When the 'Britches Maker' sign comes down, Parnell Square will be a little poorer.

Devereux is openly sorrowful about the impending demise of his craft. His hope had always been to pass it on to a son. 'I would have loved my children to be at it. But I wouldn't push them. When my son, Francis, came into me of his own free will I was delighted. I didn't let on to him. I was also disappointed when he left because I had planned to build a little business with him. . . that was my plan.' Over the years he has been offered lucrative managerial positions and even partnerships in clothing factories but he has steadfastly refused to abandon pure handcraft. 'I wouldn't have had any satisfaction.' He will never retire. Financially it is not feasible. Anyway, it has always been his wish to finish his life in the shop. 'They'll find myself here one day on the floor, I'll work up to the last day. . . I know that the craft is going to go with me.'

Notes

INTRODUCTION

1. Farleigh, *The Creative Craftsman*, 1
2. Wymer, *English Town Crafts*, v
3. Webb, *The Guilds of Dublin*, 1
4. *Ibid.*, 241
5. Keogh, *The Rise of the Irish Working Class*, 35
6. Arnold, *The Shell Book of Country Crafts*, 62
7. D'Arcy, *Dublin Artisan Activity, Opinion and Organization, 1820-1850*, iii
8. O'Suilleabhain, *A Handbook of Irish Folklore*, 64
9. Murphy, *Stone Mad*, ix
10. Arnold, *op. cit.*, footnote 6, p. 51
11. Wymer, *English Country Crafts*, 14
12. Farleigh, *op. cit.*, footnote 1, p, 59
13. Daly, 'A Few Notes on the Guild System', *Dublin Historical Record* vol. XI, no. 3, 1950, p. 71
14. O'Neill, *Life and Tradition in Rural Ireland*, 90
15. Glassie, *Irish Folk History*, 16-17
16. Paz, *In Praise of Hands*, 10
17. Terkel, *Working*, ix
18. Gailbraith, *The Affluent Society*, 261
19. 'Craftsman and Manufacturer', *The Irish Builder* vol. XXX, no. 681, 1888, p. 126
20. Mills, *White Collar: The American Middle Classes*, 223
21. Stowe, *Crafts of the Countryside*, 3
22. Mills, *op. cit.*, footnote 18, p. 222
23. Arnold, *op. cit.*, footnote 9, p. 50
24. Yanagi, *The Unknown Craftsman*, 95
25. Mills, *op. cit.*, footnote 18, p. 222
26. Veblen, *The Instinct of Workmanship*, 235
27. Farleigh, *op. cit.*, footnote 1, p. 1

CHAPTER ONE: COOPERS

1. Kilby, *The Cooper and His Trade*. This is an excellent reference work for tracing the origins and evolution of the craft of coopering.
2. McGregor, *New Picture of Dublin*, 65-66
3. Bennett, 'Barrels and Money', *Ireland's Own*, 27 September 1941, p. 6
4. Coleman, 'The Craft of Coopering', *Journal of the Cork Historical and Archaeological Society* vol. XLIX, 1944, p. 79
5. Crudden, 'Trades and Customs Long Ago', *Ireland's Own*, 5 April 1941, p. 6
6. Kilby, *op. cit.*, footnote 1, p. 169
7. Danaher, *Irish Country People*, 49
8. Kilby, *op. cit.*, footnote 1, p. 15
9. 'The Cooper: The Craft and the Man', *Guinness Time* vol. 1, no. 1, p. 15
10. This information is taken from a copy of the *Minutes of Special Dissolution Meeting of the Regular Dublin Coopers' Society*, 24 March 1983

CHAPTER TWO: SIGNWRITERS

1. Sutherland (ed.), *The Modern Signwriter*, 1
2. Shaffrey, *The Irish Town: An Approach to Survival*, 128

3. Gray, *Lettering on Buildings*, 51
4. Peter, *Sketches of Old Dublin*. For a lively treatment of this subject, see chapter entitled 'Curious Old Dublin Shop Signs'.
5. Rothery, *The Shops of Ireland*, 73
6. MacMahon, 'Shop Fronts', *Ireland of the Welcomes*, September/October 1971, p. 32
7. Bartram, *Fascia Lettering in the British Isles*, 6
8. MacMahon, *op. cit.*, footnote 6, p. 32
9. Vinycomb, 'The Heraldry of Old Signs', *Journal of the Kildare Archaeological Society* vol. 47, 1942, p. 177
10. 'The Street Life of Old Dublin', *The Lady of the House* (a Dublin magazine) vol. XXII, no. 248, 1909, p. 24
11. 'The Corporation and Projections in the Streets', *The Dublin Builder* vol. VI, no. 117, 1864, p. 215
12. Sutherland, *op. cit.*, footnote 1, p. 1
13. Sutherland, *op. cit.*, footnote 1, p. 1
14. Strange, 'The Practice of Lettering', *The Irish Builder* vol. XLII, no. 973, 1900, p. 441
15. Strange, 'The Practice of Lettering', *The Irish Builder* vol. XLII, no. 972, 1900, p. 427
16. Armstrong, 'Gentlemen of Letters', *Dublin Magazine* 23 February 1978, p. 20
17. Callingham, *Signwriting*, 9
18. Lawrance, 'Signwriters' Tools and Their Care' in Sutherland (ed.) *The Modern Signwriter* 9
19. Whittaker, *Shopfront*, 11
20. Callingham, *op. cit.*, footnote 17, p. 28
21. Lawrance, *op. cit.*, footnote 18, p. 9
22. MacMahon, *op. cit.*, footnote 6, p. 32
23. Bartram, *op. cit.*, footnote 7, p. 1
24. Bartram, *op. cit.*, footnote 7, p. 2
25. MacMahon, *op. cit.*, footnote 6, p. 32

CHAPTER THREE: SHOEMAKERS

1. Gilbert, *A History of the City of Dublin, Volume I*, 43. This is a reproduction of the original 1854 volume.
2. *The Dublin Civic Survey Report*, 90
3. Dennis, *Industrial Ireland*, 136
4. Lloyd, 'Dublin Shoeblacks', *Ireland's Own* vol. 46, no. 1187, 1925, p. 150
5. Dennis, *op. cit.*, footnote 3, p. 137
6. Joyce, *The Neighbourhood of Dublin*, 357

CHAPTER FOUR: FARRIERS

1. MacGiolla Phadraig, 'Dublin One Hundred Years Ago', *Dublin Historical Record* vol. XXIII, nos. 2-3, 1969, p. 56.
2. Norwood, *Craftsmen at Work*, 84
3. *Ibid.*, p. 81
4. Woods, *Rural Crafts of England*, 31
5. Alexander, *Crafts and Craftsmen*, 11
6. Thompson, 'The Blacksmith's Craft', *Ulster Folklife* vol. 4, 1958, pp. 33-36
7. Norwood, *op. cit.*, footnote 2, p. 80
8. Danaher, *Irish Country People*, 82
9. MacGiolla Phadraig, *op. cit.*, footnote 1, p. 56. *See also* Keatinge, 'Colourful, Tuneful Dublin', *Dublin Historical Record* vol. IX, no. 3, 1947, p. 74
10. Crosbie, *Your Dinner's Poured Out*, 72
11. Woods, *op. cit.*, footnote 4, p. 30
12. Danaher, *op. cit.*, footnote 8, p. 82
13. For two interesting personalised accounts of the lure of the forge, *see* Clare, 'The

Forge', *Ireland's Own* vol. 70, no. 1777, 1937, p. 18 *and* O'Hare, 'The Blacksmith of Burren', *Ireland's Own* vol. 36, no. 940, 1920, p. 381

14. Crosbie, *op. cit.*, footnote 10, p. 72
15. Alexander, *op. cit.*, footnote 5, p. 18
16. Daly, 'The Return to the Roads' in Nowlan (ed.) *Travel and Transport in Ireland*, 146
17. Crosbie, *op. cit.*, footnote 10, p. 73

CHAPTER FIVE: SADDLE-HARNESS MAKERS

1. Norwood, *Craftsmen at Work*, 96
2. Wymer, *English Country Crafts*, 46
3. Woods, *Rural Crafts of England*, 82
4. Keatinge, 'Colourful, Tuneful Dublin', *Dublin Historical Record* vol. IX, no. 3, 1947, p. 73
5. *Ibid*, p. 75
6. Norwood, *op. cit.*, footnote 1, p. 96

CHAPTER SIX: STONECARVERS

1. Murphy, *Stone Mad*, 5
2. Danaher, *Irish Country People*, 31
3. 'English Architects in Ireland, *The Irish Builder* vol. XX, 1978, p. 358
4. Murphy, *op. cit.*, footnote 1, p. viii
5. 'A Word for the Dublin Stonecutters', *The Dublin Builder* vol. 56, 1862, p. 96
6. Murphy, *op. cit.*, footnote 1, p. 56
7. 'Ecclesiastical Sculpture in Dublin', *The Irish Builder and Engineer* vol. XLIV, 1903, p. 1814
8. 'Number of Cremations Rising', *Irish Times*, 2 January 1985, p. 8

CHAPTER SEVEN: TAILORS

1. Dixon, 'The Dublin Tailors and Their Hall', *Dublin Historical Record* vol. XXII, no. 1, 1968, p. 148
2. 'The Dublin Sweating System', *The Irish Builder* vol. XVII, no. 380, 1875, p. 286. For further insight on these conditions *see* 'The Tailors and Their Workshops', *The Irish Builder* vol. XI, no. 233, 1869, p. 205 and *Report of the Eighth Irish Trades Congress*, p. 49
3. *Ibid.*
4. *Op. cit.*, footnote 2
5. Kennedy (ed.), *Victorian Dublin*, 76
6. 'Sewing Machinery', *The Dublin Builder* vol. LLL, no. 38, 1861, p. 574
7. 'Progress Hits the Tailors', *Irish Industry and Commerce* vol. 1, no. 6, 1924, p. 202
8. Danaher, *Irish Country People*, 19
9. Reilly, 'The Journeyman Tailor', *Ireland's Own* vol. 35, no. 907, 1920, p. 336. *See also* Larkin, 'Major Bullet and the Tailor', *Ireland's Own* vol. 5, no. 113, 1905, p. 19
10. Norwood, *Craftsmen at Work*, 48
11. 'Professional Secrecy', *The Tailor and Cutter*, 30 December 1932, p. 1
12. *Ibid.*
13. 'The Tailor Makes the Man', *The Tailor and Cutter*, 16 December 1932, p. 1

Bibliography

Alexander, Bruce *Crafts and Craftsmen* (London, Croom Helm, 1974)

Armstrong, Robert, 'Gentlemen of Letters', *Dublin Magazine,* 23 February 1978, p. 20

Arnold, James *The Shell Book of Country Crafts* (London, John Baker, 1968)

'Art Development and Woodcarving', *The Irish Builder,* vol. XVII, 1875, p. 131

'The Arts and Crafts Exhibition', *The Irish Builder,* vol. XXXVIII, no. 864, 1895

Bartram, Alan *Fascia Lettering in the British Isles* (London, Lund Humphries Publishers, 1978)

Bennett, R. J., 'Barrels and Money', *Ireland's Own,* 27 September 1941, p. 6

Callingham, James *Signwriting* (Philadelphia, Henry Carey Baird Publishers, 1876)

Clare, Nooneen, 'The Forge', *Ireland's Own,* vol. 70, no. 1777, 1932

Coleman, J. C., 'The Craft of Coopering', *Journal of the Cork Historical and Archaeological Society,* vol. XLIX, 1944

'The Cooper: The Craft and the Man', *Guinness Time,* vol. 1, no. 1, 1947

'The Corporation and Projections in the Streets', *The Dublin Builder,* vol. VI, no. 117, 1864

'Craftsman and Manufacturer', *The Irish Builder,* vol. XXX, no. 681, 1888, p. 126

Crosbie, Paddy *Your Dinner's Poured Out* (Dublin, O'Brien Press, 1982)

Crudden, Maime, 'Trades and Customs Long Ago', *Ireland's Own,* 5 April 1941, p. 6

Daly, M. H., 'A Few Notes on the Guild System', *Dublin Historical Record,* vol. XI, no. 3, 1950

Daly, Miriam, 'The Return to the Roads' in Kevin Nowlan (ed.) *Travel and Transport in Ireland* (Dublin, Gill & Macmillan, 1973)

Danaher, Kevin *Irish Country People* (Cork, Mercier Press, 1966)

D'Arcy, Fergus *Dublin Artisan Activity, Opinion and Organization, 1820-1850* (M.A. Thesis, University College, Dublin, 1968)

Dennis, Robert *Industrial Ireland* (London, John Murray, 1877)

Dixon, F. E., 'The Dublin Tailors and Their Hall', *Dublin Historical Record,* vol. XXII, no. 1, 1968

The Dublin Civic Survey Report published by the Civic Institute of Ireland (London, Hodder & Stoughton, 1925)

'The Dublin Sweating System', *The Irish Builder,* vol. XVII, no. 380, 1875

'Ecclesiastical Sculpture in Dublin', *The Irish Builder and Engineer,* vol. XLIV, 1903

Edwards, Ralph and Johnson, Margaret *Georgian Cabinet Makers* (London, Country Life, 1944)

'English Architects in Ireland', *The Irish Builder,* vol. XX, 1878

'The Exhibition and the Dublin Furniture Trade', *The Irish Builder,* vol. XXIII, no. 526, 1881

Farleigh, John *The Creative Craftsman* (London, G. Bell & Sons, 1950)

Gailbraith, John Kenneth *The Affluent Society* (Boston, Houghton Mifflin Co., 1976)

Gilbert, John T. *A History of the City of Dublin, Volume I* (Dublin, Gill & Macmillan, 1977). *This is a reproduction of the original 1854 volume.*

Glassie, Henry *Irish Folk History* (Philadelphia, University of Pennsylvania Press, 1982)

Glassie, Henry *Passing the Time in Ballymenone* (Philadelphia, University of Pennsylvania Press, 1982)

Gray, Nicolete *Lettering on Buildings* (New York, Reinhold Publishing Co., 1960)

Jenkins, J. G. *Traditional Country Crafts* (London, Routledge & Kegan Paul, 1965)

Joyce, Weston St John *The Neighbourhood of Dublin* (Dublin, M. H. Gill & Son, 1939)

Keatinge, Edgar F., 'Colourful, Tuneful Dublin', *Dublin Historical Record,* vol. IX, no. 3, 1947

Kennedy, Tom (ed.) *Victorian Dublin* (Dublin, Albertine Kennedy Publishers, 1980)

Keogh, Dermot *The Rise of the Irish Working Class* (Belfast, Appletree Press, 1982)

Kilby, Kenneth *The Cooper and His Trade* (London, John Baker, 1971)

Kurth, Godefroid *The Workingmen's Guilds of the Middle Ages* (Cork, Forum Press, 1943)

Larkin, P. J., 'Major Bullet and the Tailor', *Ireland's Own,* vol. 5, no. 113, 1905

Lawrance, James, 'Signwriters' Tools and Their Care' in W. G. Sutherland (ed.) *The Modern Signwriter* (Southport, Lancashire, The Sutherland Publishing Co., 1954)

LeHane, Una, 'Glynn's Passionate Love of Woodcarving', *Irish Times,* 14 March 1984

Lloyd, F. E., 'Dublin Shoeblacks', *Ireland's Own,* vol. 46, no. 1187, 1925

MacGiolla Phadraig, Brian, 'Dublin One Hundred Years Ago', *Dublin Historical Record,* vol. XXIII, nos. 2-3, 1969

MacMahon, Bryan, 'Shopfronts', *Ireland of the Welcomes,* September/October, 1971

Martin, Colbert *The Woodcarvers of Bray, 1887-1914* (Dublin, published by the author, 1985)

McGregor, John James *New Picture of Dublin* (Dublin, A. M. Graham, 1821)

Mills, C. Wright *White Collar: The American Middle Class* (New York, Oxford University Press, 1951)

Minutes of Special Dissolution Meeting of the Regular Dublin Coopers' Society, 24 March 1983

Murphy, Seamus *Stone Mad* (London, Routledge & Kegan Paul, 1966)

Norwood, John *Craftsmen at Work* (London, John Baker, 1977)

Nowlan, Kevin (ed.) *Travel and Transport in Ireland* (Dublin, Gill & Macmillan, 1973)

'Number of Cremations Rising', *Irish Times,* 2 January 1985

O'Hare, J., 'The Blacksmith of Burren', *Ireland's Own,* vol. 36, no. 940, 1920

O'Neill, A., 'Dublin's Eighteenth Century Trade Processions', *Ireland's Own,* vol. 64, no. 1664, 1934

O'Neill, Timothy *Life and Tradition in Rural Ireland* (London, J. M. Dent & Sons, 1977)

O'Sulleabhain, Sean *A Handbook of Irish Folklore* (Dublin, Educational Company of Ireland, 1942)

Paz, Octavio *In Praise of Hands* (Greenwich, Connecticut, New York Graphic Society, 1974)

Peter, A. *Sketches of Old Dublin* (Dublin, Sealy, Bryers and Walker, 1907)

'Professional Secrecy', *The Tailor and Cutter,* 30 December 1932

'Progress Hits the Tailors', *Irish Industry and Commerce* vol. 1, no. 6, 1924

Reilly, Joseph, 'The Journeyman Tailor', *Ireland's Own,* vol. 35, no. 907, 1920

Report of the Eighth Irish Trades Congress (Dublin, James O'Donoghue, 1901)

Riordan, E. J. *Modern Irish Trade and Industry* (London, Methuen and Company, 1920)

Rothery, Sean *The Shops of Ireland* (Dublin, Gill & Macmillan, 1978)

Rules of the Regular Operative Coopers' Society of the City of Dublin (Dublin, Joseph Dollard, Dame Street, 1872)

'Sewing Machinery', *The Dublin Builder,* vol. III, no. 38, 1861

Shaffrey, Patrick *The Irish Town: An Approach to Survival* (Dublin, O'Brien Press, 1975)

Sketches of Ireland Sixty Years Ago author not known (Dublin, James McGlashan, 1847)

Stowe, E. J. *Crafts of the Countryside* (Yorkshire, EP Publishing Company, 1973)

Strange, Edward F., 'The Practice of Lettering', *The Irish Builder,* vol. XLII, no. 973, 1900

'The Street Life of Old Dublin', *The Lady of the House,* vol. XXIII, no. 248, 1909

Sutherland, W. G. (ed.) *The Modern Signwriter* (Southport, The Sutherland Publishing Co., 1954)

'The Tailor Makes the Man', *The Tailor and Cutter,* 16 December 1932

'The Tailors and Their Workshops', *The Irish Builder,* vol. XI, no. 233, 1869

Terkel, Studs *Working* (New York, Pantheon Books, 1972)

The Knight of Glin *Irish Furniture* (Dublin, Eason & Son, 1978)

'Their Honours of the Dublin Corporation', *The Comet,* 16 October 1831

Thompson, G. B., 'The Blacksmith's Craft', *Ulster Folklife,* vol. 4, 1958

'Trades or Professions for Our Sons?', *The Irish Builder,* vol. XXXII, no. 733, 1890

Veblen, Thorstein *The Instinct of Workmanship* (New York, The Macmillan Co., 1914)

Vinycomb, John, 'The Heraldry of Old Signs', *Journal of the Kildare Archaeological Society,* vol. 47, 1942

Webb, John J. *The Guilds of Dublin* (London, Ernest Benn, 1929)

Whittaker, Neville *Shopfront* (Durham, Civic Trust for the Northeast, 1980)

'Wood Carving in Ireland', *The Irish Builder,* vol. XXIII, 1880

Woods, K. S. *Rural Crafts of England* (West Yorkshire, EP Publishing, 1975)

'A Word for the Dublin Stonecutters', *The Dublin Builder,* vol. 56, 1862, p. 96

Wymer, Norman *English Town Crafts* (London, Batsford, 1949)

Wymer, Norman *English Country Crafts* (London, Batsford, 1964)

Yanagi, Soetsu *The Unknown Craftsman* (Tokyo, Kodansha International, 1972)

Index

BEVERLY BRANCH
2121 WEST 95th STREET
CHICAGO, ILLINOIS 60643

BEVERLY BRANCH
2121 WEST 95th STREET
CHICAGO, ILLINOIS 60643